The Artist's Resource Handbook

Revised Edition

Daniel Grant

ALLWORTH PRESS, New York

Published by Allworth Press
An imprint of Allworth Communications, Inc.
10 East 23rd Street, New York, NY 10010

Cover design by Douglas Design Associates, New York, NY

Book design by Sharp Des!gns, Holt, MI

ISBN: 1-880559-58-7

Library of Congress Catalog Card Number:
96-84623

Contents

Introduction

Every year, approximately 11,000 students graduate from art schools or university art departments. For most of these art schools and universities, that is the end of the story, as few of them attempt to discover what use their students have made of their art training. Presumably, the applied arts students found jobs in publishing firms, magazines, advertising agencies, and the fine art students placed their works in major galleries. Anecdotal experience and the conclusions of numerous studies on the lives of artists conducted by private and governmental agencies over the past two decades tell another story: Too many of today's visual artists are not earning enough to support themselves in their chosen careers.

There may be various reasons for this, but one clear cause is that they do not know how and have never been prepared to develop their careers. Artists find themselves making mistakes that are costly in terms of time and money and, after years of not achieving success, they often become embittered with artmaking itself.

The fault is not strictly theirs. Those who have taught artists in schools and private classes generally have little concept of how to find a gallery or dealer, what copyright is and how it applies to fine and commercial artists, where to obtain affordable studio space and group-rate health insurance, which public or private agencies provide individual fellowships or sponsor art projects, or how to find out about basic safety precautions when using potentially dangerous art materials.

This information gap has been recognized as a serious problem since the late 1960s and early 1970s, when the first wave of help-the-artist initiatives began. Volunteer Lawyers for the Arts in New York City, for example, was founded in 1969 by a number of lawyers who understood the peculiar legal problems artists face. Since then, VLAs have cropped up around the country, dispensing free or low-cost legal advice to artists and arts organizations on a wide range of art-related matters.

The publishing industry over the past two decades has released an assortment of how-to-make-money-as-an-artist books, many of them written by artists' advisors, a relatively new group of professionals offering artists career advice. In addition, a handful of art schools have introduced "survival" courses for their students that teach the business of being an artist. During this period, arts service organizations have emerged whose main purpose is to serve as a conduit, or "umbrella," for grant-seeking artists. Nowadays, even most state arts agencies offer seminars on how to apply for grants. Most remarkable is the growing body of "art law" that has been enacted on the state and federal levels, offering protections to artists and art collectors; these legislative initiatives have been the result of lobbying by groups of artists who understand their economic needs and have learned to be politically effective.

The only remaining problem is that information remains quite diffuse—some of it uncollected, some researched by a particular arts organization but not shared with others (often, no one knows what other groups are doing or has even thought to ask)—and artists are left to piece together bits of information from a variety of conversations and books, assuming they have spoken with the right people and read the most up-to-date books. Too

often, information is third- or fourth-hand, and no one knows how to check it. In short, more available help for artists has not translated into an easier career path, and artists continue to suffer from what they don't know.

In order to avoid the scattershot approach of so many otherwise helpful arts service organizations, this handbook has been divided into categories, reflecting the greatest needs of most working artists. They are:

1. Sources of technical assistance, a bureaucratic term that means career help (other than financial), such as professional advice, in-kind donations, legal and business consulting, referrals, and project sponsorship.

2. Sources of information on health risks and precautions associated with artmaking. These include where to learn about the ingredients in arts and crafts materials and how to use these products safely. In addition, affordable health insurance programs available to artists are noted as well as where to receive medical attention for specifically arts-related ailments.

3. Sources of information on affordable living and working space for artists.

4. Financial assistance to individual artists, including fellowships, travel and sudden opportunity grants, emergency funds, and cash awards for those working in the crafts and traditional arts areas.

5. Additional reference material, because the art world has grown too large and complex for any one book to answer every question of every artist.

Pointedly, the emphasis here is on ways in which artists may help themselves in an entrepreneurial sense rather than directing them to public arts agencies or foundations to apply for grants. The reason for this is the change in the art world that has taken place since the mid-1970s. Before then, the main career advice that artists and arts organizations sought and received was where to apply for a grant and how to complete a winning grant application. This approach was a result of the ever-increasing amounts of money that were available. The budget of the National Endowment for the Arts increased every year, as did those of all the state arts agencies. Foundation support of the arts was holding its own, and business sponsorship (and collecting) of the arts was expanding dramatically. The largest section in almost every career guide written for visual artists during the 1970s and early 1980s is devoted to how they can successfully apply for a grant.

The art world began to change, however. Foundations, whose stock market–based earnings were not able to keep up with the proliferation of the arts, became less active in the support of culture by the late 1970s. The National Endowment for the Arts, whose overall budget was cut by 40 percent in fiscal year 1996, has had relatively flat funding throughout the 1980s and early 1990s. Business support for the arts plateaued in the mid-1980s and has been dropping ever since (a result of economic retrenchment and a redirection of philanthropic dollars), and the aggregate funding of the arts by state governments around the country has declined from $292.3 million in fiscal year 1990 to $263.08 million in fiscal 1996. That most of the career and business workshops developed by many state arts agencies over the past few years focus on how and where to apply for grants reveals an ironic misconception of the resources available to artists.

The optimism of the 1970s is gone, at least for now. Changed circumstances call for new priorities. Knowing how to fill out a grant application well won't matter as much if there is less or no money to apply for. By spreading less money around to the same number of artists and arts organizations, governmental arts agencies only pauperize the arts, creating more inefficiency and leading to lower quality. Artists and arts groups need to develop ways to earn—rather than simply apply for—money, which is the reason that career assistance programs around the country are introduced in the first chapter.

This handbook aims to help point artists in the right directions, not explaining how to work safely with a potential toxic art material, for example, but where they may find out. No endorsement is intended by listing any individual or organization.

One apology must be offered in advance. Many arts organizations—such as state arts agencies and major foundations—are stable, longstanding institutions that maintain a great regularity in their activities. Many others, however, are seat-of-the-pants operations, often run exclusively or primarily by volunteers, and are subject to the vagaries of the economy and available levels of financial support. Who is in charge changes frequently. The organization's address and telephone number changes almost as often—a result of the fact that many groups are headquartered in the home of the current director or president. All arts service handbooks suffer from the same frustrating problem of being partially out-of-date by the time they are in a reader's hands. If an address or telephone number proves no longer to be correct, contact the appropriate department within the local state or

municipal arts agency for more current information. These groups are usually applicants for public funds, and, therefore, the agencies will have a current address and a contact person to receive the applied-for money.

Another caveat: Declining levels of support at the National Endowment for the Arts may jeopardize existing programs, as organizations will likely cut back on services when their own fundraising drops. The degree to which public funds help generate public sector philanthropy has long been the backbone of the matching grant philosophy in arts support (that is, for every dollar in private funds raised, a government agency provides a matching dollar). One sees the reverse of this in the demise of the Artists' Projects Regional Initiative program that was, until 1996, administered by nineteen arts organizations around the United States with the financial backing of the NEA in conjunction with the Rockefeller Foundation and the Andy Warhol Foundation for the Visual Arts. This program offered "project fellowships" for artists whose work is multidisciplinary or challenges traditional art categories. When Congress slashed the arts endowment's budget by 40 percent, the NEA pulled out its support. With that, the Rockefeller Foundation and the Andy Warhol Foundation recognized that they could not carry the entire weight of the program and dropped the initiative as well. This kind of domino effect is likely to be felt throughout the arts for some time to come, making it difficult to predict which programs will last and which will not.

1

Career Assistance for the Individual Artist

If I could just get someone to exhibit my work . . ." visual artists often say. "If I could find some agency or corporation to commission me. . . ." Few people leave school with as little understanding of what to do next in their careers as fine art students. It is unlikely that their instructors offered any sound advice (or even had any to offer), and the annual result is thousands of art students thrown out into the world psychologically and professionally unprepared.

Artists have some clear needs: They need to learn what possible options are available to them in developing their careers, and they need to find out how to get what they want. Without that how-to

information and the variety of choices before them, however, they are unlikely to realize any of their goals.

Arts Service Organizations

Technical assistance and career advice are perhaps the most valuable, if underrated, services in the art world. Nonprofit arts service organizations, which in most cases are small and underfunded, generally provide these services for artists; it is because of the precarious financial state of many of these service organizations that their ability to serve artists is uncertain from one year to the next.

Nevertheless, the programs that these service organizations offer—tax and legal rights seminars, listings of job opportunities, workshops on health and safety issues, career counseling, and assistance in locating appropriate funding sources as well as help in applying for grants—are essential to artists who want to develop their careers and stay competitive in their fields.

The term "technical assistance" is a large rubric that covers all kinds of services an organization may offer to the arts that doesn't involve receiving a check (for a fellowship or project). The term encompasses the activities of Materials for the Arts programs of the New York City Department of Cultural Affairs (and a number of other arts agencies and institutions, see chapter 2) that solicit technical equipment and office furniture, for instance, which is donated to artists and arts organizations, and the artist hotlines of the New York Foundation for the Arts, the National Association of Fine Artists and the Atlanta Bureau of Cultural Affairs, which enable artists to obtain answers over the telephone to a wide range of professional questions.

The form in which career assistance may come differs from organization to organization, depending upon the audience served. Nexus/Foundation for Today's Art in Philadelphia, Pennsylvania, for instance, focuses on artists in that city and offers its Artist Information Seminars free to the public on a twice-monthly basis. Similar service is offered by D-Art Visual Arts Center in Dallas, which holds three day-long "business of art" seminars per year, costing $25 for members and $35 for nonmembers. "No one tells you in school how you are supposed to support yourself as an artist," said Troy Moore, an event coordinator of D-Art. "You graduate and think, 'My God, what am I supposed to do for money now?'"

Both Nexus and D-Art started out as artist-run exhibition spaces that expanded their services to better assist their members and other artists. Most of the service organizations that provide technical assistance are conceived

and run by artists, which explains both their understanding of the need to disseminate career information as well as their often precarious financial state.

In contrast to the locally oriented D-Art and Nexus, the Seattle, Washington–based Glass Art Society and the Society of North American Goldsmiths in Tampa, Florida, which serve glass and metal artists, respectively, are international organizations that are not easily able to gather everyone around for meetings. Instead, the two groups have annual conferences in different countries, in which a variety of professional issues are discussed, and they both publish newsletters that offer news and career advice.

The goldsmiths and glass art societies' programs are tailored to specific arts media and disciplines. The same can be said for the Chicago-based National Council for Education in the Ceramic Arts and the Individual Visual Artist Coalition in Atlanta. Most others are more broadly based, serving a range of artistic disciplines and media, such as Seattle's Artist Unlimited, which provides professional assistance to artists with disabilities, or The Field in New York City, which instructs artists in grantsmanship through individual consultations and group workshops.

The majority of state arts agencies offer some type of career help to artists, such as a slide registry of the work of state artists, bulletin board notices of job and career opportunities for artists, a newsletter with useful information, as well as a resource library (of how-to-apply-for-grants books, usually) and programs that enable artists to "network." Almost all of them provide seminars on how and when to apply for an agency grant, and some others have established other programs in addition.

The Vermont Council on the Arts, for example, periodically holds workshops on such topics as how to locate funding sources elsewhere around the country and how artists should photograph their artwork. The state agency has also created a granting category—the Artist Development program—that allocates up to $500 for individual artists who want to attend a career conference or visit an artist colony, or who need money to document their work in order to make it presentable for art dealers or arts festival sponsors. The New Hampshire State Council on the Arts' Artist Opportunity Grants program similarly aims to help emerging artists develop professionally, and the Indiana Arts Commission helps individual artists to apply for technical assistance grants.

The arts funding agency in an artist's own state often provides useful

programs. Agency officials may also know of applicable technical assistance programs offered by other organizations within the state. Artists who do not know where to contact their state arts agency may receive this information from the National Assembly of State Arts Agencies (1010 Vermont Avenue, N.W., Suite 920, Washington, D.C. 20005, tel. 202-347-6352).

A number of local arts agencies also offer career seminars or workshops on how and where to apply for grants. Those with a notably vigorous program of these kinds of artists services are listed below.

Many art societies hold regular meetings for members in which career issues—such as how to find an art dealer—may be addressed. The Southeastern Pastel Society in Atlanta, for example, has brought in speakers on how artists can photograph and market their work. These societies are even more likely to hold demonstrations and discuss new techniques in artmaking. State arts agencies and the Spring Watercolor issue of *American Artist* magazine are helpful sources in locating these societies, many of which are headquartered in the home of whoever is the group's president that year.

Were arts agencies and organizations more collaborative in their efforts to assist artists, a list of who provides what kinds of technical assistance for which artists might be easier to come by. However, these agencies and groups often work in isolation, not communicating with one another or pooling information. Below is a list of arts organizations around the country that offer career information and other types of technical assistance for artists. Undoubtedly, more exist than these. Artists should develop their own resource lists, sharing them with others.

ALASKA

Institute of Alaskan Native Art
P.O. Box 583
Fairbanks, AK 99708-0583
(907) 465-7491
Workshops, information referrals

**Shotridge Studios Cultural Center &
 Museum**
407 Stedman Street
Ketchikan, AK 99901
(907) 225-0407
*Newsletter, registry, referrals, workshops,
career consultations*

ARIZONA

ATLATL
402 West Roosevelt Street
Phoenix, AZ 85003
(602) 253-2731
*Workshops, information clearinghouse,
individual consultations for Native American
artists*

The Authors & Artists Resource Center
4001 East Fort Lowell Road
Tucson, AZ 85712-1011
(602) 325-4733
Newsletter, workshops, reference library

Tucson/Pima Arts Council
240 North Stone Avenue
Tucson, AZ 85701
(602) 624-0595
Newsletter, registry, referrals, directory, workshops, career consultations

Womankraft Corp./Community Artists Project
388 South Stone Street
Tucson, AZ 85701
(602) 624-6441
Annual conference, information referrals, seminars

CALIFORNIA

Action Arts, Inc.
P.O. Box 253
Pasadena, CA 91102
(818) 584-6368
Referrals, career consultations

American Indian Art and Gift Shop
241 F Street
Eureka, CA 95501
(707) 445-8451
Workshops, career consultations

Arts, Incorporated
315 West Ninth Street, Suite 201
Los Angeles, CA 90015
(213) 627-9276
Workshops, annual conferences on specific topics

Bay Area Video Coalition
111 17th Street
San Francisco, CA 94107
(415) 861-3282
Discounted use of video equipment, workshops, informative publications

Belize Caribbean Connection
1941 West 23rd Street
Los Angeles, CA 90018
(213) 732-9742
Newsletter, registry, referrals, directory, workshops

Black Photographers of California
107 Santa Barbara Place
Los Angeles, CA 90008
(213) 294-9024
Newsletter

California Community Foundation
606 South Olive Street
Los Angeles, CA 90014-1526
(213) 413-4042
Funding Information Center offers source materials for individuals and organizations

Foundation for Arts Resources
P.O. Box 38145
Los Angeles, CA 90038
(213) 744-0389
Seminars, lectures, acts as an umbrella organization for artists seeking a grant

Humboldt Arts Council
214 E Street
Eureka, CA 95501
(707) 442-0278
Newsletter, directory, workshops, career consultations

Japanese American Cultural and Community Center
244 South San Pedro Street, Suite 505
Los Angeles, CA 90012
(213) 628-2725
Newsletter, registry, referrals, directory

Multicultural Arts, Inc.
1237 Masselin Avenue
Los Angeles, CA 90019
(213) 933-3447
Newsletter, referrals

Multicultural Studies
11110 Alondra Boulevard
Norwalk, CA 90650
(310) 860-2451
Workshops

National Latino Communications Center
3171 Los Feliz Boulevard, Suite 201
Los Angeles, CA 90039
(213) 663-8294
Newsletter, registry

Pro Arts
461 Ninth Street
Oakland, CA 94607
(510) 763-4361
One-on-one consultations and portfolio reviews, workshops, information referral

San Francisco State University
Extended Education
425 Market Street
San Francisco, CA 94105
(415) 904-7700

Self-Help Graphics & Art
3802 Cesar Chavez Avenue
Los Angeles, CA 90063
(213) 881-6444
Newsletter, referrals, workshops, career consultations

Stanislaus Arts Council
1014 A Scenic Drive
Modesto, CA 95350
(209) 558-8628
Newsletter, registry, referrals, directory, workshops, career consultations

Surface Design Association
P.O. Box 20799
Oakland, CA 94620
(415) 567-1992
Workshops at national conference, newsletter

Visual Communications
South California Asian American Studies
 Center
263 South Los Angeles, Suite 307
Los Angeles, CA 90012
(213) 680-4462
Newsletter, referrals

COLORADO

Chicano Humanities and Arts Council, Inc.
4136 Tejon
Denver, CO 80201
(303) 477-7733
Workshops, publications, information referrals

Colorado Center for Contemporary Art & Craft
513 Manitou Avenue
Manitou Springs, CO 80829
(719) 685-1861
Workshops

CONNECTICUT

Artists Collective
35 Clark Street
Hartford, CT 06120
(203) 527-3205
Newsletter, referrals, career consultations

Connecticut Alliance of Black & Hispanic Visual Artists
981 Winchester Avenue
Hamden, CT 06517
(203) 776-9912
Workshops, information referrals

Handweavers Guild of America
120 Mountain Avenue
Bloomfield, CT 06002
Newsletter

Latino Youth Development
154 Minor Street
New Haven, CT 06519
(203) 776-3649
Workshops, career consultations, referrals

Office of Cultural Affairs
25 Stonington Street
Hartford, CT 06106
(203) 722-6488
Referrals, career consultations

DELAWARE

Sussex County Arts Council
P.O. Box 221
Georgetown, DE 19947
(302) 856-5721
Newsletter, registry, referrals, directory

DISTRICT OF COLUMBIA

American Institute of Architects
1735 New York Avenue, N.W.
Washington, D.C. 20006-5292
(202) 626-7300
Newsletter, referrals, directory

Americans for the Arts
927 15 Street, N.W.
Washington, D.C. 20005
(202) 371-2830
Information clearinghouse, public policy development

Coalition of Washington Artists
P.O. Box 21584
Washington, D.C. 20009
(202) 362-0745
Information clearinghouse

The Crafts Center
1001 Connecticut Avenue, N.W., Suite 1138
Washington, D.C. 20036
(202) 728-9603
Information referrals for low-income crafts-people, workshops, publications

Cultural Alliance of Greater Washington
410 Eighth Street, N.W., Suite 600
Washington, D.C. 20004
(202) 638-2406
Workshops, publications, career counseling, discounts on goods, job bank

Evans-Tibbs Collection
1910 Vermont Avenue, N.W.
Washington, D.C. 20001
(202) 234-8164
Newsletter, registry, referrals, workshops

Indian Arts and Crafts Board
Room 4004 MIB
U.S. Department of Interior
Washington, D.C. 20240
(202) 208-3773
Newsletter, directory, referrals, workshops, career consultations

International Sculpture Center
1050 17th Street, N.W., Suite 250
Washington, D.C. 20036
(202) 785-1144
Annual conference, newsletter, computerized sculptor registry

National Artists Equity Association
P.O. Box 28068
Washington, D.C. 28028-8068
(202) 628-9633; (800) 727-NAEA
Newsletter, information clearinghouse
Artist Equity chapters located in central California (408-375-6165), Northern California (415-626-6806 or 415-648-7908) and San Diego (619-721-8909), Maryland (301-995-6298), New York (212-226-0581 or 212-966-7096), Philadelphia (215-287-7086) and Pittsburgh (412-481-7544), Virginia (703-684-6318) and Washington (206-547-4552)

National Association of Artists' Organizations
918 F Street, N.W.
Washington, D.C. 20004
(202) 347-6350
Newsletter, directory, information clearinghouse

National Center on Arts and the Aging
600 Maryland Avenue, S.W.
Washington, D.C. 20024
(212) 479-6990; (800) 424-9046
Information referrals

National Conference of Artists
409 Seventh Street, N.W.
Washington, D.C. 20004
(202) 393-3116
Information clearinghouse, seminars, publications

National Endowment for the Arts
1100 Pennsylvania Avenue, N.W.
Washington, D.C. 20506
(202) 682-5570
http://arts.endow.gov
Web site includes arts.community, a monthly on-line magazine on the nonprofit arts with news about the arts endowment and links to other Web sites, and an Arts Resource Center that offers information on arts service organizations and current research in the arts

National Jazz Service Organization
P.O. Box 50152
Washington, D.C. 20091
(202) 347-2604
Information clearinghouse, workshops, demonstrations

FLORIDA

Koubek Memorial Center
University of Miami
2705 S.W. Third Street
Miami, FL 33135
(305) 649-6000
Workshops

National Association of Fine Artists
550 South Federal Highway
Ft. Lauderdale, FL 33301
(800) 996-6232
Information clearinghouse

Society of North American Goldsmiths
5009 Londonderry Drive
Tampa, FL 33647-0169
(813) 977-5326
Slide registry, annual conferences, workshops, newsletter

GEORGIA
Alternate Roots
1083 Austin Avenue
Atlanta, GA 30307
(404) 577-1079
Newsletter, referrals, directory, workshops, career consultations

The Arts Exchange
750 Kalb Street, S.E.
Atlanta, GA 30312
(404) 624-4211
Consultations with individuals and organizations on identifying funding sources and assistance in grant-writing, workshops, seminars

Atlanta Bureau of Cultural Affairs
887 West Marietta
Atlanta, GA 30318
(404) 853-3261 or (404) 817-6823
Information referral service and information clearinghouse

Handweavers Guild of America, Inc.
Two Executive Concourse, Suite 201
3327 Duluth Highway
Duluth, GA 30136-3373
(770) 495-7702
Workshops, newsletter, meetings

Southeast Community Cultural Center
750 Kalb Street, S.E.
Atlanta, GA 30312
(404) 624-4211
Newsletter, referrals, workshops, career consultations

Video Data Bank
675 Ponce de Leon Avenue, N.E.
Atlanta, GA 30308
(404) 817-6815
Information clearinghouse and Materials for the Arts program

GUAM
Isla Center for the Arts
University of Guam
P.O. Box 5203
Mangilao, Guam 96923
Newsletter, referrals

HAWAII
Arts Council of Hawaii
P.O. Box 38000
Honolulu, HI 96837
(808) 524-7120
Workshops, information referrals

Honolulu Academy of Arts
900 South Beretania Street
Honolulu, HI 96814
(808) 532-8714
Newsletter, referrals, career consultations

ILLINOIS
American Society of Artists
P.O. Box 1326
Palatine, IL 60078
(312) 751-2500; (312) 991-4748
Information clearinghouse, discounts on arts and crafts supplies through bulk orders

Beacon Street Gallery & Theatre
4520 North Beacon Street
129½ West State Street
Chicago, IL 60640
(708) 232-2728
Information clearinghouse, registry, referrals, directory, workshops

Chicago Artists' Coalition
5 West Grand Avenue
Chicago, IL 60610
(312) 670-2060
Seminars and workshops, newsletter, slide registry, resource center, member discounts at selected art supply shops

Destin Asian
5945 North Lakewood, Suite 2
Chicago, IL 60660
(312) 275-7101
Newsletter, registry, referrals, directory

National Council for Education in the Ceramic Arts
1411 West Farragut Street
Chicago, IL 60640
(312) 784-7057
Annual conference, newsletter

Near Northwest Arts Council
1579 North Milwaukee, Room 300
Chicago, IL 60622
(312) 278-7677
Slide registry, workshops, newsletter, referrals

Professional Photographers of America, Inc.
1090 Executive Way
Des Plaines, IL 60018
(708) 299-8161
Newsletter

Sun Foundation
RR 2
P.O. Box 156E
Washburn, IL 61570
(309) 246-8403
Newsletter, referrals, career consultations

Video Data Bank
Columbus at Jackson Boulevard
Chicago, IL 60603
(312) 899-5172
Information clearinghouse

INDIANA

Indianapolis Art League
820 East 67th Street
Indianapolis, IN 46220
(317) 255-2464
Workshops, publications

IOWA

Iowa Designer Crafts Association
723 Seneca
Webster City, IA 50595
(515) 832-2801
Workshops, newsletter

KENTUCKY

North Fork Media, Inc.
307 Fifth Street
Whitesburg, KY 41858
(606) 633-4252
Referrals, workshops

LOUISIANA

Arcadiana Arts Council
P.O. Box 53762
Lafayette, LA 70505
(318) 233-7060
Information clearinghouse, quarterly workshops on career issues

Artists Alliance
125 Main Street
Lafayette, LA 70502
(318) 233-7518
Publications, workshops, information referrals

Arts Council of Greater Baton Rouge
427 Laurel Street
Baton Rouge, LA 70801
(504) 344-8558
Newsletter, registry, directory, referrals, workshops, career consultations

Arts Council of New Orleans
821 Gravier Street, Suite 600
New Orleans, LA 70112
(504) 523-1465
Workshops, information referrals

Commission on the Arts
P.O. Box 828
Slidell, LA 70459
(504) 646-4375
Workshops, information referrals

New Orleans Video Access Center
2010 Magazine Street
New Orleans, LA 70130
(504) 524-8626
Workshops

MAINE

Maine Arts
582 Congress Street
Portland, ME 04101
(207) 772-9012
Newsletter, referrals, workshops

Maine Arts Sponsors Association
P.O. Box 2352
Augusta, ME 04338
(207) 626-3277
Workshops, resource directory (for performing and visual artists)

Maine Crafts Association
P.O. Box 228
Deer Isle, ME 04627
(207) 348-9943
*Workshops (for craftspeople and fine artists),
newsletter, resource directory*

Maine Writers and Publishers Alliance
190 Mason Street
Brunswick, ME 04011
(207) 729-6333
Newsletter, workshops

Union of Maine Visual Artists
P.O. Box 21
Bowdoinham, ME 04008
(207) 737-4749
Newsletter, workshops

MARYLAND
**National Council for the
 Traditional Arts**
1320 Fenwick Lane, Suite 200
Silver Spring, MD 20910
(301) 565-0654
Information clearinghouse

Pyramid Atlantic
6001 66th Avenue
Riverdale, MD 20737
(301) 459-7154
Workshops in technical and career issues

MASSACHUSETTS
Arts Extension Service
604 Goodell
University of Massachusetts
Amherst, MA 01003
(413) 545-2360
Workshops, publications

Boston Arts Organization
P.O. Box 6061, JFK Station
Boston, MA 02114
Newsletter

Boston Film and Video Foundation
1126 Boylston Street
Boston, MA 02215
(617) 536-1540
*Workshops on finding and applying for
grants; artist data base of festivals and grants*

Boston Visual Artists Union
P.O. Box 399
Newtonville, MA 02160
(617) 695-1266
Workshops on career issues, slide registry

**Chesterwood Seminars for Professional
 Sculptors**
Chesterwood Estate & Museum
Stockbridge, MA 01262
(413) 298-3579
Workshops on career issues

Photographic Resource Center
602 Commonwealth Avenue
Boston, MA 02215
(617) 353-0700
*Workshops in technical and career issues,
newsletter, member discounts for darkroom
rentals*

Research Institute of African Diaspora
12 Morley Street
Roxbury, MA 02119
(617) 427-8325
*Newsletter, registry, referrals, directory,
workshops, career consultations*

Society of Arts and Crafts
175 Newbury Street
Boston, MA 02116
(617) 266-1810
*Information referrals, one-on-one consulta-
tions, workshops, lectures*

United South End Settlements
566 Columbus Avenue
Boston, MA 02118
(617) 375-8132
Referrals, workshops, career consultations

MICHIGAN
Ann Arbor Art Association
117 West Liberty
Ann Arbor, MI 48104
(313) 994-8004
Career workshops

Concerned Citizens for the Arts in Michigan
230 East Grand River, Suite 201
Detroit, MI 48226
(313) 961-1776
Publications, hotline, workshops, information clearinghouse

Michigan Traditional Arts Program
Michigan State University
East Lansing, MI 48824
(517) 355-2370
Referrals, workshops

Oakland County Cultural Affairs
1200 North Telegraph Road
Pontiac, MI 48053
(313) 858-0415
Information clearinghouse, job bank

United Black Artists, USA, Inc.
7661 LaSalle Boulevard
Detroit, MI 48206
(313) 898-5574
Workshops

MINNESOTA

Compas
308 Landmark Center
75 West Fifth Street, Room 304
St. Paul, MN 55102
(612) 292-3287
Workshops

Lake Region Arts Council
P.O. Box 661
112 West Washington Avenue
Fergus Falls, MN 56537-0661
(218) 739-4617
Workshops, information referrals

Native American Arts Initiative
Region 2 Arts Council
426 Bemdji Avenue
Bemdji, MN 56601
(218) 751-5447
Registry

Northfield Arts Guild
304 Division Street
Northfield, MN 55057
(507) 645-8877
Newsletter, referrals, directory, career consultations

Pillsbury Neighborhood Service Center for Cultural Arts
3501 Chicago Avenue South
Minneapolis, MN 55407
(612) 824-0708
Workshops

Resources and Counseling for the Arts
429 Landmark Center
75 West Fifth Street
St. Paul, MN 55102
(612) 292-3206
Workshops and private consultations

MISSOURI

Greater Kansas City National Hispanic Heritage Commission
10430 Askew Avenue
Kansas City, MO 64137
(816) 765-1992
Registry, workshops, career consultations

Heart of America Indian Center
1340 East Admiral Boulevard
Kansas City, MO 64106
(816) 421-0039
Newsletter, referrals, workshops

Kansas City Artists Coalition
201 Wyandotte
Kansas City, MO 64105
(816) 421-5222
Slide registry, resource library, workshops

MONTANA

Flathead Valley Community College
777 Grandview Drive
Kalispell, MT 59901
(406) 756-3945
Newsletter, workshops

Salish Kootenai College
Box 117
Pablo, MT 59855
(406) 675-4800
Newsletter, workshops

NEBRASKA

Metro Arts
P.O. Box 1077
Omaha, NE 68101
(402) 341-7910
Workshops

Mexican American Commission
P.O. Box 94965
Lincoln, NE 68509
(402) 471-2791
Newsletter

**Nee-shoch-ha-chee Community
Development Corporation**
P.O. Box 748
Winnebago, NE 68071
(402) 878-2972
Workshops, career consultations, loan fund

NEVADA

Allied Arts Council of Southern Nevada
3135 Industrial Road, Suite 224
Las Vegas, NV 89109
(702) 731-5419
Workshops, publications

NEW HAMPSHIRE

The Drum
P.O. Box 353
Raymond, NH 03077
(603) 895-1459
Referrals, workshops, career consultations

Studio Potter Network
69 High Street
Exeter, NH 03833
(603) 772-6323
*Workshops, conferences, information
clearinghouse*

NEW JERSEY

**Passaic County Cultural and Heritage
Council**
One College Boulevard
Paleston, NJ 07505
(201) 684-6555
*Newsletter, directory, referrals, workshops,
career consultations*

NEW MEXICO

Hispanic Culture Foundation
P.O. Box 7279
Albuquerque, NM 87194
(505) 831-8360
*Workshops, information clearinghouse,
newsletter, registry, career consultations,
directory*

School of American Research
Indian Arts Research
P.O. Box 2188
Santa Fe, NM 87504
(505) 982-3584
Newsletter, referrals

NEW YORK

Americans for the Arts
1 East 53 Street
New York, NY 10022
(212) 223-2787
*Information clearinghouse, publications,
public policy development*

American Craft Council
72 Spring Street
New York, NY 10012
(212) 274-0630; (800) 724-0859
Resource library, information referral

American Institute of Graphic Arts
1059 Third Avenue
New York, NY 10021
(800) 548-1634
Newsletter

American Society of Media Photographers
419 Park Avenue South
New York, NY 10016
(212) 889-9144
Seminars, publications

Arts Council at Freeport
P.O. Box 97
130 East Merrick Road
Freeport, NY 11520
(516) 223-2522
Workshops, information referrals

Arts Council for Wyoming County
P.O. Box 249
63 South Main Street
Perry, NY 14530
(716) 237-3517
*Newsletter, registry, referrals, directory,
workshops, information referrals*

Arts for Greater Rochester
335 East Main Street, Suite 200
Rochester, NY 14604-2185
(716) 546-5602
Workshops, information clearinghouse

Asian American Arts Alliance
339 Lafayette Street
New York, NY 10012
(212) 979-6734
Newsletter, registry, referrals, directory, workshops, career consultations

Association of Hispanic Arts
173 East 116th Street
New York, NY 10029
(212) 860-5445
Information clearinghouse, newsletter, referrals, directory, workshops, career consultations

Association of Independent Video and Filmmakers
625 Broadway, Ninth Floor
New York, NY 10012
(212) 473-3400
Information clearinghouse

Authors Guild
330 West 42nd Street, 29th Floor
New York, NY 10036
(212) 398-0838
Workshops and one-on-one consultations on contract negotiations, copyright, taxation

Brooklyn Arts Council
200 Eastern Parkway
Brooklyn, NY 11238-4205
(718) 783-4469
Workshops, information referrals

Center for Book Arts
626 Broadway
New York, NY 10012
(212) 460-9768
E-mail: bookarts@pipeline.com

Center for Safety in the Arts
155 Avenue of the Americas
New York, NY 10013-1507
(212) 366-6900
Newsletter, information clearinghouse

College Art Association
275 Seventh Avenue
New York, NY 10001
(212) 691-1051
Annual conference, publications

Creative Coalition
1100 Avenue of the Americas
New York, NY 10036
(212) 512-5515
Seminars on social, political, and freedom of speech issues

El Museo del Barrio
1230 Fifth Avenue
New York, NY 10029
(212) 831-7272
Newsletter, registry, referrals, directory

En Foco, Inc.
32 East Kingsbridge Road
Bronx, NY 10468
(718) 584-7718
Newsletter, seminars, portfolio reviews, slide registry

The Field
161 Avenue of the Americas
New York, NY 10013
(212) 691-6969
Grant-writing consultations, and workshops for artists conference

Graphic Artists Guild
11 West 20th Street
New York, NY 10011-3704
(212) 463-7730/7759
E-mail: basista@pipeline.com
Guild chapters located in Albany, NY (518-482-2236), Atlanta, GA (404-516-8746), Boston, MA (617-277-0828), Chicago, IL (312-275-5895), District of Columbia (202-829-3278), Indianapolis, IN (317-359-1217), Philadelphia, PA (215-293-9673), South Florida (305-455-0411), Bedford, TX (817-292-1855), and Vermont (802-425-2192).
Workshops, newsletter

Grupo de Artistas Latino Americanos, Inc.
21 West 112th Street
New York, NY 10026
(212) 369-3401
Newsletter, workshops, meetings

Hatch-Billops Collection
491 Broadway
New York, NY 10012
Newsletter, registry, referrals

Heresies
P.O. Box 1306
Canal Street Station
New York, NY 10013
(212) 227-2108
Heresies is a feminist journal examining
issues in, and the relationship of, art and
politics

**Hispanic Academy of Media Arts and
 Sciences**
P.O. Box 3268
New York, NY 10163
(212) 686-7030
Newsletter, workshops

International Society of Copier Artists
759 President Street, Suite 2H
Brooklyn, NY 11215
(718) 638-3264
Newsletter, meetings

Ken Keleba House
214 East Second Street
New York, NY 10009
(212) 674-3939
Registry, referrals, career consultations

Latino Collaborative
280 Broadway, Suite 412
New York, NY 10007
(212) 732-1121
Newsletter, information clearinghouse,
referrals, workshops

Long Island Arts Council
130 East Merrick Road
Freeport, NY 11520
(516) 223-2522
Newsletter, referrals, workshops, career
consultations, directory

Media Alliance
c/o Thirteen/WNET
356 West 58th Street
New York, NY 10019
(212) 560-2919
Publications, workshops, low-cost editing

Midmarch Associates
Box 3304 Grand Central Station
New York, NY 10163
(212) 666-6990
Information clearinghouse, resource library;
publishes books for women artists and
women's arts organizations

Molly Olga Neighborhood Art Classes
139 Locust Street
Buffalo, NY 14204
(716) 885-1388
Workshops, career consultations

National Association of Women Artists
41 Union Square West
New York, NY 10003
(212) 675-1616
Meetings, newsletter

National Sculpture Society
Dept. AA
1177 Avenue of the Americas
New York, NY 10036
(212) 764-5645
Publications, conferences; listings of
foundries, sculpture supply stores, tools and
equipment

New York Artists Equity Association
498 Broome Street
New York, NY 10013
(212) 941-0130
Newsletter, information clearinghouse

**New York City Department of Cultural
 Affairs**
2 Columbus Circle
New York, NY 10019
(212) 841-4100
Materials for the Arts program, arts
management counseling

New York Foundation for the Arts
155 Avenue of the Americas
New York, NY 10013-1507
(212) 366-6900; (800) 232-2789
Artist "hotline"

Ollantay Art Heritage Center
P.O. Box 720636
Jackson Heights, NY 11372
(718) 565-6499
Newsletter, registry, referrals, directory

Organization of Independent Artists
19 Hudson Street, Suite 402
New York, NY 10013
(212) 219-9213
Publications

Poets and Writers
72 Spring Street
New York, NY 10012
(212) 226-3586
Information clearinghouse, publications, workshops

Society of Photographer and Artist Representatives, Inc.
60 East 42 Street
New York, NY 10165
(212) 779-7464
Directory, meetings

Squeaky Wheel/Buffalo Media Resources
P.O. Box 251 Ellicott Station
Buffalo, NY 14205-0251
(716) 884-7172
Information clearinghouse

Visual Artists and Galleries Association
521 Fifth Avenue
New York, NY 10017
(212) 808-0616
Information clearinghouse, protects artists' copyright

NORTH CAROLINA
Black Artists Guild
P.O. Box 2162
400 North Queens Street
Kinston, NC 28501
(919) 523-0003
Newsletter

City of Raleigh Arts Commission
311 South Blount Street
Raleigh, NC 27601
(919) 831-6234
Free one-on-one consultations, information referrals, publications

Guilford Native American Art Gallery & Association
P.O. Box 5623
Greensboro, NC 27435
(910) 273-6605
Newsletter, referrals, directory

Winston-Salem Delta Fine Arts
1511 East Third Street
Winston-Salem, NC 27101
(910) 722-2625
Newsletter, referrals, career consultations

YMI Cultural Center
39 South Market Street
Asheville, NC 28802
(704) 252-4614
Career consultations

NORTH DAKOTA
North Dakota Indian Arts Association
Mandan Train Depot
401 West Main Street
Mandan, ND 58554
(701) 663-1263
Workshops

OHIO
Art for Community Expression
772 North High , Suite 102
Columbus, OH 43215
(614) 294-4200
Newsletter, registry, referrals, directory

Miami Valley Arts Company
P.O. Box 95
Dayton, OH 45402-0095
(513) 228-0737
Workshops, information referrals

NOVA/New Organization for the Visual Arts
4614 Prospect Avenue
Cleveland, OH 44103
(216) 431-7500
Workshops, newsletter, resource center

Professional Artists Services
Peaceworks Gallery
703 Bryden Road
Columbus, OH 43205
(614) 464-4648
Referrals, career consultations

Women of Color Quilter's Network
556 Bessinger Drive
Cincinnati, OH 45240
(513) 825-9707
Newsletter, referrals, career consultations

OKLAHOMA

**Oklahoma Indian Arts & Crafts
 Cooperative**
P.O. Box 966
Aadarko, OK 73005
(405) 247-3486
Referrals, career consultations

Oklahoma Visual Arts Coalition
P.O. Box 54416
Oklahoma City, OK 73154
(405) 842-6991
Publications, business-of-art seminars

Red Earth, Inc.
2100 N.E. 52 Street
Oklahoma City, OK 73111
(405) 427-5228
Newsletter, career consultations

OREGON

Interstate Firehouse Culture Center
5340 North Interstate
Portland, OR 97217
(503) 823-2000
*Newsletter, registry, workshops, career
consultations, referrals*

**National Council for Education for
 Ceramic Arts**
P.O. Box 1677
Bandon, OR 97411
(503) 347-4394
Information clearinghouse

Quintana Galleries
139 N.W. Second Avenue
Portland, OR 97209
(503) 223-1729
Referrals, career consultations

PENNSYLVANIA

Creative Artists Network
P.O. Box 30027
Philadelphia, PA 19103
(215) 546-7775
*Job bank, one-on-one consultations,
workshops, information clearinghouse*

Greater Philadelphia Cultural Alliance
320 Walnut Street, Suite 500
Philadelphia, PA 19106
(215) 440-8100
*Job bank, workshops, publications,
information referrals*

**International Arts-Medicine
 Association**
3600 Market Street
Philadelphia, PA 19104
(215) 525-3784
Newsletter, information clearinghouse

Manchester Craftsmen's Guild
1815 Metropolitan Street
Pittsburgh, PA 15233
(412) 322-1773
Referrals, workshops

Nexus/Foundation for Today's Art
137 North Second Street
Philadelphia, PA 19106
(215) 629-1103
*Artist information seminars, artist resource
room*

Pittsburgh Trust for Cultural Resources
209 Ninth Street, Fifth floor
Pittsburgh, PA 15222
(412) 471-6070
Career counseling workshops, publications

Taller Puertorrigueno
2721 North Fifth Street
Philadelphia, PA 19133
(215) 426-3311
*Newsletter, referrals, registry, directory,
career consultations*

SOUTH DAKOTA

Mitchell Area Arts Council
119 West Third Avenue
Mitchell, SD 57301
(605) 996-4111
Newsletter, referrals, workshops

TENNESSEE

Africa in April Cultural Awareness Festival
P.O. Box 111261
Memphis, TN 38111
(901) 785-2542
Workshops, career consultations

African American Cultural Alliance
P.O. Box 22173
Nashville, TN 37218
(615) 256-7720
Referrals, workshops, career consultations

Memphis Black Arts Alliance
Shelby State Community College
P.O. Box 40854
Memphis, TN 38174-0854
(901) 458-3400
Workshops, information referrals, career consultations, directory, newsletter

Native American Indian Association
211 Union Street, Suite 932
Nashville, TN 37221
(615) 726-0806
Newsletter

Rose Center
P.O. Box 1976
Morristown, TN 37816
(615) 581-4330
Newsletter, referrals, workshops, career consultations

TEXAS

Art League of Houston
1953 Montrose Boulevard
Houston, TX 77006
(713) 523-9530
Workshops, information referrals

The Association of American Cultures
1703 West Kingshighway
San Antonio, TX 78201
(210) 736-9272
"Leadership 2000" program, publications for people of color

Black Arts Alliance
1157 Nauasota
Austin, TX 78702
Newsletter, registry, directory, referrals, workshops

Centro Cultural Aztlan
803 Castroville Road, Suite 402
San Antonio, TX 78237
(210) 432-1896
Newsletter, referrals

Community Artists' Collective
1501 Elgin Avenue
Houston, TX 77004
(713) 523-1616
Newsletter, referrals, workshops, career consultations

Country Corner
Box 727
Van Horn, TX 79855
(915) 283-2788
Workshops, career consultations

Cultural Arts Council of Houston
1964 West Gray, Suite 224
Houston, TX 77109
(713) 527-9330
Grant-writing workshops, job bank and funding library

D-Art Visual Arts Center
2917 Swiss Avenue
Dallas, TX 75204
(214) 821-2522
Seminars on the business of art, newsletter, resource library

Dallas Office of Cultural Affairs
1925 Elm Street
Dallas, TX 75201
(214) 670-3687
Workshops on how to market art, how to raise money, how to apply for funds

Houston Women's Caucus for Art
1413 Westheimer
Houston, TX 77006
(409) 295-3006
Newsletter, workshops

National Association of Latino Arts and Culture
1300 Guadalupe Street
San Antonio, TX 78207
(210) 271-3151
Workshops

Society for Photographic Education
P.O. Box 222116
Dallas, TX 75222-2116
(817) 273-2845
Annual conference, newsletter, resource file of grant sources

Arts Services Network
1812 West Main Street
Richmond, VA 23220
(804) 359-9488
Slide registry, information resource center,
grant-writing consultations, newsletter

Branches of the Arts
P.O. Box 26034
Richmond, VA 23260-6034
(804) 355-3586
Workshops

Harrison Museum of African American
Culture
P.O. Box 12544
Roanoke, VA 24026
(703) 345-4818
Newsletter, registry, career consultations

National Art Education Association
1916 Association Drive
Reston, VA 22091-1590
(703) 860-8000
Newsletter

Southeastern Virginia Arts Association
P.O. Box 1673
Norfolk, VA 23501
(804) 683-8714
Newsletter, referrals, career consultations

WASHINGTON
Allied Arts of Seattle
105 South Main, Room 201
Seattle, WA 98104
(206) 624-0432
Free consultations, artist forums

Artist Trust
1402 Third Avenue, Suite 415
Seattle, WA 98101
(206) 467-8734
Information clearinghouse, workshops

Glass Art Society
1305 4th Avenue, Suite 711
Seattle, WA 98101
(206) 382-1305
Networking services for artists, collectors, and
suppliers, newsletter, annual conference

Reflex
105 South Main, Suite 204
Seattle, WA 98104
(206) 682-7688
Publishes the magazine, Reflex, *which offers*
discussion, news, and resources

WISCONSIN
Milwaukee Inner City Arts
642 West North Avenue
Milwaukee, WI 53212
(414) 265-5050
Workshops, information referrals

Wisconsin Folk Museum
100 South Second Street
Mt. Horeb, WI 53572
(608) 437-4742
Newsletter, referrals, directory, career
consultations

Wisconsin Painters and Sculptors, Inc.
341 North Milwaukee Street
Milwaukee, WI 53202
(414) 276-0605
Workshops

Wisconsin Women in the Arts
c/o Ehlers
12530 West Tremont Street
Brookfield, WI 53005
(414) 782-8398
Publications

CANADA

ALBERTA
Alberta Craft Council
10106—124th Street
Edmonton, Alberta T5N 1P6
(403) 488-6611
Information clearinghouse

Alberta Handicrafts Guild
11 Mayfair Road, S.W.
Calgary, Alberta T2V 1Y5
Meetings, newsletter

Alberta Potters Association
400, 119-14th Street, N.W.
Calgary, Alberta T2M 1Z6
(403) 270-3759
Meetings

Alberta Printmakers Society
P.O. Box 6821, Station D
Calgary, Alberta T2P 2E7
(403) 287-1056
Newsletter, meetings

Alberta Society of Artists
5151—Third Street, S.E.
Calgary, Alberta T2H 2X6
(403) 640-4542
Newsletter, meetings

Film and Video Arts Society of Alberta
9722—102nd Street
Edmonton, Alberta T5X 0X4
(403) 429-1671
Meetings, newsletter

BRITISH COLUMBIA
Crafts Association of British Columbia
1386 Cartwright Street
Granville Island
Vancouver, British Columbia V6H 3R8
(604) 687-6511
Meetings, newsletter

Embroiderers Association of Canada, Inc.
4424 Rangemont Place
Victoria, British Columbia V8N 5L6
(604) 477-1583
Meetings, newsletter

MANITOBA
Craft Guild of Manitoba
183 Kennedy Street
Winnipeg, Manitoba R3G 1S6
(204) 943-1190
Meetings, newsletter

Manitoba Crafts Council
3—100 Arthur Street
Winnipeg, Manitoba R3B 1H3
(204) 942-1816
Newsletter

Mentoring Artists for Women's Art
2A—290 McDermot Avenue
Winnipeg, Manitoba R3B 0T2
(204) 949-9490
Meetings

NEW BRUNSWICK
Association des artistes acadiens professionnelles du Nouveau-Brunswick
Aberdeen Cultural Centre
140 Botsford Street, Suite 10
Moncton, New Brunswick E1C 4X4
(506) 852-3313
Meetings, newsletter

New Brunswick Crafts Council
181 Westmorland Street, Suite 304A
P.O. Box 1231
Fredericton, New Brunswick E3B 5C8
(506) 450-8989
Newsletter

New Brunswick Filmmakers Cooperative
51 York Street
P.O. Box 1537, Station A
Fredericton, New Brunswick E3B 4Y1
(506) 455-1632
Newsletter, meetings

NEWFOUNDLAND & LABRADOR
Newfoundland Independent Filmmakers Cooperative
40 Kings Road
St. John's, Newfoundland A1C 3P5
(709) 753-6121
Meetings, newsletter

Visual Arts—Newfoundland and Labrador
Devon House
59 Duckworth Street
St. John's, Newfoundland A1C 1E6
(709) 738-7303
Meetings

NOVA SCOTIA
Metal Arts Guild of Nova Scotia
153 Frenchman's Road
Oakfield, Nova Scotia B2T 1A9
(902) 454-0994
Newsletter, meetings

Nova Scotia Designer Crafts Council
1809 Barring Street, Suite 901
Halifax, Nova Scotia B3J 3K8
(902) 423-3837
Newsletter

Photographic Guild of Nova Scotia
122 Flagstone Drive
Dartmouth, Nova Scotia B2V 1Z8
Meetings, newsletter

Visual Arts—Nova Scotia
1809 Barrington Street, Suite 901
Halifax, Nova Scotia B3J 3K8
(902) 423-4694
Meetings, newsletter

ONTARIO

Artist-Run Network
183 Baathurst Street
Toronto, Ontario M5T 2R7
(416) 703-1275
Newsletter, advocacy

Artists in Stained Glass
c/o Ontario Crafts Council
35 McCaul Street, Suite 220
Toronto, Ontario M5T 1V7
(416) 581-1072
Publications

**Association for Native Development in
the Performing and Visual Arts**
39 Spadina Road
Toronto, Ontario M5R 2S9
(416) 972-0871
*Information clearinghouse, advocacy,
newsletter*

**Association of National Nonprofit
Artists Centers (ANNPAC)**
183 Bathurst Street
Toronto, Ontario M5T 2R7
(416) 869-1275
Publications, workshops

**Canadian Artists Network: Black Artists
in Action**
54 Wolseley Street
Toronto, Ontario M5T 1A5
(416) 703-9040
Newsletter, meetings

**Canadian Artists' Representation/
Le Front des Artistes Canadiens
(CAR/FAC)**
100 Gloucester Street, Suite B1
Ottawa, Ontario K2P 0A4
(613) 231-6277
 or

221—100 Arthur Street
Winnipeg, Manitoba R3B 1G4
(204) 943-7211
 or
497 Robinson Street
Moncton, New Brunswick E1C 5E7
(506) 855-0746
 or
401 Richmond Street West, Suite 440
Toronto, Ontario M5V 3A8
(416) 340-8850
 or
210—1808 Smith Street
Regina, Saskatchewan S4N 0N7
(306) 565-8916
 or
21 Forest Drive
Aylmer, Québec J9H 4E3
(819) 682-4183
*Information clearinghouse, newsletter,
meetings, workshops, advocacy*

Canadian Conference of the Arts
189 Laurent Avenue Eaast
Ottawa, Ontario K1N 6P1
(613) 238-3561
*Newsletter, information clearinghouse,
advocacy, meetings*

Canadian Crafts Council
189 Laurier Avenue East
Ottawa, Ontario K1N 6P1
(613) 235-8200
*Information clearinghouse, newsletter,
advocacy*

Canadian Native Arts Foundation
77 Mowat Avenue, Suite 508
Toronto, Ontario M6K 3E3
(416) 588-3328
*Newsletter, advocacy, workshops, information
clearinghouse*

**Canadian Society of Painters in Water
Colour**
258 Wallace Street, Suite 102
Toronto, Ontario M6P 3M9
(416) 533-5100
Publications, information clearinghouse

**Fusion: The Ontario Clay and Glass
Association**
225 Confederation Drive
Scarborough, Ontario M1G 1B2
(416) 438-8946
Newsletter, meetings

Inuit Art Foundation
Country Place
2081 Merivale Road
Nepean, Ontario K2G 1G9
(613) 224-8189
Workshops, newsletter

Native Arts and Crafts Corporation
1186 Memorial Avenue
Thunder Bay, Ontario P7B 5K5
(807) 622-5731
Newsletter

Ontario Crafts Council
35 McCaul Street
Toronto, Ontario M5T 1V7
(416) 977-3551
Newsletter

Ontario Handweavers and Spinners
35 McCaul Street
Toronto, Ontario M5T 1V7
(416) 971-9641
Meetings, newsletter

Pastel Society of Canada
P.O. Box 3396, Station D
Ottawa, Ontario K1P 6H8
(613) 825-4577
Workshops, newsletter

The Print and Drawing Council of Canada
c/o Extension Gallery
80 Spadina Avenue, Suite 503
Toronto, Ontario M5V 2J6
(416) 977-5311, ext. 323
Information clearinghouse, newsletter

Sculptors' Society of Canada
P.O. Box 40
130 King Street West, Suite 301
Toronto, Ontario M5X 1B5
(416) 214-0389
Workshops, information clearinghouse, publications

Visual Arts—Ontario
439 Wellington Street
Toronto, Ontario M5V 1E7
(416) 591-8883
Meetings

PRINCE EDWARD ISLAND

Prince Edward Island Crafts Council
156 Richmond Street
Charlottetown, Prince Edward Island C1A 1H9
(902) 892-5152
Newsletter

QUÉBEC

Artexte
3375 Boulevard St. Laurent, Suite 103
Montreal, Québec H2X 2T7
(514) 845-2759

Independent Film and Video Alliance
5505 St. Laurent Boulevard, Suite 3000
Montreal, Québec H2T 1S6
(514) 277-0328
Publications

Regroupement des artistes en Arts Visuels due Québec
460 St. Catherine Street West, Suite 412
Montreal, Québec H3B 1A7
(514) 866-7101
Meetings

SASKATCHEWAN

Association des artistes de la Saskatchewan
514 Victoria Avenue East, Suite 218
Regina, Saskatchewan S4N 0N7
(306) 522-0940
Meetings

Saskatchewan Craft Council
813 Broadway Avenue
Saskatoon, Saskatchewan S7N 1B5
(306) 653-3616
Newsletter

Saskatchewan Embroiderers Guild
P.O. Box 563
Cut Knife, Saskatchewan S0M 0N0
Meetings, newsletter

The Changing World of Arts Services

These are uncertain days in the arts because a previous national policy of governmental assistance to artists and arts organizations has been replaced by one of self-reliance. There is no "system" of self-help to replace the system of public support—local, state, regional and federal arts agencies whose yearly budgets grew regularly but have more recently been cut. These days, traditionally underfunded service organizations face extinction. Artists make unanswered pleas for money with new urgency, while once-heeded advocacy groups now can only claim as a victory that the National Endowment for the Arts has not been abolished yet.

"All the efforts to eliminate the National Endowment for the Arts, or cut its budget in half, really jolted the traditional arts supporters, and they haven't known what to do," said George Koch, president of the Washington, D.C.–based National Artists Equity Association. "It's a new world for the arts out there, and a lot of people aren't ready for it."

Slowly, there are signs of change in the arts community, from current and planned mergers of groups and the creation of new advocacy groups to new sources of information for artists and arts organizations and new areas of study for researchers.

For instance, in 1995, National Artists Equity merged its membership with that of the Communication Workers of America, one of the larger members of the AFL/CIO, in order to offer its current 1,500 artist members a wider array of services and union-level health and life insurance. In 1996, the New York City–based American Council for the Arts merged with the Washington, D.C.–headquartered National Assembly of Local Arts Agencies to form Americans for the Arts, with offices in both Manhattan and the nation's capital.

"Most arts service groups are unique, single-focus organizations that are duplicating each other's services, and there isn't enough money for all of them," Jack Duncan, a board member of Americans for the Arts, said. This merger came about following a major restructuring at the American Council for the Arts in which its touted toll-free Artist Hotline was shut down, resulting from the pullout of its foundation sponsors.

Over the five years that the American Council for the Arts ran the Artist Hotline, approximately, 20,000 calls were received. However, according to David Bosca, director of Americans for the Arts' information clearinghouse, "many funders don't want to continue something after the first year. They want to go on to the next sexy thing."

The clearinghouse continues to provide information to artists, although not as conveniently or inexpensively as through a toll-free telephone call. An Americans for the Arts Web site (http://www.artsusa.org) is available for those who are on-line, and one may still call Americans for the Arts with general or specific questions (212-223-2787, ext. 225) and be mailed information sheets at a certain charge per sheet.

Fortunately, the hotline (still with the same toll-free telephone number: 800-232-2789) was picked up by the New York Foundation for the Arts, adding to that organization's information services for artists. The foundation's on-line Arts Wire (http://www.tmn.com/Artswire/www/nyfa/awfront.html), which provides arts-related news and facilitates communication between artists and arts groups, was established in 1992. The Foundation also recently took over some of the services of the Center for Safety in the Arts (including its newsletter and Web site), which closed for financial reasons at the end of 1995. A number of information resources can now only be found on the Internet.

The American Crafts Council, whose library is often contacted by artists and craftspeople seeking information on upcoming shows, organizations, schools, materials and career issues, also moved on-line (http://www.amcraft.org) for those with access to a computer and modem.

Another organization, the Ft. Lauderdale–based National Association of Fine Artists, also has both a recently-established toll-free hotline (800-996-6232, ask for the hotline) and a Web site (http://www.nafa.com/) through which artists may obtain information on legal issues, marketing their work and other career-related topics.

Yet another Web site called Feedback (http://www.know1.com/), set up privately by a husband-and-wife team of artists' advisors, advertises their business services to fine and commercial artists, but also offers ideas for free on how to prepare a portfolio and provides "feedback" on the presentation of individual portfolios.

Perhaps more quietly but no less importantly, career information for visual artists is being made available through a growing number of the art schools they attend. "I see art schools all over the country adding survival courses and workshops on how artists are supposed to live and work in the real world," said Lisa Pines, director of career services at Parsons School of Design in New York City and a founder of Career Professionals in the Arts. "There is a hunger out there for information, and schools are being forced to respond."

Another change in the art world, according to Randy Cohen, membership director at the Americans for the Arts, is the recognition of the need for a different message for legislators than what has been traditionally offered by arts supporters. "In the past, one talked about how the arts were an elevating presence in society, that they were good in themselves, and that we should support art for art's sake. Now, we talk about the economic impact of the arts industry on communities and about using the arts to address cultural, educational and social issues within a community, such as crime prevention."

He described a "Midnight Shakespeare" program offered by the San Francisco Shakespeare Festival, which is designed for urban teenagers, as an example of this new emphasis. Americans for the Arts is currently undertaking a three-year study of programs such as this in which a community benefit is derived from cultural activities.

In late 1994, the association also sponsored the creation of a cultural advocacy group, composed of 60 artists' organizations, arts funding agencies, museums and other grassroots groups, that meet monthly in the offices of the U.S. Conference of Mayors in Washington, D.C. They share information and plan strategies for countering legislative efforts to decrease or eliminate governmental support for the arts. One of its most visible activities was the establishment of a toll-free number (800-651-1575) through which arts supporters could send mailgrams (at a cost of $9.50) to both their two United States senators and to the members of the House of Representatives urging federal arts support. Over 70,000 mailgrams have been sent to date. A portion of the $9.50 is used to purchase space in newspapers and magazines for full-page advertisements warning of the potential harm to the arts and humanities if federal assistance is lost.

Another new organization that has emerged is the Washington, D.C.–based Center for Arts and Culture, founded last October through the largesse of the Pew Charitable Trusts, the Rockefeller Foundation and the Lila Wallace–Reader's Digest Fund, among others. According to its director, Daniel Ritter, the purpose of the Center is not so much to be an advocate for governmental arts funding as to provide scholarly reports and information for these debates in Congress and state legislatures. "We're looking to do for the arts what the Heritage Foundation, the Cato Foundation and the American Enterprise Institute have done to further the ideas and agenda of the conservative movement in this country," he said. "A problem has been that when these debates over cultural policy take

place in Congress and elsewhere, there are few or no factual studies that can be brought into the discussion. However, we are not just looking to draw reports from people identified with one side of the arts funding debate. If these reports are done by people with stature, the reports will be read and change attitudes. We want material that isn't immediately compromised."

Perhaps in keeping with the mood of budgetary restraint of the times, the first studies commissioned by the Center examine not legislative appropriations to the arts but more indirect financial assistance by government, such as changes in the tax code that would help artists and nonprofit arts organizations and enable the search for "alternative funding streams" for the arts. These alternatives, most of which exist in various cities and states around the country, include the use of hotel-motel occupancy taxes (California and Texas), state lotteries (Massachusetts), donation check-offs on tax forms, property taxes (St. Louis, Missouri and Chicago, Illinois), sales taxes (Denver, Colorado), video rentals and music purchases (Ft. Lauderdale, Florida), taxes on vanity license plates (California and Florida) and surcharges for a round of golf (Tucson, Arizona).

Developing Expertise in Arts Administration

Besides managing their own careers, many artists also run arts organizations and find themselves involved in administration, bookkeeping, fundraising, audience or membership development, and the myriad other tasks that are part of operating any business. The National Endowment for the Arts as well as most state arts agencies provide money for arts organizations in need of technical assistance. Most small and mid-sized arts organizations are run by artists, a second career that sometimes comes by design and other times just happens. Knowing how to direct an organization is no easier than running one's own artistic career. Whereas there is only one art school in the United States that has a required survival course for fine or applied art students, there are graduate-level programs that offer specific courses and degrees in arts administration. These schools are:

American University
College of Arts and Sciences
Department of Performing Arts
Kreeger 201
4400 Massachusetts Avenue
Washington, D.C. 20016-8053
(202) 885-3420

Boston University
Metropolitan College
Arts Administration
808 Commonwealth Avenue
Boston, MA 02215
(617) 353-4064

**Brooklyn College of the City University
of New York**
Performing Arts Management
Department of Theatre
Brooklyn, NY 11210
(718) 951-5989

Carnegie Mellon University
Master of Arts Management Program
H. John Heinz III School of Public Policy
 and Management
5000 Forbes Avenue
Pittsburgh, PA 15213-3890
(412) 268-8436

Columbia College Chicago
Arts, Entertainment and Media
 Management Department
600 South Michigan Avenue
Chicago, IL 60605
(312) 663-1600, ext. 5652

Columbia University/Teachers College
Program in Arts Administration
The Arts in Education
Box 78
New York, NY 10027
(212) 678-3271

Drexel University
Arts Administration Program
Department of Performing Arts
Philadelphia, PA 19104
(215) 895-2452

**L'Ecole des Hautes Etudes
 Commerciales de Montreal**
DESSGOC
5255 Avenue Decelles
Montreal, Québec H3T 1V6
Canada
(514) 340-6151

Florida State University
Center for Arts Administration
Institute for Science and Public Affairs
School of Visual Arts and Dance
126 Carrothers Hall
Tallahassee, FL 32306-3014
(904) 644-5473

Golden Gate University
Arts Administration Department
536 Mission Street
San Francisco, CA 94105
(415) 904) 6708

Indiana University
Arts Administration Program
Graduate School
Business Building, Room 660F
Bloomington, IN 47405
(812) 855-0282

New York University
Performing Arts Management Program
School of Education
Department of Music and Performing Arts
 Professions
Education Building, Suite 675
35 West 4 Street
New York, NY 10012-1172
(212) 998-5505

New York University
Visual Arts Administration Program
Department of Art and Art Professions
School of Education
34 Stuyvesant Street, Third floor
New York, NY 10003
(212) 998-5700

Saint Mary's University of Minnesota
Arts Administration Program
700 Terrace Heights
Winona, MN 55987-1399
(507) 457-1606

School of the Art Institute of Chicago
Arts Administration Program
37 Wabash Avenue
Chicago, IL 60603
(312) 899-1232

Southern Methodist University
Center for Arts Administration
Meadows School of the Arts
P.O. Box 750356
Dallas, TX 75275-0356
(214) 768-3425

State University of New York
M.B.A. in Arts Administration
School of Management
Binghamton, NY 13902-6015
(607) 777-2630

Texas Tech University
Arts Administration Specialty
The Graduate School
P.O. Box 4460
Lubbock, TX 79409
(806) 742-2781

University of Akron
Arts Administration Program
School of Theatre Arts
College of Fine and Applied Arts
Akron, OH 44325-1005
(216) 972-6823

University of Alabama
Theatre Management/Arts Administration
Department of Theatre and Dance
P.O. Box 870239
Tuscaloosa, AL 35487-3850
(205) 348-3850

University of California
Arts Management Program
John E. Anderson Graduate School of
 Management
Box 951481
Los Angeles, CA 90095-1481
(310) 206-4052

University of Cincinnati
Arts Administration Program
College—Conservatory of Music
Cincinnati, OH 45221
(513) 556-4383

University of Illinois
Community Arts Management Program
School of Public Affairs and
 Administration
Springfield, IL 62794-9243
(217) 786-7373

University of Maryland
Theatre Management Program
Department of Theatre
College Park, MD 20742-1215
(301) 405-6692

University of New Orleans
Arts Administration
College of Liberal Arts
New Orleans, LA 70148
(504) 286-6574

University of Oregon
Arts Administration Program
School of Architecture and Applied Arts
Eugene, OR 97403-5230
(503) 346-3639

University of Wisconsin
Bolz Center for Arts Administration
Graduate School of Business
975 University Avenue
Madison, WI 53706
(608) 263-4161

Virginia Tech
Arts Administration
Division of Performing Arts
PAB 213
Blacksburg, VA 24061
(703) 231-5335

Yale University
Theatre Management Department
Yale School of Drama
222 York Street
New Haven, CT 06520
(203) 432-1591

York University
Program in Arts and Media Administration
Faculty of Administrative Studies
4700 Keel Street
Toronto, Ontario M3J 1P3
Canada
(416) 736-5088

A number of organizations and associations also offer nondegree programs in arts administration, usually consisting of workshops and seminars, including:

Americans for the Arts
One East 53 Street
New York, NY 10022
(212) 223-2787
 and

Americans for the Arts
927 15 Street, N.W.
Washington, D.C. 20005
(202) 371-2830

American Film Institute
2021 North Western Avenue
Los Angeles, CA 90027
(213) 856-7690

Arts Extension Service
Division of Continuing Education
602 Goodell Building
University of Massachusetts
Amherst, MA 01003
(413) 545-2360

Arts Management Institute
Division of Performing Arts
Virginia Tech
Blacksburg, VA 24061-0141
(703) 231-4670

Association of Hispanic Arts
173 East 116 Street
Second Floor
New York, NY 10029
(212) 860-4670

The Banff Centre for Management
Arts Management Programs
P.O. Box 1020, Station 45
Banff, Alberta T0L 0C0
Canada
(403) 762-6121

Community Arts Administration
Intern Program
North Carolina Arts Council
Department of Cultural Resources
Raleigh, NC 27601-2807
(919) 733-7897

**Council for the Advancement and
 Support of Education**
11 Dupont Circle, N.W., Suite 400
Washington, D.C. 20036
(202) 328-5919

Donors Forum of Chicago
53 West Jackson, Suite 430
Chicago, IL 60604
(312) 431-0260

Fanning Leadership Center
Hokesmith Annex, Third Floor
University of Georgia
Athens, GA 30602
(706) 542-1108

The Foundation Center
79 Fifth Avenue
New York, NY 10003
(212) 620-4230

The Fundraising School
550 West North Street, Suite 301
Indianapolis, IN 46202-3162
(800) 962-6692

The Grantsmanship Center
P.O. Box 17220
Los Angeles, CA 90017
(213) 689-9222; (800) 421-9512

Greater Philadelphia Cultural Alliance
320 Walnut Street, Suite 500
Philadelphia, PA 19106
(215) 440-8100

Indiana Assembly of Local Arts Agencies
4907 North Kenwood Avenue
Indianapolis, IN 46208
(812) 855-0282

National Assembly of State Arts Agencies
1010 Vermont Avenue, N.W., Suite 920
Washington, D.C. 20005
(202) 347-6352

Points of Light Foundation
Volunteer Administration Services
1737 H Street, N.W.
Washington, D.C. 20006
(202) 223-9186

Performing Arts Management Institute
408 West 57 Street
New York, NY 10019
(212) 245-3850

Volunteer Lawyers for the Arts
One East 53 Street, Sixth Floor
New York, NY 10022
(212) 319-2787

**York University Seminars for Arts
 Administrators**
Administrative Studies Building, Room 215
4700 Keele Street
North York, Ontario M3J 1P3
Canada
(416) 736-5082

Two organizations in Canada, the Canadian Association of Arts Administration Educators (c/o Arts Administration, Jasper Place Campus, Grant MacEwan Community College, 10045-156th Street, Room 269, Edmonton, Alberta T5P 2P7, tel. 403-497-4410) and the Centre for Cultural Management (University of Waterloo, HH 143, Waterloo, Ontario N2L 3G1, tel. 519-885-1211), also serve as resource centers for arts administrators, providing information, referrals and technical support.

Artists with Disabilities

Establishing a career as an artist is a difficult enough activity without having to add the challenge of working with a physical or mental disability. To start, disabled artists frequently have not been educated to the same degree or level as their colleagues without handicaps because of the wheelchair inaccessibility of many art schools. As a result, disabled artists have less knowledge about how the art world operates and how they might make their way in it. In the past, people with disabilities tended to stay at home, away from the public, and were not encouraged to promote themselves or the artwork they might do.

Furthermore, according to Lois Kaggen, founder and president of Resources for Artists with Disability in New York City, "many disabled artists cannot physically get to the dealers who might be interested in showing their work because those galleries are not wheelchair accessible." Another problem, she added, is the larger issue that "society generally doesn't see the disabled as having anything to contribute to society. Disabled artists are often sneered at as not serious artists."

Clayton Turner, a quadriplegic since a diving accident at age 13 who began painting with a brush in his mouth in 1953, noted that "my disability has made me live in virtual slow motion. What has taken me 10 years might have taken a physically normal artist two or three years, or even less time. The time it takes me to create an original work is months or years and, when I was starting out, I'd go to some art fair and sell an original work that took so long to make for the gas money to get home. It becomes frustrating and exasperating. One has to be stubborn and persevere."

A variety of governmental agencies and private organizations exist to provide services, referrals and general information to those with disabilities. These include:

Clearinghouse on Disability Information
Office of Special Education and
Rehabilitative Services
U.S. Department of Education
Switzer Building, Room 3132
330 C Street, S.W.
Washington, D.C. 20202-2524
(202) 732-1241/1245/1723
*Referrals, answers inquiries on national, state
and local sources of information and
assistance to people with disabilities*

**Higher Education and Adult Training
for People with Handicaps**
One Dupont Circle, Suite 800
Washington, D.C. 20036-1193
(202) 939-9320; (800) 544-3284
*Referrals and information exchange on
educational support services and oppor-
tunities on American campuses*

Muscular Dystrophy Association
Department AA
3300 East Sunrise Drive
Tucson, AZ 85718-3208
(502) 529-2000
*As well as providing information and
referrals, the association began collecting art
by physically disabled artists in 1992. A*

*traveling exhibition of this art took place in
New York City and Washington, D.C. in the
fall of 1995.*

**National Clearinghouse on Women and
Girls with Disabilities**
Educational Equity Concepts
114 East 32 Street, Suite 306
New York, NY 10016
(212) 725-1803
*Listings of agencies and organizations
providing services in the United States and
Canada*

**National Information Center on
Deafness**
Gallaudet University
800 Florida Avenue, N.E.
Washington, D.C. 20002-3625
(202) 651-5051; TDD: (202) 651-5052
*Referrals, information clearinghouse,
publications*

National Organization on Disability
910 16 Street, N.W., Suite 600
Washington, D.C. 20006
(202) 293-5960; (800) 248-ABLE
*Referrals, offers publications and technical
assistance to organizations on disability issues*

There are also a number of organizations around the country that serve disabled artists, providing information, resources, and advice of all kinds. These include:

FEDERAL GOVERNMENT
National Endowment for the Arts
Office of Special Constituencies
Nancy Hanks Center
1100 Pennsylvania Avenue, N.W.
Washington, D.C. 20506-0001
(202) 682-5532
Grants, publications

CALIFORNIA
Association for Theater and Disability
c/o Access Theatre
527 Garden Street
Santa Barbara, CA 93101
(805) 564-2063

Braille Institute of America
741 North Vermont Avenue
Los Angeles, CA 90029
(213) 663-1111
*Classes for artists, students and teachers
involved with visually impaired artists*

Career Growth Art Center
355 24th Street
Oakland, CA 94612
(510) 836-2340
Workshops, one-on-one consultations

Disability Arts Fair
City of Berkley Recreation
2180 Milvia Street
Berkley, CA 94704
(510) 644-6530
Annual festival includes directories, referrals

Enabled Artists United
P.O. Box 178
Dobbins, CA 95935
(916) 692-1581
Publications

**Expressions: Literature and Art by
People with Disabilities**
P.O. Box 16294
St. Paul, MN 55116-0294
Awards for art, poetry and prose

**Greater Los Angeles Council on
Deafness, Inc.**
616 South Westmorland, Second Floor
Los Angeles, CA 90005
(213) 383-2220
*Information referrals, legal and peer
counseling, job development*

Institute of Art and Disabilities
233 South 41 Street
Richmond, CA 94804
(415) 620-0290
Workshops, consultations, exhibitions

National Institute of Art and Disabilities
551 23rd Street
Richmond, CA 94804
(415) 620-0290
Workshops, consultations, publications

**The Performing Arts Theater of the
Handicapped**
P.O. Box 3106
Carlsbad, CA 92009
(619) 753-3386
Workshops

DISTRICT OF COLUMBIA

The Dole Foundation
1819 H Street, N.W., Suite 850
Washington, D.C. 20006
(202) 457-0318
*Job training, employment search for
individuals, grants to organizations*

**President's Committee on Employment
of Disabled Persons**
1331 F Street, N.W., Third Floor
Washington, D.C. 20004
(202) 376-6200
Publications

FLORIDA

Research Grant Guides
P.O. Box 1214
Loxahatchee, FL 33470
(407) 795-6129
Publications

ILLINOIS

Friends-in-Art
7001 North Clark Street
Chicago, IL 60626
(312) 973-7600
Newsletter, meetings

IOWA

National Federation of the Blind
814 Fourth Avenue
Grinnell, IA 50112
(515) 236-3366
*Advocacy, employment counseling,
scholarships*

LOUISIANA

**Louisiana Council for Music and
Performing Arts, Inc.**
Pan American Life Center, 21st Floor
601 Poydras Street
New Orleans, LA 70130
(504) 584-9142
*Conferences, seminars, information
clearinghouse*

MARYLAND

National Institute of Mental Health
Grant Management Branch
5600 Fishers Lane, Room 7C05
Rockville, MD 20857
(301) 443-3065
Information referral, grants

MINNESOTA

Sister Kenny Institute
800 East 28th Street
Minneapolis, MN 55407
(612) 863-5304
*Fee-for-service consultations, advocacy,
annual art show*

NEW JERSEY

Brookdale Community College
765 Newman Springs Road
Lincroft, NJ 07738
(908) 842-1900
Workshops, job bank

NEW YORK

Association of Handicapped Artists
5150 Broadway
Depew, NY 14043
(716) 683-4624
Workshops, information clearinghouse for mouth and foot painters; organizes exhibition opportunities

Deaf Artists of America
87 North Clinton Avenue, Suite 408
Rochester, NY 14604
(716) 325-2403; TDD: (716) 325-2400
Publications, conference, information referral

Disabled Artists' Network
P.O. Box 20781
New York, NY 10025
Publications

Education and Job Information Center
Brooklyn Public Library
Grand Army Plaza
Brooklyn, NY 11238
(718) 780-7777
Employment training, job search

Just One Break
373 Park Avenue South
New York, NY 10036
(212) 725-0804
Job search, employment training

Learning Through Art
Guggenheim Museum Children's Program
Department AA
1071 Fifth Avenue

New York, NY 10128
(212) 831-7044
Classes

Resources for Artists with Disabilities, Inc.
77 Seventh Avenue, Suite PhG
New York, NY 10011-6645
(212) 691-5490
Information referral, workshops and seminars; organizes exhibition opportunities

OHIO

Kaleidoscope
United Disability Services
326 Locust Street
Akron, OH 44302
(216) 762-9755
Publication

WASHINGTON

Artists Unlimited
158 Thompson Street
Seattle, WA 98109
(206) 441-8480
Information clearinghouse

WEST VIRGINIA

Job Accommodation Network
West Virginia University
P.O. Box 6123
Morgantown, WV 26506-6123
(800) JAN-7234
Information clearinghouse

CANADA

Arts Carousel/Arts with the Handicapped Foundation
1262 Don Mills Road
Toronto, Ontario M5S 2S8
(416) 391-2086
Workshops

In addition to the Sister Kenny Institute and Resources for Artists with Disabilities, Inc. (listed above), a number of organizations around the United States organize exhibitions of the work of disabled artists, including:

Artquake
P.O. Box 9100
Portland, OR 97207
(503) 227-2787

Camden House
Cultural and Heritage Commission
South Park Drive and Shady Lane
Haddon Township, NJ 08108
(609) 858-0040

Harmarville Rehabilitation Center
P.O. Box 11460
Pittsburgh, PA 15238
(412) 781-5700; (412) 828-1300

Moss Rehabilitation Hospital
Twelfth Street at Tabor Road
Philadelphia, PA 19141
(215) 456-9900

National Exhibits by Blind Artists, Inc.
919 Walnut Street
Philadelphia, PA 19107
(215) 925-3213

Touch Foundation
20 Fifth Avenue, Suite 2B
New York, NY 10011
(212) 995-8880

Since its founding by Jean Kennedy Smith in 1974, Very Special Arts programs and offices have been established throughout the United States and the world, offering artistic participatory experiences for people of all ages who have physical and mental disabilities. Among these events are ballet lessons, painting classes, and choral music performances. These programs are generally a source of short-term teaching positions for artists, but many state affiliates also offer career assistance to disabled artists, usually through business skills workshops.

Very Special Arts
Education Office
John F. Kennedy Center for the Performing
 Arts
Washington, D.C. 20566
(202) 628-2800; (800) 933-8721

Very Special Arts Alabama
Liz Moore Low Vision Center
50 Medical Park East Drive
Birmingham, AL 35235
(205) 838-3162

Very Special Arts Alaska
P.O. Box 773185
Eagle River, AK 99577
(907) 694-8722

Very Special Arts Arizona
3321 North Chapel
Tucson, AZ 85716
(602) 795-6502
 and

1660 West Meadow Hills
Nogales, AZ 85621
(602) 281-0406

Very Special Arts Arkansas
(800) 933-8721

Very Special Arts California
15241 Springdale
Huntington Beach, CA 92649
(714) 892-4884

Very Special Arts Colorado
200 Grant Street, Suite 303
Denver, CO 80203
(303) 777-0797

Very Special Arts Connecticut
56 Arbor Street
Hartford, CT 06106
(203) 236-3812

Very Special Arts Delaware
University of Delaware
018 Hall Education Building
Newark, DE 19716-2940
(302) 831-2084

Washington (D.C.) Very Special Arts
c/o Trinity College
125 Michigan Avenue, N.E.
Washington, D.C. 20017
(202) 939-5008

Very Special Arts Florida
P.O. Box 10453
Tallahassee, FL 32302
(904) 644-7910

Very Special Arts Georgia
1904 Monroe Drive, Suite 110
Atlanta, GA 30324
(404) 892-3645

Very Special Arts Hawaii
P.O. Box 88277
Honolulu, HI 96830-8277
(808) 735-4325

Very Special Arts Idaho
(800) 933-8721

Very Special Arts Illinois
c/o Williams Advertising
3306 East Washington Road
East Peoria, IL 61611
(310) 698-0959
 or
Apparel Center
350 North Orleans, Suite 5-128
Chicago, IL 60654
(312) 321-3611

Very Special Arts Indiana
1605 East 86th Street
Indianapolis, IN 46240
(317) 253-5504

Very Special Arts Iowa
Department of Education
Grimes State Office Building, Room 3EN
Des Moines, IA 50319
(515) 281-3179

Very Special Arts Kansas
334 North Topeka, Suite 104
Wichita, KS 67202
(316) 262-8184

Very Special Arts Kentucky
c/o Kentucky Department of Education
Capitol Plaza Tower, Eighth Floor
Frankfort, KY 40601
(502) 564-4970

Very Special Arts Louisiana
Department of Education
2758-C Brightside Lane
Baton Rouge, LA 70820
(504) 765-2600

Very Special Arts Maine
P.O. Box 8534
Portland, ME 04104
(207) 761-3861

Very Special Arts Maryland
6802 McClean Boulevard
Baltimore, MD 21234
(410) 426-0022

Very Special Arts Massachusetts
China Trade Center
2 Boylston Street, Second Floor
Boston, MA 02116
(617) 350-7713

Very Special Arts Michigan
P.O. Box 1999
Royal Oak, MI 48068
(313) 546-9298

Very Special Arts Minnesota
Hennepin Center for the Arts
528 Hennepin Avenue, Room 201
Minneapolis, MN 55403
(612) 332-3888

Very Special Arts Mississippi
P.O. Box 5365
Mississippi State, MS 39762-5365
(601) 325-2367

Very Special Arts Missouri
Behavioral Studies Department
8001 Natural Bridge Road ·
St. Louis, MO 63121
(314) 553-5752

Very Special Arts Montana
University of Montana
25 North Corbin Hall
Missoula, MT 59812
(406) 243-4847/5467

Very Special Arts Nebraska
P.O. Box 163
Norfolk, NE 68702-0163
(402) 887-5444; (402) 397-9454

Very Special Arts Nevada
200 Flint Street
Reno, NV 89501
(702) 329-1401

Very Special Arts New Hampshire
80 North Main Street, Second Floor
Concord, NH 03301-4942
(603) 228-4330

Very Special Arts New Jersey
841 Georges Road
North Brunswick, NJ 08902
(908) 745-3885

Very Special Arts New Mexico
P.O. Box 7784
Albuquerque, NM 87194
(505) 768-5188

Very Special Arts New York
Margaret Chapman School
5 Bradhurst Avenue
Hawthorne, NY 10532
(914) 592-8526

Very Special Arts New York City
18-05 215th Street
Bayside, NY 11360
(718) 225-6305
 or
Letchworth Development Center
2 East Kirkbride Road
Thiells, NY 10984
(914) 947-2899

Very Special Arts North Carolina
Department of Public Instruction
Division of Exceptional Children's Services
310 Wilmington Street
Raleigh, NC 27601-1058
(919) 715-1597

Very Special Arts North Dakota
(800) 933-8721

Very Special Arts Ohio
Baker & Hostetler
65 East State Street, Suite 2100
Columbus, OH 43215
(614) 462-4715

Very Special Arts Oklahoma
P.O. Box 54490
Oklahoma City, OK 73154
(405) 948-6411

Very Special Arts Oregon
P.O. Box 304
Salem, OR 97308-0304
(503) 378-3598

Very Special Arts Pennsylvania
117 Tuscarora Street
Harrisburg, PA 17104
(717) 238-0907

Very Special Arts Rhode Island
500 Prospect Street
Pawtucket, RI 02860
(401) 725-0247

Very Special Arts South Carolina
P.O. Box 575
Ladson, SC 29456
(803) 821-5849

Very Special Arts South Dakota
300 North Dakota Avenue, Suite 602
Sioux Falls, SD 57102
(605) 339-4393

Very Special Arts Tennessee
6431 Tea Rose Terrace
Brentwood, TN 37027
(615) 373-8420

Very Special Arts Texas
18383 Gallery Drive
Dallas, TX 75252
(214) 732-1179

Very Special Arts Utah
P.O. Box 526244
Salt Lake City, UT 84152-6244
(801) 328-0703

Very Special Arts Vermont
P.O. Box 432
79 Weaver Street
Winooski, VT 05404-0432
(802) 655-4105

Very Special Arts Virginia
P.O. Box 29081
Richmond, VA 23229
(804) 225-2070

Very Special Arts Washington
158 Thomas Street, Suite 15
Seattle, WA 98109
(206) 443-1843

Very Special Arts West Virginia
Marshall University
400 Hal Greer Boulevard
Huntington, WV 25755
(304) 696-6384

Very Special Arts Wisconsin
4797 Hayes Road, Suite 202
Madison, WI 53704
(608) 241-2131

Very Special Arts Wyoming
6009 Horse Creek Road
Cheyenne, WY 82009
(307) 634-8812

CANADA
Very Special Arts British Columbia
British Columbia Association for
 Community Living
300 30 East Sixth
Vancouver, British Columbia V5T 4P4
Canada
(604) 875-1119

Very Special Arts Quebec
Visions Sur l'Art Quebec
244 rue Sherbrooke, Suite 414
Montreal, Québec H2X 1E1
Canada
(514) 845-2481

Power in Numbers

Pope Julius pleaded with, and even threatened war against, the rulers of Florence to convince Michelangelo to return to Rome and complete the rebuilding of St. Peter's that the artist had been commissioned to do. That an artist would willingly walk away from the world's best art patron at the time and that a pope would need to go to such lengths in order to fetch him back reflects the power that a single artist once wielded. Our present-day image of the artist is rather different: Artists beg and plead for support and legal protections to government officials and political leaders, who make it clear that they have larger issues to which they must attend. The most respect that any government has shown to an artist's prestige in the twentieth century was by the Nazis, who did not incarcerate Pablo Picasso during their occupation of Paris in the early 1940s, only denying him most art materials and an opportunity to exhibit.

Isolated artists have been the easiest prey for people who would rob them of their copyright protections, damage, destroy or alter their art and reputations, deny them freedom of speech or censor their artwork, deny them information on potentially harmful ingredients in the art products they use, and welsh on implied or contractual agreements. As is noted in chapter 3, volunteer lawyers for the arts groups around the United States enable artists to pursue their legal rights when art-related laws are broken. However, motivating legislators to sponsor and pass these laws, and gaining a forum in which artists may publicly express their desire for public

recognition, financial assistance, and further legal protections require artists to band together in service and political action groups.

There are many artist membership organizations to be considered, some of them exclusively involved in art-political endeavors, others focusing on the economic and social needs of artists, and yet others doing some of both. Membership, for which there is an annual fee, usually provides artists with a periodic newsletter, and in some instances with opportunities for insurance of one or more types and discounts on goods and services. Some of the national, regional, and local organizations to which artists may belong are:

CALIFORNIA

Enabled Artists United
P.O. Box 178
Dobbins, CA 95935
(916) 692-1581
Legal referrals and advocacy on behalf of disabled artists

No More Censorship Defense Fund
P.O. Box 11458
San Francisco, CA 94101
Source of information

DISTRICT OF COLUMBIA

American Arts Alliance
1319 F Street, N.W., Suite 500
Washington, D.C. 20004
(202) 737-1727
http://www.tmn.com/Oh/Artswire/www/
aaa/aaahome.html
Lobbies on behalf of increased support of the arts, involved in national public policy issues for the arts

Center for Arts and Culture
1755 Massachusetts Avenue, N.W., Suite 416
Washington, D.C. 20036
(202) 588-5277
Commissions studies on cultural policy for use in political debates and hearings

Cultural Advocacy Group
c/o Americans for the Arts
927 15th Street, N.W.
Washington, D.C. 20005
(202) 371-2830
Grass-roots organizing, lobbies Congress in support of the arts

Independent Sector
1828 L Street, N.W.
Washington, D.C. 20036
(202) 223-8100
Researches issues in public financing on nonprofit institutions, including arts groups

U.S. Committee of the International Association of Art
c/o National Artists Equity Association
P.O. Box 28068 Central Station
Washington, D.C. 20038
(202) 628-9633; (800) 727-6232
Advocates for artists' rights

National Gay and Lesbian Task Force
1734 14th Street, N.W.
Washington, D.C. 20009-4309
(202) 332-6483
Promotes equality under the law for gays

People for the American Way
2000 M Street, N.W., Suite 400
Washington, D.C. 20036
(202) 467-4999
Advocates for constitutional liberties

Recording Industry Association of America
1020 19th Street, N.W., Suite 200
Washington, D.C. 20036
(202) 775-7253
Rock the Vote program looks to influence young voters on free speech issues

ILLINOIS

**American Library Association's Office
for Intellectual Freedom**
50 East Huron Street
Chicago, IL 60611
(312) 280-4223
*Alerts the field to issues of freedom of speech
and censorship*

Parents for Rock and Rap
c/o Mary Morello
Box 53
Libertyville, IL 60048
Identifies instances of censorship

MARYLAND

ARTFBI/Artists for a Better Image
1440 East Baltimore Street, Suite 2
Baltimore, MD 21231-1404
(410) 563-1903
http://www.tmn.com/community/jgates/
 artfbi.html
*Promotes the value of artists and art;
evaluates how artists are perceived by society*

MASSACHUSETTS

Comic Book Legal Defense Fund
P.O. Box 693
Northampton, MA 01061
(413) 586-6967
*Involved in defending comic book artists
against threats to their first amendment
rights*

Gay & Lesbian Advocates & Defenders
P.O. Box 218
Boston, MA 02112
(617) 426-1350
*Involved in gay rights issues, the organization
also has an AIDS law project for AIDS-related
discrimination cases*

Photographic Collective
c/o Community Change, Inc.
14 Beacon Street, Room 602
Boston, MA 02108
(617) 523-0555
Antiracism activities

MINNESOTA

Arts Over AIDS
P.O. Box 4758
St. Paul, MN 55104-0758
(612) 646-5407
*Emergency financial assistance to artists with
HIV, public awareness campaigns*

United Arts
75 Fifth Street West, Suite 416
St. Paul, MN 55102
(612) 292-3222
*Newsletter, directory, information clearing-
house, lobbies for public arts support*

NEW YORK

Alliance for the Arts
The Estate Project for Artists with AIDS
330 West 42nd Street
New York, NY 10036
(212) 947-6340
 or
8851 Santa Monica Boulevard, Suite 400
West Hollywood, CA 90069
(310) 652-1282
E-mail: estate@netcom.com
Web: http://www.artistswithaids.org
*Promotes arts-in-education, assistance for
artists with AIDS; researches economic impact
of the arts on communities*

**American Booksellers Association
Foundation for Free Expression**
P.O. Box 672
New York, NY 10113
(212) 463-8450
Public education on free expression

American Civil Liberties Union
Arts Censorship Project
132 West 43rd Street
New York, NY 10036
(212) 944-9800
*Involved in advocacy, litigation, and public
education on the issue of censorship*

Americans for the Arts
One East 53 Street
New York, NY 10022
(212) 223-2787
http://199.222.60.120
*Lobbies on behalf of increased public
support of the arts*

ArtsWire
155 Avenue of the Americas
New York, NY 10013-1507
(212) 366-6900
http://www.artswire.org/Artswire/www/
 awfront.html
*Facilitates communication between artists and
arts administrators*

Asian American Arts Alliance
339 Lafayette Street
New York, NY 10012
(212) 979-6734
*Advocates on behalf of artists of Asian
descent*

Center for Constitutional Rights
666 Broadway
New York, NY 10012
(212) 614-6464; (212) 614-6422
*Provides legal assistance to artists who feel
they are a target of governmental oppression*

Fund for Free Expression
485 Fifth Avenue
New York, NY 10017
(212) 972-8400
*Part of Human Rights Watch, the Fund points
out instances of censorship and other actions
against artists*

**Gay & Lesbian Alliance Against
 Defamation**
80 Varick Street, Suite 3
New York, NY 10013
(212) 966-1700
*Researches and condemns instances of
homophobia; promotes the improvement of
public understanding of gays*

Guerilla Girls
Box 237
532 LaGuardia Place
New York, NY 10012
(212) 228-6000, ext. 867
*Direct action on issues affecting women in
the arts*

LAMBDA Legal Defense Fund, Inc.
666 Broadway
New York, NY 10012
(212) 995-8585
Defends gays in litigation

**Media Coalition/Americans for
 Constitutional Freedom**
1221 Avenue of the Americas
New York, NY 10020
(212) 768-6770
*Defends first amendment rights, including
the right to publish sexually explicit material*

Media Network
39 West 14th Street, Suite 403
New York, NY 10011
(212) 929-2663
Promotes "social issue" video

National Coalition Against Censorship
275 Seventh Avenue
New York, NY 10001
(212) 807-6222
E-mail: NCAC@Netcom.com
Defends free speech

PEN American Center
568 Broadway, Fourth Floor
New York, NY 10012
(212) 334-1660
Involved in freedom of expression issues

Visual AIDS
155 Avenue of the Americas, 14th Floor
New York, NY 10013-1507
(212) 206-6758
Political action on behalf of those with AIDS

Women's Action Coalition
(212) 967-7711, ext. 9226
*Involved in direct action on behalf of issues
affecting women*

PENNSYLVANIA
Art Emergency Coalition
4735 Hazel Avenue
Philadelphia, PA 19143
(215) 724-6552
*Advocates for governmental financial
assistance to the arts*

ArtsWire
Coleman Building
811 First Avenue, Suite 403
Seattle, WA 98104
(206) 343-0769; (415) 255-2854;
(212) 233-3900, ext. 212
http://www.artswire.org/Artswire/www/
 awfront.html
*Promotes advocacy and communication
within the arts*

**National Campaign for Freedom of
 Expression**
1402 Third Avenue, Suite 421
Seattle, WA 98101
(800) 477-NCFE
*Protects the right to freedom of expression;
combats instances of censorship*

**Northwest Feminists Against
 Censorship Task Force**
13510 A Aurora North, Suite 229
Seattle, WA 98133
Involved in freedom of expression issues

Coalition of Women's Art Organizations
123 East Beutel Road
Port Washington, WI 53074-1103
(414) 284-4458
*Provides information and advocacy on
upcoming legislation, taxes, and other issues*

ANNPAC/RACA
183 Bathurst Street
Toronto, Ontario M5T 2R7
Canada
(416) 869-1275
*Comprised of over 100 artist-run organi-
zations across Canada, the group lobbies
government on issues affecting the arts
community*

Finding a Job

Supporting oneself while pursuing one's art—or just supporting oneself—
is no easy matter in the art world, especially in these times of budgetary
stress. A variety of arts organizations maintain job listings of current
opportunities in one's field or in a related area. Among them are:

Cultural Alliance of Greater Washington
410 Eighth Street, N.W.
Washington, D.C. 20004
(202) 638-2406

Resources and Counseling for the Arts
429 Landmark Center
75 West Fifth Street
St. Paul, MN 55102
(612) 292-3206

Creative Artists Network
P.O. Box 30027
Philadelphia, PA 19103
(215) 546-7775

Greater Philadelphia Cultural Alliance
320 Walnut Street, Suite 500
Philadelphia, PA 19106
(215) 440-8100

Cultural Arts Council of Houston
1964 West Gray, Suite 224
Houston, TX 77109
(713) 527-9330

The state arts agencies of Maryland, Montana and Tennessee (see chapter 5 for addresses and telephone numbers) maintain job listings. One should also examine the classified sections of service organizations' newsletters, which may list job openings; and some of these organizations also maintain a job file, within their offices, of currently available positions. A number of organizations, some nonprofit and some for-profit, list available jobs and opportunities.

The National Network for Artist Placement
935 West Avenue 37
Los Angeles, CA 90065
(213) 222-4035
Publishes a National Directory of Arts Internships *($35) that lists internship opportunities at small and large arts organizations around the country*

American Symphony Orchestra League Bulletin
777 14th Street, N.W.
Washington, D.C. 20005
(202) 628-0099
$25 for monthly listing of conducting positions; $25 for monthly listing of performing positions; $30 bi-monthly listing of administrative positions

Artists
Plymouth Publishing
P.O. Box 40550
Washington, D.C. 20016
(703) 506-4400
$25 for 12 monthly issues, listing jobs for artists, arts administrators and arts educators

Artjob
WESTAF
236 Montezuma Avenue
Santa Fe, NM 87501
(505) 986-8939
http://www.webart.com/artjob
$30 for six monthly issues; $45 for one year

Artsearch
355 Lexington Avenue
New York, NY 10017
(212) 697-5230
$40 for 23 issues

Aviso
American Association of Museums
1225 Eye Street, N.W., Suite 200
Washington, D.C. 20005
(202) 289-1818
$33 for AAM nonmembers

Central Opera Service Bulletin
Metropolitan Opera Association
Lincoln Center
New York, NY 10023
(212) 799-3467
$35 individual, $50 company and institution

College Art Association of America
Placement Service
275 Seventh Avenue
New York, NY 10001
(212) 691-1051
$23 subscription for a full year

College Music Society
Music Faculty Vacancy List
1444 15th Street
Boulder, CO 80302
(303) 449-1611; (303) 449-1613
Membership, which is required for a subscription, is $35 per year, $25 for students

Current Jobs in the Arts
P.O. Box 40550
Washington, D.C. 20016
(703) 506-4400
$19 for three monthly issues

Dance U.S.A.
777 14th Street, N.W.
Washington, D.C. 20005
(202) 628-0144
$15 per year for 10 issues of the periodical, listing mostly management positions

National Arts Placement
National Art Education Association
1916 Association Drive
Reston, VA 22091
(703) 860-8000
$45 for nonmembers

Opera America
777 14th Street, N.W.
Washington, D.C. 20005
(202) 347-9262
$37.50 per year for the periodical, listing mostly management positions

Artlinks
P.O. Box 223
Berkeley, CA 94701
(510) 528-2668)
Arts employment agency

DC Art/Works
410 Eighth Street, N.W.
Washington, D.C. 20004
(202) 727-3412
Arts employment agency

Opportunity Resources, Inc.
500 Fifth Avenue
New York, NY 10017
(212) 575-1688
Executive search firm for mid- and upper-management positions for cultural institutions across the United States

One of the more innovative ideas in helping artists find jobs, a two-year professional development fellowship sponsored by the College Art Association (275 Seventh Avenue, New York, NY 10001, tel. 212-691-1051), assists artists of color and other diverse backgrounds (ethnicity, race and sexual orientation) who are in financial need and in the process of earning an M.A., M.F.A. or Ph.D. During the first year, the artist receives $5,000; in the second year, the artist will be assisted in finding work for which the College Art Association provides a subsidy to the employer.

Finding an Artists' Advisor

Pleading voices call out, "How do I get an exhibition? How can I get people to buy my work?" but the answers do not come from God; rather, artists receive a plethora of opinions and suggestions from artists' advisors. These advisors help plan an artist's career, winnowing through a body of artwork to determine the most saleable, preparing slides or actual pieces for presentation to gallery owners, negotiating agreements with dealers or print publishers, establishing a basic price structure for the art, setting up simple bookkeeping procedures, directing a marketing strategy, tapping into networks of services and information, and whatever else is necessary.

Artists' advisor is a relatively new profession, based on the historically recent assumptions that artists can make a living from the sale of their work and that a career path exists. They can be distinguished from artists' representatives (whose aim is to sell work) and public relations firms (whose aim is to publicize) by the fact that they look to set their clients on the right

road that makes selling and publicizing artwork possible. Most, although not all, of their clients are in the "emerging" category, with either little or poor experience exhibiting or selling their work. "I get retired people, people switching from commercial to fine arts, art teachers who want to pursue their work more seriously and sell it, graduates from art schools who have been out of school for three or four years and find that the world isn't the way their teachers described it, people who have never been to art school at all and are self-taught," Sue Viders, an advisor in Denver, Colorado, said.

Viders, as many others in her field, has found that the number of artists seeking career help has grown enormously. "A lot of them had felt, and some still do, that if they create the perfect picture the world will come to them," she stated. Even those who do look for assistance may set certain unspoken limits on how much they will change their attitudes or artwork. "My biggest challenge is fighting an unwritten artist etiquette book," Caroll Michels, a Long Island, New York–based advisor, said. "Artists often think that, if they don't have an extensive resume, they shouldn't ask very much for their work — that they should price their work according to their resume. I tell them, 'Be ballsy and demand what you want. If the work is good enough and collectors want it enough, they'll pay it.' Artists think that they shouldn't demand a written contract with their dealers, because it might turn off their dealers, and so they accept terrible treatment from these dealers. I tell them, 'Get out of the dinosaur age and demand your rights.'"

There are numerous differences between artists' advisors, in terms of both their approach to establishing a career and their fee structure. Constance Franklin (head of ArtNetwork in Penn Valley, California, who set up an artists' advisory service with Sue Viders) and Laura Stamps, an advisor in Columbia, South Carolina, both create three-year marketing plans for their clients, yet their fees are set up quite differently.

Stamps, for instance, charges $50 an hour, while Franklin and Viders ask $385 for a "Marketing Solutions" package that includes receiving various books that ArtNetwork Press publishes, as well as a series of questionnaires for artists. When the artists fill out the questionnaires and return them to Franklin, she or Viders will offer guidance in writing. The $385 also entitles artists to call with questions for 15 minutes once a month. The two also provide a "Portfolio Solutions" package, involving a review of the artist's portfolio in order to enhance the way in which an artist's work is presented, for $85.

On the other hand, Sally Davis, who advises artists from her home in Albuquerque, New Mexico, charges as little as $25 an hour while Calvin

Goodman in Los Angeles asks $160 for the same period of time. Their focus tends to be on short-term issues. "We'll work on where the next exhibit is going to be, the next dealer acquisition, the next artistic idea," Goodman noted. "Most of my clients want to know what to do now and what to do soon thereafter." He added that he does no consulting by mail, since "artists have difficulty relating to verbose material, where you have a lot of words."

With all of these people, most of the actual consultations occur over the telephone, and artists will be asked to send in portfolio material (slides or photographs of their work, resumes, press releases) for the advisor to view. "I have a cauliflower ear, and I never get hoarse," Goodman said, although Sue Viders purchased a telephone headset "because, otherwise, by the end of the day my ears hurt from the telephone receiver."

Artists' advisors in New York City, on the other hand, primarily work with clients face-to-face, with only occasional discussions over the telephone. Walter Wickiser, for instance, charges $100 for a three-hour in-person session, while Caroll Michels asks $75 per hour for the initial consultation and $50 an hour subsequently. Another New York City advisor, Katherine T. Carter, frequently works with out-of-town artists who are looking to have their work exhibited in Manhattan galleries.

Advisors are primarily selling their knowledge of the art world and art market, a knowledge that is presumably large enough to encompass the different media and styles of work that their artist clients may bring in. "I always worry that my personal opinion may become a part of the problem of helping an artist market his work," Calvin Goodman said. "I try to put my subjective feelings aside — realizing that I'm not buying it, it's not for my collection — but attempt to see what work the artist is best at, which has the greatest market potential. There is a market for just about everything, but some markets are better than others, and I want to steer the artist in the most marketable direction possible."

Still, advisors have their preferences and dislikes, and artists should ask questions in order to be certain that they will be well served for the money. In general, artists should ask various questions, including:

1. How long have you been in this business?
2. How many other artists have you worked with over this period (get names and addresses of some, and contact them about their experience with the advisor)?
3. Will you provide a general marketing strategy for my artwork or specific contacts at galleries, or both?

4. Are there certain media (oil painting, ceramics, collage, sculpture, for example) or styles of art (abstract, realist, portraiture, surrealist, for instance) that you have found to be more or less difficult to market?

Once, Goodman did tell a client that he was wasting his time and money because the would-be artist did not have sufficient talent—other advisors also told of recommending to their clients that they take more art classes—but the general aim of advisors is to determine their artists' capabilities and accentuate them.

Some advisors also candidly acknowledge that they cannot do much with certain styles of artmaking. Sue Viders, for instance, noted that "95 percent of my people are into realism, and I understand that market better. If someone is really abstract, I tend to send them to other people." For her part, Laura Stamp explained, "I have a problem with surrealism, because those paintings are not very saleable. They repulse people." It is wise for artists to determine in advance whether or not a prospective advisor will be able to help them market their particular kind of artwork.

Most advisors are not full-time, practicing artists themselves. That may suggest to potential artist-clients that advisors are relatively neutral on aesthetic questions or that they are less knowledgeable about what it takes to succeed in the art world because they've never done what they are recommending (If they're so smart, why aren't they rich?). Successful — that is, self-supporting—artists, however, generally don't counsel those who are younger or lesser-known on how to get ahead in their careers. In some instances, they do not wish to recall their own trial-and-error efforts at receiving recognition; it is also possible that they know little more than their own experience, which may not be applicable to many others. On the other hand, Beth Ames Swartz, an artists' advisor in New York City, noted that "It's important to me that I'm a bona fide artist, someone substantial and successful who has been through it."

She refers to her neo-expressionist-looking painting as "transformative art," which "deals with positive global change, rather than just making complaints." Charging an $80 per hour consultation fee, with a minimum of six hours, Swartz claims that her own particular style of art doesn't prevent her from working with artists who work in different styles and media. "One of my artists is a video artist," she said. "Another is totally abstract. One does animals. I look for total professionalism in the artist's

work, and I try to give clarity, self-confidence and a strategy to the artist."

Some artists' advisors advertise themselves in magazines, while most receive clients either through word-of-mouth or a seminar on marketing strategies that they have given. Listening to a potential advisor at a seminar discuss his or her approach to marketing an artist's work is an excellent way to gauge that person's competence or suitability. Art dealers, print publishers, and business art advisors may also recommend artists' advisors with whom they have worked and in whom they have confidence.

Many artists' advisors have published books in their field. Often, those books may obviate the need for hiring the advisor who might otherwise do little more than read his or her book to the artist-client. Calvin Goodman, who has advised artists since 1958, is the author of the continually updated *The Art Marketing Handbook,* while Laura Stamps self-published *How to Become a Financially Successful Professional Artist by Selling Your Own Fine Artwork.* Sally Davis is author of *The Fine Artist's Guide to Showing and Selling Your Work*; Sue Viders wrote *The Marketing Plan for Artists* as well as *Producing and Marketing Prints*; Constance Franklin is author of *Art Marketing Handbook for the Fine Artist* and *ArtNetwork Yellow Pages,* and Caroll Michels is represented by *How to Survive and Prosper as an Artist.* Other advisors have their own books, or have written articles for art magazines. Some advisors, among them Katharine T. Carter, may not have published articles or books but regularly give talks on career subjects for artists, and it may be worthwhile to attend an upcoming lecture. Sylvia White has a 90-minute videotape of tips and instructions for neophyte artists, and Jennifer Gilbert, who is otherwise a Boston art dealer and not an artists' advisor, sells two videos on marketing artwork. Articles, books, speeches and videos should be examined critically for their quality and depth of information and advice before artists consider hiring an artists' advisor.

CALIFORNIA

Michelle Carter
4790 Irvine Boulevard, Suite 105
Irvine, CA 92720
(714) 730-6128

Contemporary Artists' Services
Sylvia White
2022-B Broadway
Santa Monica, CA 90404
(310) 828-6200

Constance Franklin
P.O. Box 1268
18757 Wildflower Drive
Penn Valley, CA 95946
(916) 432-7630

Calvin Goodman
c/o GeePeeBee
11901 Sunset Boulevard, Unit 102
Los Angeles, CA 90049
(310) 476-2622

COLORADO

Sue Viders
2651 South Kearney Street
Denver, CO 80222
(800) 999-7013

FLORIDA

Katharine T. Carter
P.O. Box 2449
St. Leo, FL 33574
(352) 523-1948
E-mail: ktcassoc@icanect.net
http: //www.ktcassoc.com

MASSACHUSETTS

Jennifer Gilbert
DeHavilland Fine Arts
39 Newbury Street
Boston, MA 02116
(617) 859-3880
(800) 867-1015

NEW MEXICO

Sally Davis
7209 Oralee Street, N.E.
Albuquerque, NM 87109
(505) 822-9118

NEW YORK

Art Information Center
280 Broadway
New York, NY 10007
(212) 227-0282

Artists' Advisors:
The Art Planning Group
12 White Street, Dept. I
New York, NY 10013-2446
(212) 388-7298

Katharine T. Carter
24 Fifth Avenue, Suite 703
New York, NY 10011-8817
(212) 533-9530
E-mail: ktcassoc@icanect.net
http: //www.ktcassoc.com

Contemporary Artists' Services
Sylvia White
560 Broadway, Room 206
New York, NY 10012
(800) 239-6450

Gene Kraig
Individual Artist's Marketing
67 Hudson Street
New York, NY 10013
(212) 349-4381

Ellen Lourie
906 President Street
Brooklyn, NY 11215
(718) 399-2623

Peggy Lowenberg
Artists Career Planning Service
59 East Third Street, 4A
New York, NY 10003
(212) 460-8163

Caroll Michels
P.O. Box 5135
East Hampton, NY 11937-6166
(516) 329-9105

Renee Phillips
200 East 72nd Street, Apt. 26L
New York, NY 10021
(212) 472-1660

Beth Ames Swartz
354 Broome Street, Apt. 3E
New York, NY 10003
(212) 431-1057; (602) 948-6112

Walter Wickiser
247 East 94th Street
New York, NY 10028
(212) 534-4035

SOUTH CAROLINA

Laura Stamp
The Quarters
1211 Metze Road, Unit B-5
Columbia, SC 29210
(803) 798-8903

VIRGINIA

Lj Bury's Art Business Advisory
21310 Windrush Court, Suite 34
Sterling, VA 20165
(703) 430-8167; (800) 343-3444

A growing number of advisors help craftspeople develop their careers and market their work. Among them are:

MAINE
Susan Joy Sager
P.O. Box 2403
Bangor, ME 04402
(207) 945-4217

NEW HAMPSHIRE
Susan J. Frentzen
9 Littlehale Road
Durham, NH 03824
(603) 868-5467

NEW MEXICO
Sharon Kelly
236 Montezuma Avenue
Santa Fe, NM 87501
(505) 988-1166

NEW YORK
Constance Hallinan Lagan
35 Claremont Avenue
North Babylon, NY 11703
(516) 661-5181

WASHINGTON
Miriam Works
16249 Main Street
Bellevue, WA 98008-4424
(206) 644-4641

The Individual Artist within an Arts Organization or Institution

In days past, when kings or popes or other wealthy sponsors of culture sought to commission a work of art, they went straight to the artist. Nowadays, support for the arts tends to be mediated through nonprofit "umbrella" organizations. There are reasons for this: Corporations prefer to give money to nonprofit groups, thereby making the donation tax-deductible—a benefit the unincorporated artist cannot match; and a number of state governmental arts funding agencies (Hawaii, Missouri, Nebraska, New Mexico, New York, Oklahoma, Texas, and West Virginia) are prohibited by law from paying money directly to individuals.

Fellowships are still available to individual artists, and direct commissions continue to exist, but most artists seeking to create or complete a project should look to find the right "umbrella" when seeking financial support.

Working with an Umbrella Organization

There is no typical umbrella organization, nor is there any list of such organizations. An umbrella can be any nonprofit group that agrees to sponsor an artist's project for the purpose of attaining funding from a third party source. Some organizations regularly sponsor artists while others may only do so once. These umbrellas may or may not charge fees, usually a flat percentage of the grant, and the services that they offer to artists range widely. Artists should shop around for the best deal. As when they are hunting for a dealer or gallery to represent them, they should look for an umbrella group that most closely fits their ideas and working style.

In general, these organizations help artists, whose projects they have agreed to sponsor, focus their ideas into a proposal that is clearly stated and fundable. They also help locate the most appropriate funding sources. Artists usually must fill out their own grant applications, but the umbrella organization will submit a letter of support, which lets the funder know that the project has been prescreened and found acceptable—in effect, the organization puts its imprimatur on the artist. Then, when the project is funded, the organization will receive the money, and administers it, distributing it to the artist (usually on a reimbursement basis) and taking care of all other bookkeeping. The organization submits a final report to the funding source at the completion of the project. Having to hunt for an umbrella organization may seem like a bureaucratic technicality to artists in search of funding, but artists should remember the responsibility that these groups have. They are accountable for the money in the event that the project doesn't happen. Therefore, they want to know, not only that applicants have interesting ideas but, that they are reliable and have some track record; they will screen artists as carefully as artists screen them.

The best places to find out information about potential umbrella organizations for an artist's project are the funding sources themselves (a local or state arts agency as well as the National Endowment for the Arts). Any of them may direct artists to organizations with which they have worked in the past as well as indicate which groups are not thought of as reliable. "An organization may be in trouble with a funding agency for not living up to its end of a bargain on a past project," Gary Schiro, director of the

individual artist program at the New York State Council on the Arts, said. "The organization may not have submitted a final report or handled its bookkeeping properly, and it will be ruled ineligible for future funding."

Schiro added that "it happens at least once a year around here" that an umbrella organization itself goes out of business, a victim of a budgetary shortfall, leaving the artist in the lurch. Asking about the known soundness of an organization is probably not a bad idea. It is also true that some groups will turn down an artist's proposal to act as an umbrella organization because they are not set up to do all of the bookkeeping and other paperwork required.

Another useful source of information is the Washington, D.C.–based National Association of Artists' Organizations, which has over 330 members, many of which have acted as umbrellas for artists at one time or another. Groups that agree to act as an umbrella organization tend to work locally— a Pittsburgh nonprofit organization is unlikely to sponsor a project in Arizona—and artists are well advised to investigate local artist-run groups as potential sponsors.

Beyond this, artists should contact other artists who have used the organization as an umbrella to find out exactly how much and what kind of assistance was offered, whether or not the group's administrator seems trustworthy, and what (if any) fees were charged. Another question to ask: If there were disputes along the way, how were they resolved?

With organizations that regularly sponsor artists in this way, a formal agreement probably already exists. Groups that have not acted as umbrellas in the past are unlikely to have a standard contract, and artists should establish in writing what the respective roles and responsibilities are. Among the points that would be included in this agreement are how the artist is to be paid (as a lump sum or in installments, throughout the project or after its completion), how the work is to be installed and maintained (and who pays for installation and maintenance), how the artwork will be promoted and insured (and who pays for promotion and insurance), what services the organization will provide the artist (including the use of support staff, office equipment and studio space, not-for-profit mailing privileges, and assistance in finding suitable funding sources), and what the organization charges for these services. Some groups act as an umbrella organization for free, believing this kind of work to be a service to the field. However, most others charge a percentage of the money raised for the project, ranging from 3 to 10 percent.

The New York State Council on the Arts refuses to provide funding for any umbrella organization that charges an artist more than 10 percent. The New York Foundation for the Arts, which holds a free seminar the third Friday of every month on how to choose an umbrella organization, takes eight percent of the money raised by individual artists, although the group also charges a $100 initiation fee "in order to start the paperwork," according to Penelope Dannenberg, director of Artists' Services and Programs. On the other hand, colleges and universities regularly take 50 percent of the research grants that their professors and scientists are given. Of course, they provide the facilities in which the actual work can be done.

Auditing and bookkeeping, monitoring the artist's progress, helping to locate potential funding sources, writing letters of support or a final report to a private or governmental agency, and assisting the artist in shaping his or her artistic idea into something workable takes time, and many organizations may chose to forego the opportunity to act as an umbrella if the total project cost is too small, for instance, under $2,000.

For more experienced artists, the umbrella organization may actually do very little. Cynthia Pannucci, who created a number of large black-and-white stencilled drawings for the New York City subway system and was sponsored by CityArts in New York City, and Michael Blackstone, a filmmaker who received a $10,000 grant from the National Endowment for the Arts to make a documentary about architect Louis Kahn and was sponsored by the New York Foundation for the Arts, both found that they did almost all the work themselves. "CityArts didn't do all that much," Pannucci said. "I had all the drawings ready. I put together a package that showed my record of past completed projects for the Metropolitan Transportation Authority. CityArts did write a letter of support to the MTA: 'We would love to sponsor Cynthia and we will act as her fiscal agent'—something like that. After getting the MTA's approval, I did all the bookkeeping; I kept all the receipts and made up a cover sheet. CityArts sent that to the MTA. When the money came down to CityArts, they paid me, less their percentage."

Blackstone noted that he had "no great feeling for" the New York Foundation for the Arts "because they did so little for me. If I had any questions, I tended to call the NEA directly."

The process by which an organization chooses to sponsor an artist's project may also winnow out those who need more guidance and staff time than either Pannucci or Blackstone. Both CityArts and the New York Foundation for the Arts agree to sponsor only between 20 and 30 percent

of their applicants. Organizations that frequently sponsor artists' projects attempt to ascertain whether or not applicants understand fully what is involved in garnering financial support and completing the proposed work, and they prefer working with those who have undergone this experience in the past—more experienced artists will know to do more of the legwork and how to do it, lessening the amount of work for the sponsor. Psipy Ben-Haim, director of CityArts, stated that artists should "do their homework before coming to an organization you want to be an umbrella for your project. You should study the organizations you are approaching and learn about potential funding sources. You will have to do most of the work."

Another way in which more experienced artists tend to be favored is that less experienced artists may submit their proposals to an organization that has a history of sponsoring projects and wait for months, which may prove quite troublesome if certain funding sources have short application deadlines; those artists with whom the organization has worked in the past may be able to get an idea approved in minutes. "It matters who you know and who knows you," Blackstone said. "I just called up and they accepted my proposal over the phone. I'm a known quantity, and they agreed right away."

Psipy Ben-Haim, director of CityArts, reflected this two-tiered system by noting that "we have a board of directors which, with the staff, carefully goes over every application and makes its decisions, but I make the final decision. I sit down with every applicant to talk about their ideas, and I can tell in 10 minutes whether or not it's going to work."

While many of the organizations that sponsor artists' projects have an overall commitment to assisting artists, many of them also have their own missions and interests that may conflict with the ideas of the artists. The Beacon Street Gallery, an arts center in Chicago that has sponsored scores of artists' projects, aims "to exhibit or facilitate the performance of folk and ethnic art," according to director Pat Murphy. The New York Foundation for the Arts has worked with artists in a variety of media and disciplines, but the bulk of its sponsorships is for filmmakers. CityArts, on the other hand, works with artists wanting to create public artworks that "relate to a community," Ben-Haim stated, "and I want to know that the artist knows how to connect with people there."

The attitude at CityArts is found frequently around the country. "More and more organizations have a sense of responsibility to their communities, while artists often prefer to just do the work on their own in their own

studios," Michael Faubion, associate director of the Creation and Presentation Division at the National Endowment for the Arts, said. "There are bound to be conflicts." Those conflicts may include having one's ideas refashioned to fit the mission of the umbrella organization, which may result in lessening the artist's own distinct vision.

Despite the obstacles, umbrella organizations give artists the legs to stand on by making their projects attractive to prospective funders. As with any service that artists may be offered, this one does not come without cost. However, when one considers the multiplicity of nonprofit arts organizations in the United States, any of which might be willing or able to act as an umbrella for a particular project, artists find that they have a lot of choices in what they are able to do and how they can do it.

Obtaining In-Kind Donations

Some problem: "We don't have time to pick up all the free stuff we've been offered," said Eric Rudd, director of the Contemporary Artists' Center in North Adams, Massachusetts. He has found time, however, to collect sundry machines, printing presses, and artists quality papers ($50,000 worth, at retail value, from Strathmore Paper), as well as a variety of office supplies and furniture. It helps that the Center is a 130,000 square foot, four-story former factory that can accommodate all these donations.

"You can get some very good equipment if you just ask, and know whom to ask," he stated. "It's much easier getting materials than money."

Perhaps so, but sources of funding for the arts—from private donations and corporations to governmental agencies—tend to be better known, as their programs are frequently published in directories. Businesses—such as manufacturers, wholesalers, and retailers—that make donations of the products they produce usually don't do so regularly and are generally loath to advertise this practice, not wishing to undermine their commercial endeavors with philanthropy. "We don't publicize our donations too much," Tom Richards, vice-president in charge of marketing at Strathmore Paper, said. "We want to be known for selling paper, not giving it away."

It makes no sense to list all the companies that donate products, as almost all of them do it to some degree at one point or another. Just as with cash donations to arts and other groups, this kind of giving depends on the financial well-being of the business and on which products are in ample supply. Some formerly generous companies may go years without making a simple donation. Instead, a number of the circumstances that lead

businesses to donate products will be noted. The most obvious areas to start are those companies with programs for charitable giving.

Certain companies give both products and cash to those who apply, others may donate one or the other. Polaroid, for instance, has its Polaroid Foundation, which gives cash awards, but artists may also write to the company's acting curator, Micaela Garzoni, with requests for film, cameras, and anything else the company makes. The request must cite the needs of a specific photographic or cinematographic project.

Binney & Smith also donates $75,000 in cash and products through its Liquitex Paint for Publication and Excellence in Art student grant programs. These programs are intended for particular kinds of artists (students, for example, for the Excellence in Art awards) or artists who are involved in particular types of artwork (decorative, mostly, in the Paint for Publication program) using acrylic paint. Artists must write for, complete, and submit the company's own application form. Student winners receive gift certificates of either $250 or $500, depending on how various judges around the country rate their work, for materials from a Binney & Smith product catalogue they are sent.

Less formally, "artists may call up with a certain need, such as a certain size of paper or gallons of a certain color," said Mark O'Brien, media and communications specialist for Binney & Smith, "and we'll try to do whatever we can. That may involve just giving the artist something he or she can't get otherwise. We like to maintain that one-on-one relationship with artists." Donations of products in this way, however, tend to occur "if what the artist is going to do is likely to influence other artists, or if the artist is a teacher working in the public schools," O'Brien stated. Simply wanting something for free is unlikely to lead to donations.

Although some companies will accept telephone solicitations for donations, eventually all will need a letter that states with some specificity what products will be needed, how those products are to be used in the creation of an art project, what the art will look like and who will benefit from that project. The letter allows the company to examine the project's merits and protects the person within the company who actually makes the donation in the event of an audit. The letter should also note the artist's qualifications and competence in carrying out the project and any sponsoring organization, such as a funding source or art gallery that plans to exhibit the completed work.

Harold Gulamerian, president of Utrecht Manufacturing Corporation,

which creates paints and other art materials, noted that, like Mark O'Brien, he is contacted frequently by artists who need something. "They usually call," he stated. "Some write. I prefer not to get phone calls, but the amount of time it takes telling someone to write and not to call might as well be used listening to what they want. They'll still need to put it all in a letter eventually, though."

Although Utrecht is based in Brooklyn, New York, Gulamerian is contacted by artists from all over the country. He decides what to give based on product availability and whether or not what "the artist is talking about appeals to me. If the product they want is in short supply, I tend to say 'no.' But if an artist wants product X, and I happen to have a lot of product Y, I'm not going to unload Y on him. I'll try to give him what he wants. Of course, if the artist wants a million different things, I'd try to give him, say, a 20 percent discount."

Gulamerian added that he doesn't make donations to individuals but, rather, to incorporated nonprofit organizations that may be sponsoring an artist for a specific project. Most companies that donate products with any regularity prefer nonprofit organizations because of the ability to receive a tax deduction for their gifts.

Other companies require that the donation be specifically used to help the needy. Grumbacher, Winsor-Newton, and Polaroid want the organizations that apply to them for free art materials to use their products in order to serve the underprivileged or the disabled. Winsor-Newton, for example, donated paints and brushes for a painting class taught by an artist at a New England prison, while Grumbacher provided paints and brushes for a young artists' workshop for elementary schoolchildren held in Homestead, Florida, which was devastated by Hurricane Andrew in 1992.

Nonprofit organizations are also preferable to businesses that make charitable gifts of products because the size of the donations is frequently too large for a single artist to handle. "We unload paper by the ton," said Glenn Tidwell, marketing manager of special projects of International Paper, "and there may be 70 tons in a load."

An artists' center, such as that in North Adams, is able to warehouse vast quantities, parcelling out small amounts to resident artists as needed. Nonprofit organizations without such storage facilities may find the process of requesting product donations quite frustrating. In addition, accepting a large-scale donation is not without cost. Companies rarely deliver items but

expect them to be picked up, which may require the rental of trucks and other heavy machinery.

There are 15 regional and five national groups around the country that solicit donations of new and used materials from companies, making them available to nonprofit organizations, including those in the arts. They are:

REGIONAL PROGRAMS

Artscraps
4625 Bryant Avenue South
Minneapolis, MN 55409
(612) 827-2289

Capital ReUSE
1325 G Street, N.W.
Washington, D.C. 20005
(202) 783-2723

Community Resource Bank
Swiston Commons Mall
7030 Reading Road
Cincinnati, OH 45237
(513) 351-7696

Community Resource Center
P.O. Box 158520
Nashville, TN 37215
(615) 269-6679

The Loading Dock
1529 Gorsuch Avenue
Baltimore, MD 21218
(301) 235-1988

MAGIK
1936 37th Street, N.W.
Washington, D.C. 20007
(800) 653-3924

Materials for the Arts
Department of Cultural Affairs
City of New York
410 West 16 Street
New York, NY 10011
(212) 255-5924

Materials for the Arts
Bureau of Cultural Affairs
City of Atlanta
887 West Marietta Street, N.W.
Atlanta, GA 30318
(404) 853-3261

Materials for the Arts
Cultural Affairs Department
City of Los Angeles
8224 Riverside Drive
Los Angeles, CA 90027
(213) 485-1097

Materials Resource Program
The Volunteer Network
300 West Washington Street, Suite 1414
Chicago, IL 60606
(312) 606-8240

Recycle
Children's Museum of Boston
The Jamaica Way
300 Congress Street
Boston, MA 07130
(617) 426-6500

Resource Connections
1025 Beaver Avenue
Pittsburgh, PA 15233
(412) 321-9233

SCRAP
Salvageable, Consumable, Recyclable
 Arts Parts
3100 Timmons #100
Houston, TX 77027
(713) 965-0031

SCRAP
Scrounger's Center for Reusable Arts Parts
2730 Bryant Street
San Francisco, CA 94110
(415) 647-1746

The Scrap Exchange
Recycling for the Creative Arts
Northgate Mall
Durham, NC 27701
(919) 286-2559

The Surplus Exchange
1107 Hickory
Kansas City, MO 64101
(816) 472-0444

NATIONAL PROGRAMS

Brother's Brother Foundation
824 Granview Avenue
Pittsburgh, PA 15211-1442
(412) 431-1600

Educational Assistance, Ltd.
P.O. Box 3021
Glen Ellyn, IL 60138
(312) 690-0010
Serves the college community

Federal Surplus Personal Property Donation Programs
General Services Administration
Office of Federal Supply and Services,
Office of Property Management
Washington, D.C. 20406
(202) 755-0268

Gifts In-Kind
700 North Fairfax Street
Alexandria, VA 22314
(713) 836-2121

National Association for the Exchange of Industrial Resources
P.O. Box 8076
Galesburg, IL 61402
(309) 343-0704

The largest and most successful of these distributors of reusable materials for artists, Materials for the Arts in New York City, has received donations of a wide range of items, including canvas, computers, copiers, display cases, fabric, film equipment, furniture, frames, heaters and air conditioners, lumber, office supplies, power tools, theatrical lighting, trucks, automobiles and vans, video equipment, and much more. At any given time, there will be something every artist or arts group might need.

"An artist we worked with had gone to a stretcher manufacturer for a donation," Susan Glass, director of Materials for the Arts, said. "The manufacturer said, 'We can give you this amount,' but it was way more than the artist could handle. So the artist came to us, and we stepped in, taking the whole amount and giving the artist what she needed."

Another reason that businesses prefer to make donations to arts groups rather than to lone artists is that organizations are seen as more responsible than individuals; a company believes it has more in common with another organization than with some person claiming to be an artist. The sponsoring group, in effect, gives an imprimatur for an artist's work, which adds force to the pitch for free materials. It is usually advisable for artists in search of material donations as well as cash grants to look for a sponsoring umbrella nonprofit organization.

Still, individual artists who do not have studios with enormous storage facilities, whose art projects are not intended to help the disadvantaged or disabled, and who do not wish to seek the approval of—and, in many cases, share cash contributions with—an umbrella organization need not despair.

The artist should be remember that "companies" do not actually make donations; it is someone (or, perhaps, more than one person) in the business who does. Since so few corporations have defined policies regarding donations of products, the decision to give is often on the basis of catching the fancy of the right person on the right day. It is as possible for an individual artist as for an arts organization director to establish a personal relationship with that executive in the company. Most important for the artist is to know which companies produce and market what they need. A number of directories offer this kind of information, including:

American Business Directories
Omaha, NE: American Business Directories
More than 1,800 national directories compiled from the Yellow Pages

Blue Book of Building and Construction
Jefferson Valley, NY: Contractor's Register
Annual regional directory for eight areas of the United States

Directory of Corporate Affiliations
New Providence, NJ: National Register Publishing Company
Annual directory

Dun & Bradstreet Middle Market Directory
New York, NY: Dun's Marketing Services
Annual directory

Dun & Bradstreet Million Dollar Directory
New York, NY: Dun's Marketing Services
Annual directory

The Forbes Annual Directory
New York, NY: Forbes Magazine, Inc.
Annual directory

George D. Hall Directory
Boston, MA: George D. Hall Company
Regional directory of manufacturers

MacRae's State Industrial Directory
Annual editions by state, indexed by product, company name, and region

Small Business Sourcebook
Detroit, MI: Gale Research, Inc.
Annual directory

Standard Directory of Advertising Agencies
New Providence, NJ: National Register Publishing Co., Inc.
Annual directory with quarterly updates

Standard & Poor's Register of Corporations, Directors, Executives
New York, NY: Standard & Poors
Annual directory with quarterly updates

Sweet's Catalogue Files, Products for General Building
New York, NY: McGraw Hill
Annual directory, indexed by material and product name

Thomas Register of American Manufacturers
New York, NY: Thomas Regional Directory Company
Three-volume directory of products and services, with company profiles

Ward's Business Directory of U.S. Private and Public Companies
Detroit, MI: Gale Research, Inc.
Annual directory

Business-to-Business Directories
(otherwise known as the Yellow Pages)
Annual listings

It would also be advisable to contact local or national trade associations for directories of their membership, such as the National Art Materials Trade Association (178 Lakeview Avenue, Clifton, NJ 07011, tel. 201-546-6400). Yet other approaches to business leaders include volunteering for a United Way fund drive, which tend to be chaired by executives, and inquiring of a local chamber of commerce.

There is no rule of thumb concerning to whom one should apply within a company for a donation. At Grumbacher, for instance, one applies to the product manager, whereas the Liquitex awards programs are administered by the media and communications specialist. Tom Richards, who is in charge of marketing at Strathmore Paper and decides which applicants receive a donation, also noted that "if an artist's project can be part of a company's promotional efforts—that is, the company's name can be listed prominently in the project—the money to pay for the materials that will be donated can come out of the company's promotional budget without having to go through a donations committee." In other words, there may be more than one way in which a business is able to make a donation to an artist.

There is also no rule of thumb about to whom a company will donate materials. Local applicants tend to be favored, although, certainly, there are many exceptions to this generalization, especially with very large corporations. It should also be remembered that many companies go out of business, relocate, and periodically upgrade their equipment and furnishings. They find themselves needing to unload a variety of items that artists and arts groups may need.

Between manufacturers, wholesalers, and retailers, manufacturers have the most incentive to make donations, as their costs are largely the expenses in producing the items. Distributors and retail stores, on the other hand, pay higher amounts for the same items and are often loath to give away saleable materials. However, they may make product donations to local artists and arts groups, especially for arts activities providing high exposure. Rene Minneboo, owner of Amsterdam Art, Inc. in Berkeley, California, for instance, noticed that many local public school art teachers were "paying for the art materials their classes needed out of their own pockets—some were spending as much as $2,000 a year. I decided to solicit donations from my customers, matching them dollar for dollar, and every dollar collected would be used to pay for art materials"—from his own stores—"for the public schools." The resulting publicity of Minneboo's efforts, he stated, has "increased the number of people who come in to buy at my stores."

Wholesalers occasionally may also take an interest in a product donation effort, either giving materials they have purchased or arranging a gift through a manufacturer. Charles Gross, a manager at RIS Paper Company, said that "we get asked to donate paper quite often. Sometimes, we will; more often, we go to one of the mills we buy from and say, 'Do you think this is something you want to get involved in?' and we'll try to arrange a donation through them."

In most cases, wholesalers and retailers will steer those seeking a donation to the manufacturer. Therefore, artists should ask them for the names and addresses of manufacturers. As noted above, tax deductions and favorable publicity are main reasons that manufacturers donate their products. Manufacturers may also have a sizeable amount of "seconds"—products that have small (and, sometimes, unnoticeable) problems and have not met company standards or customer specifications in some way—that need to be disposed of. Mills producing artists' and other high quality papers frequently have vast holdings of paper—often referred to as "broke" paper—that they are unable to sell as is. Strathmore Paper, for example, has "a couple of million pounds of broke paper at any one time," Tom Richards said. "We regularly lose 50–60 percent of our runs, usually to spots, for our highest cost papers. In every mill, there is someone whose job is getting rid of broke paper."

Most broke paper is put back in the mill's hydropulper for reuse, but there are still great quantities left over that must be disposed of. Because of the large amounts involved, mills generally sell broke paper to other companies, such as xerographic or packaging companies, for industrial uses. "This paper is marketed as a generic product and is not to be associated with the International Paper Company," Glenn Tidwell said. The condition of this paper may also not be ideal for artists, as the mill often bales it for the purposes of easy storage.

Still, artists may wish to inquire of whomever is in charge of jobbing broke paper about either receiving a donation of usable paper or purchasing it at a discount—these discounts may be 80 percent or more over prices or similar quantities at an art supply shop. Of course, all companies produce items that do not meet specifications, although many of them would prefer to destroy imperfect merchandise than sell or give it away for fear of damaging their reputations. Artists should ask what, if anything, is available and whether or not these items may be donated or sold.

3

Professional Services for Artists and Arts Organizations

In 1969, the first Volunteer Lawyers for the Arts organization was created in New York City by a group of practicing attorneys who understood the peculiar legal concerns of literary, performing and visual artists and arts organizations and who also knew that the prohibitive cost of lawyers deprived many artists of the ability to exercise their legal rights. Since then, lawyers (and accountants) for arts groups have emerged all over the United States and Canada.

Legal Services

Volunteer lawyers groups provide legal counsel on specifically arts-related problems for free or for a small fee to individual artists with low gross incomes (generally

between $10,000 and $20,000, or between $15,000 and $30,000 in household income, as proven by past tax returns), and for arts organizations with annual operating budgets generally under $75,000 or $100,000. Toledo VLA requires organizations to have budgets under $20,000, while New York City's VLA allows these budgets to be as large as $500,000. Some VLAs ask for administrative fees of between $10 and $50 for individuals, and between $30 and $300 for organizations. However, certain VLA organizations make no charges whatsoever. Some VLAs answer basic legal questions over the telephone, setting up appointments in their offices for those with more complicated problems, while others simply take information and make referrals to lawyers who would be willing to meet with the artist or organization official at some point.

California Lawyers for the Arts also has an arts arbitration and mediation service that uses a panel of artists, attorneys, and arts administrators to conduct hearings and resolve disputes (see below). The charge for this service is established on a sliding scale, based on an individual's household income. Individual artists and arts organization officials should contact their nearest VLA group for specific criteria for assistance and types of services offered.

Artists should not forget that the lawyers assisting them are volunteering their time and knowledge. These attorneys are loath to actually take a case to court, because that entails considerable time and expense for which they are not reimbursed; as a result, they will attempt to resolve most legal disputes through an exchange of letters or telephone calls. If a problem is likely to lead to litigation, VLA groups tend to refer artists to private practice attorneys who may take the case, perhaps on a contingency fee basis.

ARIZONA
Cahill, Sutton & Thomas
2141 East Highland Avenue, #155
Phoenix, AZ 85016
(602) 956-7000

CALIFORNIA
Beverly Hills Bar Association
Barristers Committee for the Arts
300 South Beverly Drive, #201
Beverly Hills, CA 90212
(213) 553-6644

California Lawyers for the Arts
Fort Mason Center, Building C
San Francisco, CA 94123
(415) 775-7200
or
1549 11th Street, Suite 200
Santa Monica, CA 90401
(310) 395-8893
or
405 14th Street, Suite 1702
Oakland, CA 94612
(510) 444-6351

San Diego Lawyers for the Arts
1205 Prospect Street, Suite 400
La Jolla, CA 92037
(619) 454-9696

COLORADO
Colorado Lawyers for the Arts
200 Grant Street
Denver, CO 80203
(303) 722-7994

CONNECTICUT
Connecticut Volunteer Lawyers for the Arts
Connecticut Commission on the Arts
227 Lawrence Street
Hartford, CT 06106
(203) 566-4770

DISTRICT OF COLUMBIA
District of Columbia Lawyers
Committee for the Arts
918 16th Street, N.W., Suite 400
Washington, D.C. 20006
(202) 429-0229

Washington Area Lawyers for the Arts
1325 G Street, Lower Level
Washington, D.C. 20005
(202) 393-2826

FLORIDA
Volunteer Lawyers for the Arts/Broward
ArtServe, Inc.
5900 North Andrews Avenue, Suite 907
Fort Lauderdale, FL 33309

Business Volunteers for the Arts
Museum Tower
150 West Flagler Street, Suite 2500
Miami, FL 33130
(305) 789-3590

GEORGIA
Georgia Volunteer Lawyers for the Arts
141 Pryor Street, Suite 2030
Atlanta, GA 30303
(404) 525-6046

ILLINOIS
Lawyers for the Creative Arts
213 West Institute Place, Suite 411
Chicago, IL 60610
(312) 944-ARTS; (800) 525-ARTS (IL only)

KANSAS
Kansas Register of Lawyers for the Arts
c/o Susan J. Whitfield-Lundgren
P.O. Box 48
202 South Second Street
Lindsborg, KS 67456
(316) 686-1133 and (913) 227-3575

KENTUCKY
Fund for the Arts
623 West Main Street
Louisville, KY 40202
(502) 582-0100

Lexington Arts & Cultural Council
ArtsPlace
161 North Mill Street
Lexington, KY 40507
(606) 255-2951

LOUISIANA
Louisiana Volunteer Lawyers for the Arts
c/o Arts Council of New Orleans
821 Gravier Street, Suite 600
New Orleans, LA 70112
(504) 523-1465

MAINE
Maine Volunteer Lawyers for the Arts
Maine Arts Commission
55 Capitol Street
State House Station 25
Augusta, ME 04333
(207) 289-2724

MARYLAND
Maryland Lawyers for the Arts
1 East Chase Street, Suite 1118
Baltimore, MD 21202-2526
(301) 752-1633

MASSACHUSETTS
Lawyers for the Arts
P.O. 8784
Boston, MA 02114
(617) 523-1764
(800) 864-0476

MINNESOTA
Resources and Counseling for the Arts
429 Landmark Center
75 West 5th Street
St. Paul, MN 55102
(612) 292-3206

MISSOURI
Rosalee M. McNamara
Kansas City Attorneys for the Arts
Gage & Tucker
2345 Grand Avenue
Kansas City, MO 64141
(816) 474-6460

**St. Louis Volunteer Lawyers and
 Accountants for the Arts**
3540 Washington
St. Louis, MO 63103
(314) 652-2410

MONTANA
Montana Volunteer Lawyers for the Arts
c/o Joan Jonkel, Esq.
P.O. Box 8687
Missoula, MT 59807
(406) 721-1835

NEW YORK
Volunteer Lawyers for the Arts Program
Schenectady League of Arts
19 Clinton Avenue
Albany, NY 12207
(518) 449-5380

Arts Council in Buffalo and Erie County
700 Main Street
Buffalo, NY 14202
(716) 856-7520

Huntington Arts Council, Inc.
213 Main Street
Huntington, NY 11743
(516) 271-8423

Volunteer Lawyers for the Arts
1 East 53rd Street, Sixth Floor
New York, NY 10019
(212) 319-ARTS/2910

NORTH CAROLINA
**North Carolina Volunteer Lawyers for
 the Arts**
P.O. Box 831
Raleigh, NC 27601
(919) 755-2100

OHIO
**Volunteer Lawyers and Accountants for
 the Arts**
c/o Cleveland Bar Association
113 St. Clair Avenue
Cleveland, OH 44114-1253
(216) 696-3525

Toledo Volunteer Lawyers for the Arts
608 Madison Avenue, Suite 1523
Toledo, OH 43604
(419) 255-3344

OKLAHOMA
**Oklahoma Accountants and Lawyers
 for the Arts**
3000 Pershing Boulevard
Oklahoma City, OK 73107
(405) 948-6400

OREGON
Northwest Lawyers and Artists
330 Pacific Building
520 Yamhill
Portland, OR 97204
(503) 224-1901 or (503) 224-5430

PENNSYLVANIA
**Philadelphia Volunteer Lawyers for the
 Arts**
251 South 18th Street
Philadelphia, PA 19103
(215) 545-3385

PUERTO RICO
Voluntarios par las Arts
Condumo El Monte
Norte Apt. 518A

Hato Rey, Puerto Rico 00919
(809) 758-3986

RHODE ISLAND
Ocean State Lawyers for the Arts
P.O. Box 19
Saunderstown, RI 02874
(401) 789-5686

SOUTH CAROLINA
South Carolina Lawyers for the Arts
P.O. Box 8672
Greenville, SC 29604
(803) 232-3874

SOUTH DAKOTA
South Dakota Arts Council
108 West 11th Street
Sioux Falls, SD 57102-0788
(605) 339-6646

TENNESSEE
Tennessee Arts Commission
320 Sixth Avenue North
Nashville, TN 37219
(615) 741-1701

TEXAS
Austin Lawyers and Accountants
for the Arts
P.O. Box 2577
Austln, TX /8/68
(512) 476-7573

Texas Accountants and Lawyers
for the Arts
1540 Sul Rose
Houston, TX 77006
(713) 526-4876
or
2917 Swiss Avenue
Dallas, TX 75204
(214) 821-2522

UTAH
Utah Lawyers for the Arts
50 South Main Street, Suite 1600
Salt Lake City, UT 84144
(801) 482-5373

WASHINGTON
Washington Lawyers for the Arts
The New England Building
219 First Avenue South, Suite 315-A
Seattle, WA 98104
(206) 287-3546

CANADA
Canadian Artists' Representation
Ontario (CARO)
Artist's Legal Advice Services
183 Bathurst Street, First Floor
Toronto, Ontario M5T 2R7
Canada
(416) 360-0772
or
189 Laurier Avenue East
Ottawa, Ontario K1N 6P1
Canada
(613) 567-2690

Other Volunteer Lawyers for the Arts groups around the United States can also direct artists to accountants known to work with artists for a discounted fee. The state bar associations may also provide referrals to individuals and officials who need a lawyer with a particular area of expertise. These attorneys may or may not maintain policies about lowering their standard fees, not charging anything, or accepting art objects in lieu of cash. These issues likely will need to be negotiated individually between lawyer and client.

Arts Mediation

When the first volunteer lawyers for the arts group was created in New York City in 1969, the idea was simple: Help artists and arts organizations understand their legal rights and obligations through workshops and one-on-one consultations. If necessary, one of the volunteer attorneys could write a threatening letter to an offending party.

These VLA groups are actually information clearinghouses, which is both their greatest strength and shortcoming. As noted above, it is quite rare that these volunteer lawyers ever assist an artist in bringing a lawsuit. Annabel Levy, staff attorney for Texas Accountants and Lawyers for the Arts, stated that "lawyers are reluctant to get themselves into situations where they have to take time away from their paying clients." Going to trial is an expensive proposition, with court costs and lawyer's fees that add up to thousands (or tens of thousands) of dollars. Of course, if artists had that kind of money, they wouldn't need charitable organizations in the first place.

Recognizing this gap between free legal advice and costly legal representation, a third approach is being tried by a growing number of VLAs around the United States. Arts resolution services, or mediation, are being offered by volunteer lawyers groups in California, Oregon, Texas, Washington State and the District of Columbia.

In mediation, the two parties are brought together in order to resolve differences amicably. "Mediation is efficient and inexpensive, and people feel better after it is over than when they go through litigation or through the small claims court system," said Kim Jefferies, past president of Northwest Lawyers and Artists in Portland, Oregon, which has offered mediation since 1990. "The purpose of mediation is to come to some kind of consensus, for each side to compromise, and the people who come to mediation understand this. The purpose of litigation is to win. Lawyers traditionally make poor mediators because they are trained to win."

Barbara Frank, mediation coordinator at Washington Area Lawyers for the Arts in the District of Columbia, noted that "we recommend that artists and arts organizations put a mediation clause into any contract they sign, whether it's for a lease, for an exhibition, for employment or anything else. A mediation clause gives you a sense of security that you have some place to turn if there is a dispute."

Not every problem or dispute can be handled through mediation. According to Mary Brake, program coordinator for arts arbitration and mediation at California Lawyers for the Arts, "half of the time, the artist

wants mediation and the other side doesn't." Mediation is used, and is useful, when there is a pre-existing relationship that the two sides—say, a visual artist and an art dealer—want to maintain.

Mediation works in this way: Someone with an arts-related problem, who fits the VLA's low-income guidelines, comes to the offices of the volunteer lawyers group upset and looking for help. Perhaps, a painter's work has been damaged at the art gallery where it was consigned; maybe, the landlord is refusing to repair water damage at the rehearsal space of a dance troupe; or, an advertising agency assumes all rights to the artwork subcontracted out to a graphic artist without specifically paying for those rights.

The VLA staffperson directs the angered artist to the mediator, or to the person in charge of the mediation program, and an effort will be made to bring in that art gallery owner, landlord or advertising agency executive for a mediation session. The mediators may be practicing lawyers, professional artists, arts administrators, or accountants who have received special training in problem resolution. "Our mediators are not advocates," Annabel Levy said. "They are facilitators of a discussion."

Two mediators, for instance, a lawyer and an artist, are assigned to each case. The costs for mediation are low, as little as $20 for Northwest Lawyers and Artists and reaching a maximum of $75 for each party at Washington Area Lawyers for the Arts. Every VLA offering mediation services has a sliding fee scale for determining payment based on annual income.

California Lawyers for the Arts was the first VLA group to offer mediation, back in 1980, and has handled almost 500 cases since then. The charge for this service is $25 or five percent of the amount in controversy, whichever is greater. Working with a $100,000 challenge grant from the National Endowment for the Arts for the establishment of a "national mediation network," the California lawyers group has trained mediators at the Texas and Washington, D.C. volunteer lawyers organizations, and elsewhere. One of the reasons for establishing a nationwide system of disputes resolution is that many problems cross state borders. Visual artists, for example, frequently have dealers in states around the country.

For many artists, the appeal of mediation is obvious. It is far less expensive than litigation, and it enables them to resolve a problem without burning their bridges behind them. "Artists are afraid of losing their galleries if they pursue their rights too aggressively," Amy Estrin, a painter and arts mediator for Northwest Lawyers and Artists, stated. "Even if you win in court, you lose because the gallery will drop you."

While its idea of arts mediation has begun to catch on, California Lawyers for the Arts has yet to export its arbitration service. There is only one arbitrator per case, and that person makes a decision that is binding on both parties. (The difference between an arbitrator and a judge in the legal system is that the judge picks winners and losers while the arbitrator generally works out a compromise between the two sides.) Jane Lowery, executive director of Texas Accountants and Lawyers for the Arts, called mediation "a velvet glove. We explain to people that mediation is non-binding and nonthreatening, that it's just a way to get people to talk about mutual concerns. We wouldn't be able to bring people to the table if arbitration were recommended."

Mediation may solve a problem for artists, who have a safe and controlled environment in which to get something off their chests, and for volunteer lawyers for the arts organizations, settling disputes that their member attorneys don't have time to resolve through traditional legal avenues. Unfortunately, it is still a small world of problems that mediation will resolve because, as Ruth Cogen, executive director of Washington Area Lawyers for the Arts, noted, "both sides have to be interested in settling a dispute amicably and fairly. Mediation won't work with people who think that artists have no rights, or assume that artists are too poor to bring them to court—and there are far more of those cases than ones involving parties who want to settle disputes fairly. However, the courts are increasingly insisting on mediation and, don't forget, legal fees are also expensive for art dealers and landlords and publishing companies and whoever else may treat artists unfairly."

Accounting and Business Help for Artists

In addition to free or low-cost legal help, artists and arts organizations may be eligible for accounting, business, and tax assistance. These accountants and businesspeople usually do not take over an organization's bookkeeping or fill out an artist's tax forms for free (although some will offer these services at a discount); rather, they will explain how to set up a workable accounting system and what deductions may be declared on one's tax returns.

Artists should also keep in mind that the period between February and April 15th is the busiest of the year for accountants. Even those accountants who will fill out an artist's tax forms for free are unlikely to take on the job during this time, generally advising the artist to file for an extension.

Many of the Volunteer Accountants for the Arts groups that work with individuals also assist arts organizations, although fewer of the groups that aid organizations provide help for individuals. Among the volunteer groups that work exclusively with nonprofit arts organizations are:

CALIFORNIA

Arts Inc.
315 West Ninth Street, Room 201
Los Angeles, CA 90015
(213) 627-9276

Business Volunteers for the Arts/East Bay
1404 Franklin Street, Suite 713
Oakland, CA 94612
(415) 268-0505

Business Volunteers for the Arts
c/o San Francisco Chamber of Commerce
465 California Street
San Francisco, CA 94104
(415) 392-5936

CONNECTICUT

Business Volunteers for the Arts
c/o Arts Council of Greater New Haven
110 Audubon Street
New Haven, CT 06511
(203) 772-2788

DISTRICT OF COLUMBIA

Business Volunteers for the Arts
Cultural Alliance of Greater Washington
410 8th Street, N.W., Suite 600
Washington, D.C. 20004
(202) 638-2406

FLORIDA

Business Volunteers for the Arts
150 West Flagler Street, Suite 2500
Miami, FL 33130
(305) 789-3590

GEORGIA

Georgia Volunteer Accountants for the Arts
One CNN Center
1395 South Tower
Atlanta, GA 30303
(404) 658-9808

ILLINOIS

Business Volunteers for the Arts
800 South Wells Street
Chicago, IL 60607
(312) 431-3368

Illinois CPA Society
222 South Riverside Plaza
Chicago, IL 60606
(312) 993-0393

KENTUCKY

Greater Louisville Fund for the Arts
623 West Main Street
Louisville, KY 40202
(502) 582-0100

MASSACHUSETTS

The Artists Foundation
110 Broad Street
Boston, MA 02110
(617) 227-2787

MISSOURI

St. Louis Volunteer Lawyers and Accountants for the Arts
329 North Euclid
St. Louis, MO 63108
(314) 361-7686

NEW JERSEY

Business Volunteers for the Arts
390 George Street
New Brunswick, NJ 08901
(201) 745-5050

Business Volunteers for the Arts
841 Georges Road
North Brunswick, NJ 08902
(201) 745-4489

NEW YORK
Arts & Business Partnership Network
Arts Council in Buffalo and Erie County
700 Main Street
Buffalo, NY 14202
(716) 856-7520

OHIO
Volunteer Lawyers for the Arts
(of the Cleveland Bar Association)
113 St. Clair Avenue, N.E.
Cleveland, OH 44114-1253
(216) 696-3525

TEXAS
Austin Lawyers & Accountants
for the Arts
P.O. Box 2577
Austin, TX 78768
(512) 476-7573

Business Volunteers for the Arts
of Fort Worth and Tarrant County
One Tandy Center, Suite 150
Fort Worth, TX 76102
(817) 870-2564

Business Volunteers for the Arts
1100 Milam Building, Suite 2725
Houston, TX 77002
(713) 658-2483

Texas Accountants & Lawyers
for the Arts
1540 Sul Rose
Houston, TX 77006
(713) 526-4876

Texas Accountants & Lawyers
for the Arts
c/o Business Committee for the Arts
110 Broadway, Suite 250
San Antonio, TX 78205
(512) 224-8031

WASHINGTON
Business Volunteers for the Arts
1200 One Union Square
600 University Street
Seattle, WA 98101-3186
(206) 389-7280

Small Business Development Centers also exist in the District of Columbia, Puerto Rico, and the Virgin Islands as well as 47 states around the country, providing counseling and advice to small businesses (including arts organizations).

Volunteer income tax assistance is available in many cities and towns for low-income individuals through the National Association of Accountants. For more information about where to find free accounting services, contact Accountants for the Public Interest, 1625 I Street, N.W., Washington, D.C. 20006, (202) 347-1668, for the *National Directory of Volunteer Accounting Programs*. Officials of arts organizations, which often include or are run by artists, may also contact the Business Volunteers for the Arts/USA, a branch of the Arts and Business Council at 25 West 45 Street, New York, NY 10036, (212) 819-9287, with 31 affiliate branches around the country, for free or discounted assistance in bookkeeping, business organization, and tax preparation.

4

Sources of Public and Private Support for the Individual Artist, Part 1

To the uninitiated, the search for arts funding is a matter of asking for money from a certain group of well-known arts patrons: There is the National Endowment for the Arts in Washington, D.C., 50 state arts agencies, and a variety of foundations and corporations that provide either (or both) project or fellowship grants. So look up the address, submit an application, and take your chances.

In fact, funding is far more intricate, with varied sources of potential financial assistance for artists—some national, some regional, some local, some private, some public—and requires a certain amount of research. All public arts agencies have their own standard application forms, with

specific due dates and procedures for judging applicants, while many businesses that buy art or donate money to the arts make their choices (or decide to do nothing) based on the personal preferences of a top executive. Most foundations have their own application forms, which artists and arts groups may submit, while others give out grants on the basis of nomination and do not invite requests for money. No one book has a complete listing of all arts patronage, and artists would be wise to develop their own resource files as well as to visit the museum, public, and university libraries where many of the expensive money-for-the-arts books (see bibliography) may be found.

Fellowships for Individual Artists

When most artists think of the preferred arts support, they tend to think of fellowships, which are to individuals what general operating support is to organizations. Both general operating support and fellowships are the most difficult kinds of money to come by, precisely because there usually isn't a lot to show for it after the money has been spent. Project grants, in which a particular art piece will be exhibited or performed for the public, is far easier to justify. Project support tends to be a favored means of arts patronage not only for governmental arts agencies but for foundations, private organizations, and corporations as well. In fact, if a nonprofit organization doesn't include a statement about providing money specifically to individuals in its charter as well as register as a competitive program with the Internal Revenue Service, it is prohibited by law from making fellowships. The McKnight Foundation in Minneapolis, for example, is unable to grant individual fellowships, although the foundation has allocated monies to the Minneapolis College of Art and Design and the Arrowhead Regional Arts Council in Duluth in order to channel these awards to individuals. In effect, both the college and the arts council have become regranting organizations for McKnight.

Another way in which the problem of how to make individual fellowships has been sidestepped may be seen in the case of the Pew Charitable Trusts, which set up a subsidiary organization, Pew Fellowships in the Arts, in late 1990 in order to aid individual artists. This program has an annual budget of $800,000 with which it provides twelve fellowships of $50,000 apiece to artists in nine disciplines (choreography, craft arts, new genres/inter-disciplinary forms, literature, media arts, music composition, scriptworks, visual arts 2-D, and visual arts 3-D) in the Philadelphia area. Only three of the nine fields of application are selected each year.

While $50,000 is considerably more than almost all other fellowship programs are able to pay artists, Melissa Franklin, program coordinator for Pew Fellowships in the Arts, stated that "$50,000 is really sort of peanuts in comparison with our other funding areas"—including biomedical sciences, conservation and the environment, education, and religion—"where between $100,000 and $200,000 is a standard grant. We think of this money as research and development for an artist as it would be for a scientist, for instance. Our only regret is that the artist is subject to federal income taxes for this money."

The Pew Fellowship program was itself modeled on the Bush Artist Fellowships, a department of the Bush Foundation that makes grants to both individuals and institutions in Minnesota and the Dakotas. Started in the late 1970s, the Bush Artist Fellowships is a leader among foundations for its commitment to individual artists.

Among the most artist-friendly organizations for funding, which happen to be run by artists, are Art/Net in Portland, Oregon, and the Artist Trust in Seattle, Washington. Art/Net offers financial assistance to those Oregon artists who have already had a project grant application approved by the Oregon Arts Commission because, according to Christie Edmunds, one of Art/Net's founders, "you only get 50 percent of the money allocated by the state until the project is completed. We make a loan to the artist against the rest of his or her grant. This makes for better art because, as we all know, artists usually scale back their work to the level of their financing."

Art/Net assists as many artists as the organization funding will allow, with loans of up to $3,000 per artist. Additionally, Art/Net has plans to establish an emergency grants program for Oregon artists, providing cash for artists who need to undergo an operation, for instance.

Art/Net was modeled on the Artist Trust, which came into existence in 1986. The Artist Trust's grants program, which is available only for Washington State residents, includes both fellowships—up to $50,000 in various disciplines for six or eight artists (generally who are more established)—and project grants (between $500 and $2,000) that have gone to 40 "emerging" artists annually.

"We are a pioneer organization," Marschel Paul, executive director of the Artist Trust, said. "Our mission is to help the individual in the creative process." She added that the Trust is different in kind from a regular foundation, as "a foundation has its assets intact, managing and distributing the interest it earns on its endowment. We have to raise money throughout

the year and distribute it as we get it." The organization, in fact, spent the first two years of its existence raising money in order to start giving out grants.

The Artist Trust also holds seminars on career issues and publishes a quarterly newsletter that looks at such practical issues as safety in the art studio or resources for artists with HIV or AIDS as well as political concerns, including censorship in the arts and the arts and racism. Art/Net offers news and information to artists by way of a periodic newsletter and occasional conferences and seminars on professional and business issues in their careers.

Not every state arts agency provides fellowships; in fact, nine states (Connecticut, Georgia, Iowa, Michigan, Missouri, New Mexico, Oklahoma, Texas and Vermont) and two territories (Northern Marianas Islands, and Virgin Islands) do not. New York is prohibited by law from giving money to individuals, but the state arts agency gets around this problem by funding the Manhattan-based New York Foundation for the Arts, which makes fellowships available for artists residing in the state. Texas has a similar prohibition. On the other hand, not only does Hawaii provide individual fellowships, but the state arts agency also commissions new work that is purchased by the state. The amounts of the awards range from $2,000 to $10,000.

Fellowships of generally $5,000 to individual artists are also made available through the seven regional arts agencies. These artists are deemed worthy of support but might not receive an award on the more competitive national level of the arts endowment. These seven agencies are:

Arts Midwest
Hennepin Center for the Arts
528 Hennepin Avenue, Suite 310
Minneapolis, MN 55403
(612) 341-0755
Serving Illinois, Indiana, Iowa, Michigan, Minnesota, North Dakota, Ohio, South Dakota, and Wisconsin

Consortium for Pacific Arts and Culture
2141C Atherton Road
Honolulu, HI 96822
(808) 946-7381
Serving American Samoa, Guam, and Northern Marianas

Mid-America Arts Alliance
20 West 9th Street, Suite 550
Kansas City, MO 64105
(816) 421-1388
Serving Arkansas, Kansas, Missouri, Nebraska, Oklahoma, and Texas

Mid-Atlantic Arts Foundation
11 East Chase Street, Suite 1-A
Baltimore, MD 21202
(410) 539-6656
Serving Delaware, the District of Columbia, Maryland, New Jersey, New York, Pennsylvania, Virginia, and West Virginia

New England Foundation for the Arts
330 Congress Street, Sixth Floor
Boston, MA 02210-1216
(617) 951-0010
http://www.nefa.org
Serving Connecticut, Maine, Massachusetts, New Hampshire, Rhode Island, and Vermont

Southern Arts Foundation
1401 Peachtree Street, N.E., Suite 122
Atlanta, GA 30309
(404) 874-7244

Serving Alabama, Florida, Georgia, Kentucky, Louisiana, Mississippi, North Carolina, South Carolina, and Tennessee

Western States Arts Foundation
207 Shelby Street, Suite 200
Santa Fe, NM 87501
(505) 988-1166
Serving Alaska, Arizona, California, Colorado, Hawaii, Idaho, Montana, Nevada, New Mexico, Oregon, Utah, Washington and Wyoming

The National Endowment for the Arts offers fellowships of $20,000 now only for creative writers, artists who have contributed to their art form or community (through the Heritage and Preservation Division) and to "jazz masters" (through the Education and Access Division).

The differences between these three federally sponsored fellowship programs are found in the amount of money each offers and for whom the money is intended. The reason for having several fellowship programs is to give as many artists as possible a fighting chance.

"It's a wide net, but the net's still not wide enough," Theodore Berger, executive director of the New York Foundation for the Arts, said. "You still need more kinds of fellowships, such as what the [Seattle] Artist Trust is doing and even more than that, because the need is overwhelming. We give out between 10 and 15 fellowships in the category of painting, and we get 2,000 applications."

The funding picture is intricate because many private, nonprofit groups offer fellowships to artists with governmental assistance, such as the New York Foundation for the Arts, which works as a subcontractor (regranting agency) for the New York State Council on the Arts or the seven regional arts organizations, which were created by the National Endowment for the Arts. These groups are known in funding circles as "Quangos"—Quasi-Autonomous Nonprofit Governmental Organizations—because their status falls somewhere between private and governmental agencies. Other groups, such as the Artist Trust and Art/Net, on the other hand, offer fellowships to artists without being a specific arm of the government.

"Fellowship" is also a word with a somewhat elastic meaning. Many nonprofit organizations call payment for an artist-in-residence appointment a fellowship, for instance, such as the one-year fellowship/residence at the Baltimore Clayworks in Maryland in which an artist is provided with studio space, clay, and $1,000 per month. Similarly, the Center for Exploratory &

Perceptual Art in Buffalo, New York, has a residency program lasting between one week and one month, offering equipment, gallery space, and a fellowship of between $200 and $2,000 for emerging visual artists using new technology in photography. The fellowship that Harvestworks in New York City sponsors for composers and musicians is used to pay the cost of studio time, audiotape, and the services of a professional engineer. The fellowship term is expanded yet further by Sculpture Space in Utica, New York, an artist colony that provides a $2,000 scholarship to stay and work for two months.

"To my mind," Theodore Berger said, "a fellowship means giving an artist as much free time as possible with no requirement for that artist to produce something. In other words, free money. That's the ideal, but it is very difficult to get that in this country."

Artists Supporting Other Artists

Artists are each other's best resource. They share information about exhibition and funding opportunities with one another, provide impromptu critiques when asked and commiserate over the folly of a world that doesn't recognize their talents. Most major art dealers "discover" new artists only after another artist has told them to give this or that person's work a look. Increasingly, the process of artists helping each other has become formalized, with prosperous artists—either while they are alive or through their wills—establishing foundations for needy colleagues. Some funds are intended as general support, while others principally offer emergency grants. A number of these foundations are cited below.

The Academy of American Poets
584 Broadway
New York, NY 10012
(212) 274-0343
Emergency funds

AGVA Sick and Relief Fund—East
184 Fifth Avenue, Sixth Floor
New York, NY 10010
(212) 627-4820
Emergency funds for members of this music and theater union

AGVA Sick and Relief Fund—West
4741 Laurel Canyon Boulevard, Suite 208
North Hollywood, CA 91607
(818) 508-9984
Emergency funds for members of this music and theater union

Aid to Artisans
64 Fairgreen Place
Chestnut Hill, MA 02167
(617) 277-7220
$500-$1,500 for groups (such as cooperatives and community organizations)

Edward F. Albee Foundation
14 Harrison Street
New York, NY 10013
(212) 226-2020
Supports the art colony of the same name

American Society of Journalists and Authors
1501 Broadway, Suite 302
New York, NY 10036
(212) 997-0947
Emergency fund

Artist Trust
1402 3rd Avenue, Suite 415
Seattle, WA 98101
(206) 467-8734
Fellowships and project grants

Artists Community Federal Credit Union
155 Avenue of the Americas
New York, NY 10013-1507
(212) 366-5669

Artist Fellowship, Inc.
c/o Salmagundi Club
47 Fifth Avenue
New York, NY 10003
(212) 255-7740
Emergency assistance for artists suffering from a serious illness, distress, or bereavement

Artists Foundation
8 Park Plaza
Boston, MA 02116
(617) 227-2787
Grants for artists confronted by medical emergencies, fire, or unexpected catastrophes; loans to complete an arts project

Artists Space/Committee for the Visual Arts
223 West Broadway
New York, NY 10013
(212) 226-3970
Provides up to $200 for individuals and up to $500 for groups to cover exhibition costs

Artists Welfare Fund, Inc.
498 Broome Street
New York, NY 10013
(212) 941-0130
Emergency funds

Art Matters, Inc.
The Critical Needs Fund for Photographers with AIDS
131 West 24th Street
New York, NY 10011-1942
(212) 929-7190
Fellowships range from $1,000 to $1,500

Art/Net
2603 Southeast 15th Street
Portland, OR 97202
(503) 226-2811, ext. 237
Fellowships and emergency grants

Athena Foundation
P.O. Box 6259
Long Island City, NY 11106
Primarily offers exhibition space for sculptors

Authors League Fund
Authors League of America
330 West 42nd Street, 29th floor
New York, NY 10036
(212) 398-0838
Interest-free loans for published authors experiencing sudden emergencies

Alice Baber Art Fund
15 East 36th Street, 2C
New York, NY 10016
(212) 696-1788

Broadway Cares/Equity Fights AIDS
165 West 46th Street
New York, NY 10036
(212) 840-0770
Provides money for groups that care for artists with AIDS

Change, Inc.
P.O. Box 705
Cooper Station
New York, NY 10276
(212) 473-3742
Emergency grants of between $100 and $500

Blanche E. Coleman Foundation
Boston Safe Deposit and Trust Co.
One Boston Place
Boston, MA 02106
(617) 722-7300

Craft Emergency Relief Fund
P.O. Box 838
Montpelier, VT 05601
(802) 229-2306
Loans of up to $1,000 for full-time craftspeople whose work has been interrupted by an emergency situation

Dayton Hudson Artists Loan Fund
Resources and Counseling
429 Landmark Center
75 West Fifth Street
St. Paul, MN 55102
(612) 292-4381
Low-interest loans, to be repaid within three years

Eben Demarest Trust
4601 Bayard Street, Suite 807
Pittsburgh, PA 15213
(412) 621-4464

Directors Guild of America
9000 Sunset Boulevard, Suite 412
Los Angeles, CA 90069
(213) 278-4170/4171
Emergency funds and loans

The Dramatists Guild
234 West 44th Street
New York, NY 10036
(212) 398-9366
Emergency funds

Film Arts Foundation
346 Ninth Street, Second Floor
San Francisco, CA 94103
(415) 552-6350/8760
For filmmakers

Adolph and Esther Gottlieb Foundation
380 West Broadway
New York, NY 10012
(212) 226-0581
Emergency grants up to $10,000 for mature artists

J. Happy-Delpech Foundation
c/o Around the Coyote
1579 North Milwaukee
Chicago, IL 60622
(312) 342-9928
Fellowships for artists with AIDS

Keith Haring Foundation
676 Broadway
New York, NY 10012
(212) 477-1579

Robert Mapplethorpe Foundation
1370 Avenue of the Americas
New York, NY 10019
(212) 977-9750

Motion Picture and Television Fund
23450 Calabasa Road
Woodland Hills, CA 91364
(818) 347-1591
Emergency funds and loans

**Musicians Assistance Program—
Local 802**
American Federation of Musicians
330 West 42nd Street
New York, NY 10036
(212) 244-1802
Emergency funds

Musicians Emergency Fund, Inc.
16 East 64th Street
New York, NY 10021
(212) 578-2450
Emergency funds

Musicians Foundation, Inc.
200 West 55 Street
New York, NY 10019
(212) 247-5332
Emergency assistance of up to $2,000 to musicians and their families

National Academy of Design
Edwin Austin Abbey Memorial Scholarship
1083 Fifth Avenue
New York, NY 10028
(212) 369-4880
Provides funds enabling postgraduate muralists to travel in order to study important mural paintings

Nee-Shoch-Ha-Chee
P.O. Box 748
Winnebago, NE 68071
(402) 878-2972
Loan fund

New Dramatists
424 West 44 Street
New York, NY 10036
(212) 757-6960
Loan fund

New York Foundation for the Arts
Special Arts Fund for Emergencies
Artists Community Federal Credit Union
155 Avenue of the Americas
New York, NY 10013-1507
(212) 366-6900
For Manhattan-based arts organizations; credit union; also, loans to organizations

PEN Writer's Fund
PEN Fund for Writers and Editors with AIDS
568 Broadway
New York, NY 10012
(212) 334-1660
Emergency funds of up to $1,000

Jackson Pollock–Lee Krasner Foundation
725 Park Avenue
New York, NY 10021
(212) 517-5400
Grants made based on financial need

Religious Arts Guild
Paul D'Orlando Memorial Art Scholarship
25 Beacon Street
Boston, MA 02108
(617) 742-2100
Awarded to an art student at an accredited school who is a member in good standing of a Unitarian Universalist Society for at least one year prior to date of application

Aaron Siskind Foundation
73 Warren Street
New York, NY 10017

Texas Fine Arts Association
3908-B West 35th Street
Austin, TX 78703
(512) 453-5312
Disaster relief for Texas artists; credit union

Louis Comfort Tiffany Foundation
P.O. Box 480 Canal Street Station
New York, NY 10013
(212) 431-9880
Grant awards as large as $20,000

Visual Aid
530 Bush Street, Suite 405
San Francisco, CA 94018
(415) 391-9663
Up to $250 in art supply vouchers to 17 art supply companies in the Bay Area for Bay Area artists with life-threatening illnesses

**Andy Warhol Foundation
for the Visual Arts**
22 East 33rd Street
New York, NY 10016
(212) 683-6456

There are a number of arts and non-arts associations around the country that offer emergency no-interest loans and grants to those in need. They include:

American Indian Community House, Inc.
842 Broadway
New York, NY 10003
(212) 598-0100
Grants and scholarships

Bronx Council on the Arts
1738 Hone Avenue
Bronx, NY 10461
(718) 931-9500
Emergency funds for Bronx resident artists

Catholic Community Services
200 Josephine Street
Denver, CO 80206
(303) 388-4435
Emergency grants for Denver residents

Chemung Valley Arts Council
Corning Crafts Project
Baron Steuben Place
Market Street
Corning, NY 14830
(607) 962-5871
(800) 635-1330 (New York State only)
Low-interest loans for craftspeople who wish to relocate to Corning, New York

Jewish Family Service
1860 Howe Avenue, Suite 260
Sacramento, CA 95825
(916) 921-1921
No-interest loans and grants for county residents

Jewish Free Loan Association
6505 Wilshire Boulevard
Los Angeles, CA 90048
(213) 655-6922
No-interest loans for California residents

National Conference of Artists
415 Seventh Street, N.W.
Washington, D.C. 20004
(202) 393-3116
Financial aid for members

In addition, a number of membership arts organizations provide credit unions, discounts, and financial counseling to artists, including:

AFTRA-SAG Federal Credit Union
1717 North Highland Avenue
Hollywood, CA 90028
(800) 354-3728
Credit union

College Art Association
275 Seventh Avenue
New York, NY 10001
(212) 691-1051
Discounts on services and supplies

American Institute of Architects
1735 New York Avenue, N.W.
Washington, D.C. 20006
(202) 626-7300
Credit union, investment opportunities, discounts on services and supplies

International Sculpture Center
1050 Potomac Street, N.W.
Washington, D.C. 20007
(202) 965-6066
Debt counseling, discounts on services and supplies

American Society of Media Photographers
419 Park Avenue South
New York, NY 10016
(212) 889-9144
Discounts on services and supplies

Pentacle
104 Franklin Street
New York, NY 10013-2910
(212) 226-2000
Bookkeeping, planning, budgeting, debt counseling for performing artists

Association of Independent Video & Filmmakers
625 Broadway, Ninth Floor
New York, NY 10012
(212) 473-3400
Discounts on services and supplies

Fellowships are available in a variety of artistic categories from the National Endowment for the Arts as well as from the seven regional arts agencies (see above). Most state arts agencies offer fellowships (their addresses and telephone numbers are listed in chapter 5). Some municipal arts agencies also have fellowship or awards programs as do a number of private foundations, educational institutions and museums. They include:

ALASKA
Juneau Arts and Humanities Council
Individual Artists' Assistance Program
P.O. Box 20562
Juneau, AK 99802-0562
(907) 586-2787

ARIZONA
Tucson/Pima Arts Council
Individual Artist Fellowships
P.O. Box 27210
Tucson, AZ 85726
(602) 624-0595
For Pima County artists

CALIFORNIA

Arts Council of Santa Clara County
Individual Artist Accomplishment Awards
4 North Second Street
San Jose, CA 95113
(408) 998-2787
For Santa Clara County residents

California Community Foundation
Brody Arts Fund
606 South Olive Street, Suite 2400
Los Angeles, CA 90014-1526
(213) 413-4042
For emerging, multicultural artists

California Community Foundation
J. Paul Getty Trust Fund for the Visual Arts
606 South Olive Street, Suite 2400
Los Angeles, CA 90014-1526
(213) 413-4042
For mid-career artists

Fleischhacker Foundation
Eureka Fellowship Program
One Maritime Plaza, Suite 830
San Francisco, CA 94111
(415) 788-2909

Friends of Photography
Ferguson Award
250 Fourth Street
San Francisco, CA 94103
(415) 495-7000
For photographers

International Society for the Arts,
 Sciences and Technology
Frank J. Malina Leonardo Prize
P.O. Box 42170
San Francisco, CA 94142
(415) 642-2693
Awards for contemporary artists whose work reflects an interaction with science and technology

Marin Arts Council
Individual Artist Grants
251 North San Pedro Road
San Rafael, CA 94903
(415) 499-8350
Fellowships not restricted to Marin County residents

Peninsula Community Foundation
1204 Burlingame Avenue
Burlingame, CA 94011-0627
(415) 342-2477
Grants for residents of San Mateo and Northern Santa Clara county

DISTRICT OF COLUMBIA

National Museum of Women in the Arts
Library Fellows Grant for Book Artists
1250 New York Avenue, N.W.
Washington, D.C. 20005
(202) 783-7364
Pays for the creation of a new artist's book

FLORIDA

Richard A. Florsheim Art Fund
University of South Florida
P.O. Box 3033
Tampa, FL 33620-3033
(813) 949-6886

South Florida Cultural Consortium
Metro-Dade County Cultural Affairs Council
Visual and Media Arts Fellowships
111 N.W. First Street, Suite 625
Miami, FL 33301
(305) 375-4634
For artist residents of Martin, Palm Beach, Broward, Dade, or Monroe counties

GEORGIA

City of Atlanta Bureau of Cultural Affairs
Mayor's Fellowship in the Arts
236 Forsyth Street, S.W., Suite 402
Atlanta, GA 30303
(404) 653-7160
For Atlanta resident artists

ILLINOIS

Virginia A. Groot Foundation
P.O. Box 1050
Evanston, IL 60204-1050
Up to $25,000 for a ceramicist or a sculptor

INDIANA

Arts Council of Indianapolis
Fellowships
47 South Pennsylvania, Suite 703
Indianapolis, IN 46204
(317) 631-3301
For Indianapolis resident artists

KENTUCKY

Kentucky Foundation for Women
Heyburn Building, Suite 1215
Louisville, KY 40202
(502) 562-0045
For women artists residing in Kentucky who use the arts for social change

LOUISIANA

Honor Society of Phi Kappa Phi
Artist Award
P.O. Box 16000
Louisiana State University
Baton Rouge, LA 70893
(504) 388-4917
Awards

Shreveport Parks and Recreation/ Shreveport Regional Arts Council
800 Snow Street
Shreveport, LA 71101
(318) 226-6446
Awards

MARYLAND

Arts Council of Montgomery County
Individual Artist Fellowships
10701 Rockville Pike
Rockville, MD 20852
(301) 530-6744
For residents of Montgomery County

Washington County Arts Council
Antietam Review Photography Award
33 West Washington Street
Hagerstown, MD 21740
(301) 791-3125
Award

MASSACHUSETTS

Brandeis University
Creative Arts Awards
Creative Arts Commission
Kutz Hall 211
Waltham, MA 02254
(617) 736-3518
Awards

Mary Ingraham Bunting Institute of Radcliffe College
34 Concord Avenue
Cambridge, MA 02138
(617) 495-8212
Specifically for women artists and scholars

Photographic Resource Center
Leopold Godowsky, Jr. Color Photography
 Award
602 Commonwealth Avenue
Boston, MA 02215
(617) 353-0700
For photographers

Society of Arts and Crafts
Artist Awards
175 Newbury Street
Boston, MA 02116
Five artists receive $2,000 apiece, an exhibition and a photographer in the formative stages of a documentary project

MINNESOTA

American Museum of Wildlife Art
3303 North Service Drive
Red Wing, MN 55066
(612) 388-0755
For wildlife artists

Arrowhead Regional Arts Council
101 West Second Street, Suite 201
Duluth, MN 55802
(218) 722-0952
Fellowships of $1,200 available to artists in the Minnesota counties of Aitkin, Carlton, Cook, Itasca, Lake, Koochiching and St. Louis.

Bush Artist Fellowships
East 900
First National Bank Building
332 Minnesota Street
St. Paul, MN 55101
(612) 227-0891
Fellowships for artists and institutions in Minnesota and the Dakotas

The Jerome Foundation
West 1050 First National Bank Building
332 Minnesota Street
St. Paul, MN 55101
(612) 224-9431
For film and video artists living and working in the New York City metropolitan area

Minneapolis College of Art and Design
Jerome Foundation Visual Artist Fellowship
2501 Stevens Avenue South
Minneapolis, MN 55404
(612) 874-3785
For emerging artists in the Minneapolis-St. Paul area

Minneapolis College of Art and Design
McKnight Foundation Visual Artist
 Fellowship
2501 Stevens Avenue South
Minneapolis, MN 55404
(612) 874-3785
For mid-career Minnesota artists

NEW MEXICO
Indian Arts and Crafts Association
Artist of the Year
4215 Lead, S.E.
Albuquerque, NM 87108
(505) 388-4917
Awards to Bureau of Indian Affairs for certified Native Americans

New Mexico Council on Photography
The Willard Van Dyke Annual Fellowship
P.O. Box 1283
Santa Fe, NM 87504
(505) 988-3240
For New Mexico photographers

NEW YORK
American Academy and Institute of
 Arts and Letters
633 West 155 Street
New York, NY 10032
(212) 368-5900
Awards

American-Scandanavian Foundation
127 East 73 Street
New York, NY 10021
(212) 879-9779
For artists studying in the Scandanavian countries

Art Matters
131 West 24th Street
New York, NY 10011
(212) 929-7190
For artists whose work is concerned with social and political issues

Arts Council for Chautauqua County
Fund for the Arts Project Pool Awards
116 East Third Street
Jamestown, NY 14701
(716) 664-2465
For Chautauqua County artists

Arts International
Cintas Foundation Fellowship
809 United Nations Plaza
New York, NY 10017
(212) 984-5370
For artists of Cuban lineage

Bronx Council on the Arts
Bronx Recognizes Its Own (BRIO)
1738 Hone Avenue
Bronx, NY 10461
(212) 931-9500
For Bronx residents

Center for Photography at Woodstock
Photographer's Fund
59 Tinker Street
Woodstock, NY 12498
(914) 679-9957
For artist residents of Albany, Clinton, Columbia, Delaware, Dutchess, Essex, Fulton, Greene, Hamilton, Montgomery, Orange, Ostego, Rensselaer, Saratoga, Schenectady, Schoharie, Sullivan, Ulster, Warren, or Washington counties

Dutchess County Arts Council
Individual Artist Fellowship
39 Market Street
Poughkeepsie, NY 12601
(914) 454-3222
For Dutchess County residents

The Elizabeth Foundation for the Arts
P.O. Box 2670
New York, NY 10036
(212) 956-6633
Up to $12,000 to complete a project

Experimental Television Center, Ltd.
180 Front Street
Oswego, NY 13827
(607) 687-1423
Up to $500 to complete an electronic media work

The Funding Exchange
666 Broadway
New York, NY 10012
(212) 529-5300
Occasionally makes grants to community-oriented artists creating socially-conscious art

Guggenheim Foundation
90 Park Avenue
New York, NY 10016
(212) 687-4470

Ingram Merrill Foundation
P.O. Box 202 Village Station
New York, NY 10014

Institute of International Education
Fulbright Program
U.S. Student Program Division
809 United Nations Plaza
New York, NY 10017
(212) 984-5330

Media Alliance
c/o Thirteen/WNET
356 West 58th Street
New York, NY 10019
(212) 560-2919
For media artists

Money for Women
Barbara Deming Memorial Fund
P.O. Box 401043
Brooklyn, NY 11240-1043
Specifically for women whose artwork is concerned with peace and justice

National Academy of Design
1083 Fifth Avenue
New York, NY 10028
(212) 369-4880
Awards in various media and subject matter

National Audubon Society
Hal Boreland Award
950 Third Avenue
New York, NY 10022
(212) 546-9203
Awards to painters and photographers who have made a lasting contribution to understanding and appreciation of nature

National Sculpture Society
15 East 26th Street
New York, NY 10010
(212) 889-6960
For figurative sculptors

New York Foundation for the Arts
155 Avenue of the Americas
New York, NY 10013-1507
(212) 366-6900
For New York State residents

W. Eugene Smith Memorial Fund
International Center for Photography
1130 Fifth Avenue
New York, NY 10028
(212) 679-3288
For photographers

Thanks Be to Grandmother Winnifred Foundation
P.O. Box 1449
Wainscott, NY 11975
(516) 725-0323
Up to $5,000 for women visual artists age 54 and up

Ludwig Vogelstein Foundation
P.O. Box 4924
Brooklyn, NY 11240-4924
(718) 643-0614

NORTH CAROLINA
Arts Council of Winston-Salem/Forsyth County
Emerging Artists Fellowship Program
305 West Fourth Street
Winston-Salem, NC 27101
(919) 722-2585
For Forsyth County residents

Center for Documentary Studies
Dorothea Lange/Paul Taylor Prize
Box 90802
Duke University
Durham, NC 27708-0802
$10,000 to promote collaboration between a writer and a photographer in the formative stages of a documentary project

Southeastern Center for Contemporary Art
Awards in the Visual Arts
750 Marguerite Drive
Winston-Salem, NC 27106
(919) 725-1904
Cash award plus the creation of a traveling exhibition with a catalogue

Wilmington Star News
North Carolina Arts Award
1003 South 17 Street
Wilmington, NC 28402
(919) 343-2000
Awards

OHIO

Greater Columbus Arts Council
Individual Artists' Fellowships
55 East State Street
Columbus, OH 43215
(614) 224-2606
For Franklin County residents

Summerfair, Inc.
P.O. Box 8287
Cincinnati, OH 45208
(513) 531-0050
For Cincinnati artist residents

OKLAHOMA

Arts and Humanities Council of Tulsa
2210 South Main Street
Tulsa, OK 74114
(918) 584-3333
For Tulsa residents

Oklahoma Visual Arts Coalition
P.O. Box 54416
Oklahoma City, OK 73154
(405) 842-6991
Up to $2,500 for Oklahoma residents

PENNSYLVANIA

Pew Fellowships in the Arts
c/o University of the Arts
250 South Broad Street
Philadelphia, PA 19102
(215) 875-2285
A national program of fellowships in 9 artistic disciplines

TENNESSEE

Lyndhurst Foundation
Young Career Prize
Tallan Building
100 W. Martin Luther King Blvd., Suite 701
Chattanooga, TN 37402
(615) 756-0767

TEXAS

Cultural Arts Council of Houston
Creative Artist Program
1964 West Gray, Suite 224
Houston, TX 77019-4808
(713) 527-9330
For Houston residents

Dallas Museum of Art
Clare Hart DeGoyler Memorial Fund
Anne Giles Kimbrough Awards
1717 North Harwood
Dallas, TX 75201
(214) 922-1234
For young, emerging artists

VIRGINIA

Virginia Museum of Fine Arts
Fellowship Program
2800 Grove Avenue
Richmond, VA 23221-2466
(804) 367-0844
For residents of Virginia

WASHINGTON

Seattle Art Museum
Berry Bowen Memorial Award
Volunteer Park
14th East and East Prospect
Seattle, WA 98112
(206) 625-8980
Awards to residents of Idaho, Oregon, and Washington

WISCONSIN

Dane County Cultural Affairs Commission
Fellowships
City Council Building
210 Martin Luther King, Jr. Blvd., Room 421
Madison, WI 53709
(608) 266-5915
For Dane County residents

CANADA

Canadian Independent Film and Video Fund
666 Kirkwood Avenue, Suite 203
Ottawa, Ontario K1Z 5X9
Canada
(613) 729-1900
E-mail: cifvf-fund@encyclomedia.com
Funding for educational and documentary films, videos and multi-media programs

Greenshields Foundation
1814 Sherbrooke Street, West, Suite 1
Montreal, Québec H3H 1E4
Canada
(514) 937-9225
For emerging figurative and representational artists

There are many other awards that artists are eligible to receive, some of which are not cash awards but, rather, medals, plaques and statues from one organization or another. Forty states in the U.S. present Governor's Awards in the arts, all of which are certificates and only that of Delaware involves any cash. Others are contest awards and purchase awards, and some of these may be quite substantial, such as the annual purchase awards of the National Cowboy Hall of Fame, which pays $100,000 for a two- or three-dimensional artwork that embodies the Hall of Fame's idea of the American West.

The Canada Council, which is a federal arts agency (see chapter 5), maintains a number of private and public endowments that support prizes to artists in a variety of disciplines and media, including media artists (Petro-Canada Award), videographers (Bell Canada Award), architecture (Prix de Rome in Architecture, Ronald J. Thom Award), photography (Duke and Duchess of York Prize), and young artists (Joseph S. Stauffer Prizes). The Council administers the awards and chooses the winners.

There are also a number of other lucrative awards for which one cannot apply directly, as the nominations come from within the organization or through secret nominators selected by the organization. Among them are the American Academy of Arts and Letters, John D. and Catherine T. MacArthur Foundation and the Municipal Art Society. In addition, a number of state arts agencies have "fellowship awards," that is, fellowships for which artists do not apply but are nominated internally—Hawaii, Idaho, Montana and Utah.

The focus of this chapter has been awards, fellowships and grants to fine artists. Certainly, there are many awards for those in the commercial or applied arts, especially in photography where countless groups from the American Mosquito Control Association to Wedding Photographers International all offer monetary recognition for excellence. Books on trade associations, Gale Research Company's *Awards, Honors & Prizes* and commercial artists' own trade groups are valuable sources of information on these awards.

Knowing who gives money to artists, in what form and how (or if) to apply for it is very important. The Foundation Center, which maintains a library of resource material on giving by private foundations, has four main offices around the country: San Francisco (312 Sutter Street, Room 312, San Francisco, CA 94108, tel. 415-397-0902), the District of Columbia (1001 Connecticut Avenue, N.W., Washington, D.C. 20036, tel. 202-331-1400), New York City (79 Fifth Avenue, New York, NY 10003, tel. 212-620-4230) and Cleveland (Kent H. Smith Library, 1442 Hanna Building, Cleveland, OH 44115, tel. 216-861-1933). The Foundation Center also works with over 180 libraries or branch offices around the country, and these contain fundraising information on all types of donors (call or write for their nearest location).

A very large, expensive, but useful, book for individuals or organizations in search of money is the Foundation Center's *National Directory of Corporate Giving*, a good companion to *ARTnews' International Directory of Corporate Art Collections*. The arts, of course, are a relatively small object of corporate philanthropy, but these two books offer a sense of which companies regularly or occasionally set aside arts dollars, either for purchase or donation; some corporations both buy and give.

There are few groups that artists who are looking for project support would want to overlook. Foundation giving represents approximately five percent of all charitable donations in the United States, and corporate giving is less than that. Most giving is done by private individuals. Wealthy individuals may be approached for a donation in the same manner as most corporations—make a telephone call, follow-up with a detailed proposal, follow-up with a telephone call to schedule a meeting. One may start with club membership rosters and donor lists of major philanthropic organizations. Among the most useful sources of information about potential donors are:

Martindale-Hubble Law Directory	**Who's Who of American Women**
Martindale-Hubble American Architects Directory	**Who's Who in Advertising**
	Who's Who in Oil and Gas
Martindale-Hubble Medical Specialists Directory	**Social Register**
Who's Who in America	

5

Sources of Public and Private Support for the Individual Artist, Part 2

Beyond fellowships and project grants, there are a variety of funding categories available at arts agencies on the local, state, and federal levels. These agencies are also useful sources of information on where else to turn for assistance of all kinds. A reasonable starting point is the National Endowment for the Arts (Nancy Hanks Center, 1100 Pennsylvania Avenue, N.W. Washington, D.C. 20506-0001, tel. 202-682-5400, http://www.arts. endow.gov). Closer to home are regional, state and local arts agencies, all of which have programs to which artists may apply. For instance, there are an estimated 3,800 local arts agencies in the United States (only 1,000 or so of them have any paid staff), and

approximately one-third of them offer grants to individual artists. Some of those grants are fellowships, while others are for public art projects, artists-in-the-schools programs or specific art projects (occasionally called contracts for services). Artists with concerns about where to apply might look to their town's chamber of commerce or town hall as well as to the National Assembly of State Arts Agencies (1010 Vermont Avenue, N.W., Washington, D.C. 20005, tel. 202-347-6352) and Americans for the Arts (927 15th Street, N.W., Washington, D.C. 20005-2304, tel. 202-371-2830).

STATE ARTS AGENCIES

Alabama State Council on the Arts
One Dexter Avenue
Montgomery, AL 36130-1800
(334) 242-4076

Alaska State Council on the Arts
411 West Fourth Street, Suite 1E
Anchorage, AK 99501-2343
(907) 269-6610
E-mail: tjwasca@tm.com

American Samoa Council on Culture, Art and Humanities
Office of the Governor
P.O. Box 1540
Pago Pago, AS 96799
(011-684) 633-4347

Arizona Commission on the Arts
417 West Roosevelt Avenue
Phoenix, AZ 85003
(602) 255-5882

Arkansas Arts Council
1500 Tower Building
323 Center Street
Little Rock, AR 72201
(501) 324-9766
E-mail: jim@dah.state.ar.us

California Arts Council
1300 I Street
Suite 930
Sacramento, CA 95814
(916)322-6555
E-mail: calartcl@tmn.com

Colorado Council on the Arts and Humanities
750 Pennsylvania Street
Denver, CO 80203-3699
(303) 894-2617
E-mail: coarts@tmn.com

Connecticut Commission on the Arts
755 Main Street
Hartford, CT 06103
(860) 566-4770

Delaware Division of the Arts
820 North French Street
Wilmington, DE 19801
(302) 577-3540
E-mail: delarts@tmn.com

District of Columbia Commission on the Arts and Humanities
410 8th Street, N.W.
Washington, D.C. 20004
(202) 724-5613

Florida Arts Council
Department of State
The Capitol
Tallahassee, FL 32399-0250
(904) 487-2980

Georgia Council for the Arts
530 Means Street, N.W., Suite 115
Atlanta, GA 30318
(404) 651-7920

Guam Council on the Arts and Humanities
Office of the Governor
P.O. Box 2950
Agana, GU 96910
(011-671) 475-2242

Hawaii State Foundation on Culture and the Arts
44 Merchant Street
Honolulu, HI 96813
(808) 586-0306
E-mail: 44sfca@tmn.com

Idaho Commission on the Arts
P.O. Box 83720
Boise, ID 83720-0008
(208) 334-2119
E-mail: idarts@tmn.com

Illinois Arts Council
100 West Randolph Street, Suite 10-500
Chicago, IL 60601
(312) 814-6750; (800) 237-6994 (IL only)
E-mail: brose@tmn.com

Indiana Arts Commission
402 West Washington Street, Room 072
Indianapolis, IN 46204
(317) 232-1268

Iowa Arts Council
Capitol Complex
600 East Locust
Des Moines, IA 50319
(515) 281-4451

Kansas Arts Commission
700 S.W. Jackson, Suite 1004
Topeka, KS 66603-3714
(913) 296-3335

Kentucky Arts Council
31 Fountain Place
Frankfort, KY 40601
(502) 564-3757

Louisiana State Arts Council
P.O. Box 44247
900 Riverside North
Baton Rouge, LA 70804
(504) 342-8180

Maine Arts Commission
State House Station 25
55 Capitol Street
Augusta, ME 04333-0025
(207) 287-2724

Maryland State Arts Council
601 North Howard Street, First Floor
Baltimore, MD 21201
(301) 333-8232

Massachusetts Cultural Council
120 Boylston Street, Second Floor
Boston, MA 02116-4600
(617) 727-3668; (800) 232-0960 (MA only)

Michigan Council for the Arts
Executive Plaza
1200 6th Avenue
Detroit, MI 48226-2461
(313) 256-3731
E-mail: mcacal@tmn.com

Minnesota State Arts Board
400 Sibley Street, Suite 200
St. Paul, MN 55102
(612) 215-1600

Mississippi Arts Commission
239 North Lamar Street, Second Floor
Jackson, MS 39201
(601) 359-6030/6040
E-mail: msarts@tmn.com

Missouri Arts Council
111 North 7th Street, Suite 105
St. Louis, MO 63101-2188
(314) 340-6845

Montana Arts Council
P.O. Box 202201
316 North Park Avenue, Room 205
Helena, MT 59620-2201
(406) 444-6430
E-mail: montana@tmn.com

Nebraska Arts Council
3838 Davenport
Omaha, NE 681031-2379
(402) 595-2122
E-mail: lindanac@tmn.com

Nevada State Council on the Arts
Capitol Complex
602 North Curry Street
Carson City, NV 89701
(702) 687-6680

New Hampshire State Council on the Arts
40 North Main Street
Concord, NH 03301
(603) 271-2789

New Jersey State Council on the Arts
20 West State Street, CN 306
Trenton, NJ 08625-0306
(609) 292-6130
E-mail: njscaaah@tmn.com

New Mexico Arts Division
228 East Palace Avenue
Santa FE, NM 87501
(505) 827-6490

New York State Council on the Arts
915 Broadway
New York, NY 10010
(212) 387-7000
E-mail: nysca@tmn.com

North Carolina Arts Council
Department of Cultural Resources
Raleigh, NC 27611
(919) 733-2821
E-mail: ncartscl@tmn.com

North Dakota Council on the Arts
418 East Broadway, Suite 70
Fargo, ND 58501-4086
(701) 328-3954
E-mail: ndca@tmn.com

**Northern Marianas Islands Common-
wealth Council for Arts and Culture**
P.O. Box 553, CHRB
Saipan, MP 96950
(011-670) 322-9982/9983

Ohio Arts Council
727 East Main Street
Columbus, OH 43205-1796
(614) 466-2613
E-mail: wlawson@mail.oac.ohio.gov

State Arts Council of Oklahoma
Jim Thorpe Building
P.O. Box 52001-2001
Oklahoma City, OK 73152-2001
(405) 521-2931
E-mail: okarts@tmn.com

Oregon Arts Commission
775 Summer Street, N.E.
Salem, OR 97301
(503) 986-0082
E-mail: oregon@tmn.com

Pennsylvania Council on the Arts
216 Finance Building
Harrisburg, PA 17120
(717) 787-6883

Institute of Puerto Rican Culture
Apartado Postal 4184
San Juan, PR 00902-4184
(809) 723-2115

Rhode Island State Council on the Arts
95 Cedar Street, Suite 103
Providence, RI 02903-1034
(401) 277-3880
E-mail: ae418@osfn.rhilinet.gov

South Carolina Arts Commission
1800 Gervais Street
Columbia, SC 29201
(803) 734-8696
E-mail: kenmay@tmn.com

South Dakota Arts Council
800 Governor's Drive
Pierre, SD 57501-2294
(605) 773-3131
E-mail: dennish@deca.state.sd.us

Tennessee Arts Commission
404 James Robertson Parkway, Suite 160
Nashville, TN 37243-0780
(615) 741-1701

Texas Commission on the Arts
P.O. Box 13406 Capitol Station
920 Colorado Street, Fifth Floor
Austin, TX 78711
(512) 463-5535; (800) 252-9415 (TX only)

Utah Arts Council
617 East South Temple Street
Salt Lake City, UT 84102
(801) 533-5895
E-mail: jeanirwi@tmn.com

Vermont Council on the Arts
136 State Street
Drawer 33
Montpelier, VT 05633-6001
(802) 828-3291

Virgin Islands Council on the Arts
P.O. Box 103
41-42 Norre Gade
St. Thomas, VI 00802
(809) 774-5984

Virginia Commission for the Arts
223 Governor Street
Richmond, VA 23219
(804) 225-3132
E-mail: vacomm@tmn.com

Washington State Arts Commission
P.O. Box 42675
Olympia, WA 98504-2675
(206) 753-3860
E-mail: wsac@tmm.com

**West Virginia Division of Culture &
 History**
Arts & Humanities Section
1900 Kanawha Boulevard East
Charleston, WV 25305
(304) 558-0240

Wisconsin Arts Board
101 East Wilson Street, First Floor
Madison, WI 53702
(608) 266-0190

Wyoming Council on the Arts
2320 Capitol Avenue
Cheyenne, WY 82002
(307) 777-7742
E-mail: wyoarts@tmn.com

CANADA

The Canada Council
350 Albert Street
P.O. Box 1047
Ottawa, Ontario K1P 5V8
Canada
(613) 237-3400
(800) 263-5588
http://www.culturenet.ca/cc

Alberta Culture and Multiculturalism
10158 103rd Street, Third Floor
Edmonton, Alberta T5J 0X6
Canada
(403) 427-2031

**British Columbia Ministry of Municipal
 Affairs**
Recreation and Culture—Cultural Services
 Branch
800 Johnson Street, Sixth Floor
Victoria, British Columbia V8V 1X4
Canada
(604) 356-1728

Manitoba Arts Council
525-93 Lombard Avenue
Winnipeg, Manitoba R3B 3B1
Canada
(204) 945-4537

**New Brunswick Department of
 Tourism, Recreation and Heritage**
Arts Branch
P.O. Box 12345
Fredericton, New Brunswick E3B 5C3
Canada
(506) 453-2555

**Newfoundland Department of
 Municipal and Provincial Affairs**
Viking Building
136 Crosbie Road
St. John's, Newfoundland A1B 3K3
Canada
(709) 729-7182

**Northwest Territories Department of
 Culture and Communications**
Government of the Northwest Territories
Box 1320
Yellowknife, Northwest Territories X1A 2L9
Canada
(403) 920-3103

Ontario Arts Council
151 Bloor Street West, Suite 500
Toronto, Ontario M5S 1T6
Canada
(416) 961-1660
(800) 387-0058 (Ontario only)

Prince Edward Island Council of the Arts
Box 2234
94 Great George Street
Charlottetown, Prince Edward Island C1A 8B9
Canada
(902) 368-4410

Helping Artists to Help Themselves

Contrary to the view of those whose applications have not been accepted, local, state, and federal public arts funding agencies really do try to help individual artists as best they can. Sometimes, they simply don't know how or are so strapped for money that good ideas must be put on the back burner. An example of this effort to help may be seen in the fact that almost every state arts agency maintains a funding resource library and holds workshops on how and where to apply for grants. A number of them also run juried art exhibitions or sponsor arts festivals, offering in-state artists an opportunity to publicly exhibit their work. In some cases, this art is toured around the state in order to expose the public to art and the artists to potential buyers. Many also publish directories (Florida's *Florida Cultural Directory*, Utah's *Sketchbook of Services*, Wisconsin's *Arts and Crafts Fairs*, for example) and maintain a job bank, a mailing list of resident artists, and an unjuried slide registry (the New Jersey State Council on the Arts has separate slide registries for fine artists, craftspeople, and performing artists).

A number of state arts agencies also collect art, known as "arts banks," and some states tour these works or keep them on display either in state office buildings or in art galleries that they operate. Purchasing art is usually not indicated as a regular activity or program in the agency's information packets for artists and arts organizations, and the mandate to buy the work of in-state artists and craftspeople often comes from the state legislature in its funding allocation. Artists who are interested in selling their work to a state agency should contact the office of the executive director to learn whether or not there is a purchasing program in existence and what the guidelines for those acquisitions are.

For fiscal year 1992, 265 objects were purchased for a combined $2.6 million by the following state arts agencies:

- Alabama (objects decorating the state house and government office buildings)
- Alaska (strictly native Alaskan arts and crafts)
- American Samoa
- California (objects for exhibition in the state fair and for touring)
- Connecticut (The Connecticut Artists Collection, used in state office buildings)
- Georgia (objects for government office buildings and toured around the state)

- Guam (objects decorating the offices of the executive branch of government)
- Iowa (objects for state buildings)
- New Hampshire (permanent artworks, rather than transportable paintings and sculpture)
- South Carolina (works exhibited in the South Carolina State Museum in Columbia)
- South Dakota (objects for state office buildings)
- Utah (objects for government office buildings and toured around the state)

In addition, the majority of these agencies answer questions over the telephone or in writing (sometimes acting as an information clearinghouse), publish resource guides, and refer artists to lawyers and accountants who volunteer their services.

Below are programs that arts agencies have developed in order to assist artists in their careers. They include apprenticeships and fellowships for folk artists, project grants and fellowships for craftspeople, travel grants (to be used for further study or in order to attend a professional event), technical assistance grants (funds for educational and career development) and sudden opportunity grants (money to pay for events that will significantly advance an artist's career or that are available for a limited period of time). Of course, eligibility is limited to those residing within the municipality or state.

FINANCIAL ASSISTANCE FOR FOLK ARTISTS

National Endowment for the Arts
Heritage and Preservation Division
Nancy Hanks Center
1100 Pennsylvania Avenue, N.W.
Washington, D.C. 20506
(202) 682-5400

Alabama State Council on the Arts
Folk Arts Apprenticeships
One Dexter Avenue
Montgomery, AL 36130
(205) 242-4076

Alaska State Council on the Arts
Master Artist and Apprentice Grants in
Traditional Native Arts
411 West Fourth Avenue, Suite 1E
Anchorage, AK 99501-2343
(907) 269-6610

Arkansas Arts Council
Folk Arts Apprenticeships
1500 Tower Building
323 Center Street
Little Rock, AR 72201
(501) 324-9766

California Arts Council
Traditional Folk Arts Program
1300 I Street, Suite 930
Sacramento, CA 95817
(916) 739-3186

Colorado Council on the Arts and
** Humanities**
Folk Arts Master Apprentice Program
750 Pennsylvania Street
Denver, CO 80203-3699
(303) 894-2617

Hawaii State Foundation on Culture
** and the Arts**
Folk Arts Apprenticeship Awards
44 Merchant Street
Honolulu, HI 96813
(808) 586-0306

Idaho Commission on the Arts
Traditional Native Arts Apprenticeship
 Program
P.O. Box 83720
Boise, ID 83720-0008
(208) 334-2119

Illinois Arts Council
Ethnic and Folk Arts Apprenticeship
100 West Randolph, Suite 10-500
Chicago, IL 60601
(312) 814-6750; (800) 237-6994 (IL only)

Iowa Arts Council
Folk Arts Apprenticeship
Capitol Complex
600 East Locust
Des Moines, IA 50319
(515) 281-4451

Kansas Arts Commission
Folk Arts Apprenticeships
Jayhawk Tower
700 Jackson, Suite 1004
Topeka, KS 66603-3714
(913) 296-4989

Los Angeles Cultural Affairs Department
Traditional and Folk Arts—Master
 Apprenticeship Program Cultural
 Grants
433 South Spring Street, Tenth Floor
Los Angeles, CA 90013
(213) 485-2433

Louisiana Division of the Arts
Folklife Apprenticeships
P.O. Box 44247
Baton Rouge, LA 70804
(504) 342-8180

Maine Arts Commission
Traditional Arts Apprenticeships
55 Capitol Street, Station 25
Augusta, ME 04333-0025
(207) 289-2724

Minnesota State Arts Board
Folk Arts Apprenticeships
400 Sibley Street, Suite 200
St. Paul, MN 55102
(612) 215-1600

Missouri State Council on the Arts
Traditional Arts Apprenticeship Program
111 North Seventh Street, Suite 105
St. Louis, MO 63101-2188
(314) 340-6845

Nevada State Council on the Arts
Folk Arts Apprenticeships
Capitol Complex
602 North Curry Street
Carson City, NV 89710
(702) 687-6680

New Mexico Arts Division
Folk Arts Master/Apprentice Teams
224 East Palace Avenue
Santa Fe, NM 87501
(505) 827-6490

Ohio Arts Council
Traditional and Ethnic Arts Apprenticeship
 Program
727 East Main Street
Columbus, OH 43205-1796
(614) 466-2613

Oregon Arts Commission
Traditional Arts Apprenticeship Program
775 Summer Street, N.E.
Salem, OR 97301
(503) 986-0082

Rhode Island State Council on the Arts
Folk Arts Apprenticeships
95 Cedar Street, Suite 103
Providence, RI 02903-1034
(401) 277-3880

Utah Arts Council
Folk Arts Apprenticeship Project
617 East South Temple
Salt Lake City, UT 84102
(801) 533-5895

Wisconsin Arts Board
Folk Arts Apprenticeships
101 West Wilson Street
Madison, WI 53702
(608) 266-0190

TRAVEL GRANTS

National Endowment for the Arts
Organizational Projects
Nancy Hanks Center
1100 Pennsylvania Avenue, N.W., Room 625
Washington, D.C. 20506
(202) 682-5437
Travel grants are available through all four of the endowment's divisions

Alaska State Council on the Arts
Artist Travel Grants
411 West Fourth Avenue, Suite 1E
Anchorage, AK 99501-2343
(907) 269-6610

Dallas Museum of Art
1717 North Harwood
Dallas, TX 75201
(214) 922-1234
Otis and Velma Davis Dozier Travel Grants up to $6,000 for "professional artists who wish to expand their artistic horizons through travel"

Rhode Island State Council on the Arts
Travel Grants
95 Cedar Street, Suite 103
Providence, RI 02903
(401) 277-3880

West Virginia Division of Culture and History
Travel Fund
1900 Kanawha Boulevard East
Charleston, WV 25305
(304) 558-0240

CANADA

Alberta Culture and Multiculturalism
Visual Arts Branch
Study Grants/Travel Grants
10158 103rd Street, Third Floor
Edmonton, Alberta T5J 0X6
Canada
(403) 427-2031

The Canada Council
350 Albert Street
P.O. Box 1047
Ottawa, Ontario K1P 5V8
Canada
(613) 237-3400; (800) 263-5588
Travel grants in architecture, interdisciplinary work, performance, photography and the visual arts

New Brunswick Department of Tourism, Recreation and Heritage
Arts Branch
Travel Program
P.O. Box 12345
Fredericton, New Brunswick E3B 5C3
Canada
(506) 453-2555

Prince Edward Island Council of the Arts
Travel-Study Grants
Box 2234
94 Great George Street
Charlottetown, Prince Edward Island C1A 8B9
Canada
(902) 368-4410

TECHNICAL ASSISTANCE GRANTS

Alabama State Council on the Arts
One Dexter Avenue
Montgomery, AL 36130
(205) 242-4076
Money to help artists learn tax laws, fundraising, and accounting techniques, and how to establish a portfolio, market their work and perfect an artistic technique

Arizona Commission on the Arts
Professional Development Grants
417 West Roosevelt Street
Phoenix, AZ 85003
(602) 255-5882
Up to $500 in assistance to individuals and organizations needing to travel out-of-state for professional conferences

The Arts Assembly of Jacksonville, Inc.
Art Ventures Fund
128 East Forsyth Street, Third Floor
Jacksonville, FL 32202
(904) 358-3600
Up to $5,000 for such reasons as studying with a mentor, contracting professional services, renting equipment, buying materials and living expenses during the course of a project

The Arts Assembly of Jacksonville, Inc.
Jacksonville Community Foundation
128 East Forsyth Street, Third Floor
Jacksonville, FL 32202
(904) 358-3600
Awards, between $800 and $5,000, may be used for travel

Chicago Department of Cultural Affairs
Community Arts Assistance Program
78 East Washington Street
Chicago, IL 60602
(312) 744-1742
Up to $1,500 for professional development projects that assist multicultural artists and nonprofit organizations

Contemporary Forum
Phoenix Art Museum
1625 North Central Avenue
Phoenix, AZ 85004
(602) 257-1880
Up to $1,000 for materials for artists working in Arizona

Idaho Commission on the Arts
Worksites Awards
P.O. Box 83720
Boise, ID 83720-0008
(208) 334-2119
Up to $5,000 for artists seeking to work with a master or to investigate ideas relevant to a work-in-progress

Illinois Arts Council
Special Assistance Grants
100 West Randolph
Suite 10-500
Chicago, IL 60601
(312) 814-6750; (800) 237-6994 (IL only)
Up to $1,500 to attend a conference, purchase supplies or services, or hire a consultant

Indiana Arts Commission
Technical Assistance Grants
402 West Washington, Room 072
Indianapolis, IN 46204
(317) 232-1268
Up to $500 for the professional development of artists and arts administrators, such as conference or workshop fees or hiring a consultant

Iowa Arts Council
Artist Mini-Grants
Department of Cultural Affairs
Capitol Complex
600 East Locust
Des Moines, IA 50319
(515) 281-4451
Up to $500 for technical assistance, up to $200 for attending a professional workshop or seminar

Kansas Arts Commission
Professional Development Grant
Jayhawk Tower
700 S.W. Jackson, Suite 1004
Topeka, KS 66603-3714
(913) 296-3335
Between $100 and $500 for exhibition preparation, technical assistance and training, or other activities that may further the artist's career

Metropolitan Arts Commission
1120 S.W. Fifth Avenue, Room 518
Portland, OR 97204
(503) 796-5111
Technical assistance grants, ranging from $500 to $1,000, for "professional development"

North Dakota Council on the Arts
Professional Development Grants
418 East Broadway, Suite 70
Bismarck, ND 58501-4086
(701) 328-3954
Up to $300 for educational seminars related to the arts, hiring consultants, obtaining technical or artistic advice

Ohio Arts Council
Professional Development Assistance Awards
727 East Main Street
Columbus, OH 43205-1796
(614) 466-2613
Up to $1,000 for participation in workshops and conferences, rental of studio space

Pinellas County Arts Council
400 Pierce Boulevard
Clearwater, FL 34616
(813) 462-3327
Awards up to $1,000 for professional development for Pinellas County artists

Vermont Council on the Arts
136 State Street, Drawer 33
Montpelier, VT 05633-6001
(802) 828-3291
Awards up to $1,000 for professional development

Virgin Islands Council on the Arts
Expanding Opportunities for Participation
 in the Arts
41-42 Norre Gade
St. Thomas, VI 00804
(809) 774-5984

The Cultural Center
1900 Kanawha Boulevard East
Charleston, WV 25305-0300
(304) 558-0240
Up to $2,500 for the professional development of West Virginia fine artists (attending a workshop, purchasing equipment, apprenticeship)

CANADA

Alberta Culture and Multiculturalism
Visual Arts Branch
10158 103rd Street, Third Floor
Edmonton, Alberta T5J 0X6
Canada
(403) 427-2031
Study grants; Professional Development program holds one-on-one and group portfolio reviews as well as consultations on finding exhibition space and commissions; Consumer/Exposure Development Program provides artists with ideas on how best to exhibit artwork and set themselves up as small businesses

**British Columbia Ministry of Municipal
 Affairs**
Recreation and Culture—Cultural Services
 Branch
Professional Development Assistance
 Program
800 Johnson Street, Sixth Floor
Victoria, British Columbia V8V 1X4
Canada
(604) 356-1728
Up to $1,500 for tuition and course-related expenses of artists attempting to improve their business skills

Canada Council
Long and Short-Term Grants for Visual
 Artists
350 Albert Street
P.O. Box 1017
Ottawa, Ontario K1P 5V8
Canada
(613) 237-3400; (800) 263-5588

Manitoba Arts Council
Short Term Project Grants for Visual Arts/
 Crafts
525-93 Lombard Avenue
Winnipeg, Manitoba R3B 3B1
Canada
(204) 945-4537
Up to $750 in tuition or travel for professional development workshops or classes

**New Brunswick Department of
 Tourism, Recreation and Heritage**
Arts Branch
Professional Development Program
Frame Loan Program
P.O. Box 12345
Fredericton, New Brunswick E3B 5C3
Canada
(506) 453-2555
*Up to $500 for travel to professional
workshops and conferences, hiring a
consultant; frames may be borrowed by
artists needing them for exhibition purposes
(delivered free to the artist, and the artist is
responsible for their return)*

**Newfoundland Department of
 Municipal and Provincial Affairs**
Craft Industry Development Program
Viking Building
136 Crosbie Road
St. John's, Newfoundland A1B 3K3
Canada
(709) 729-7182
*Up to $8,000 for craftspeople and crafts
organizations for market and product
development, apprenticeships, and training*

Ontario Arts Council
Individual Exhibition Assistance Grants
151 Bloor Street West, Suite 500
Toronto, Ontario M5S 1T6

Canada
(416) 961-1660
(800) 387-0058 (Ontario only)
*Up to $1,000 for costs of crating, framing,
transportation, as well as materials*

SUDDEN OPPORTUNITY GRANTS

Idaho Commission on the Arts
P.O. Box 83702
Boise, ID 83702-0008
(208) 334-2119
Up to $1,000

Minnesota State Arts Board
400 Sibley Street, Suite 200
St. Paul, MN 55102
(612) 215-1600
Up to $1,000

Ohio Arts Council
727 East Main Street
Columbus, OH 43205-2613
(614) 466-2613
Up to $2,000

Oklahoma Visual Arts Coalition
P.O. Box 18275
Oklahoma City, OK 73154
(405) 842-6991
Up to $600

Exhibition Honoraria

When authors are invited by a literary society to read from their latest books, they are frequently paid for their time and expenses. Visual artists, however, generally exhibit their artwork for free, often paying for most if not all of the costs of framing, crating, shipping and insurance, and whatever else is required to put their work on exhibition. Unless a museum is staging the show, the only payback for most artists is when someone buys their artwork.

Some exhibition spaces offer small honoraria to artists whose work will be shown. Think of these as falling somewhere between a fellowship and a thank-you. Among these spaces are:

Art in General
79 Walker Street
New York, NY 10013
(212) 219-0473
*Between $150 and $1,000 for art projects
exhibited at Art in General*

Franklin Furnace
112 Franklin Street
New York, NY 10013
(212) 925-4671
$1,000

Intermedia Arts Minnesota
Jerome Foundation Installation Art
 Commissions
425 Ontario Street, S.E.
Minneapolis, MN 55414
(612) 627-4444
$2,000

Rosenberg Gallery
Goucher College
Site Specific Installation Exhibit
Dulaney Valley Road
Baltimore, MD 21204
(301) 337-6073
Between $500 and $1,000

Sierra Arts Foundation
200 Flint Street
Reno, NV 89501
(702) 329-1324
Amount of artists' fees varies with particular art projects on display

Walker's Point Center for the Arts
911 National Avenue
Milwaukee, WI 53204
(414) 672-2787
Between $500 and $1,000

Women & Their Work
1137 West Sixth
Austin, TX 78703
(512) 477-1064
$600 for between six and 20 artists

There are undoubtedly many more art spaces that pay something to the artists whose work they show, although they may not have specific funds set aside for this purpose. Artists should try asking for some type of payment or reimbursement of costs.

Financial and Technical Assistance to Craftspeople

As a governmental funding category, craftspeople are usually mixed with visual artists. Craftspeople—specifically, those who create nonutilitarian, one-of-a-kind art objects—may apply to the National Endowment for the Arts and in all of the state arts agencies for project grants. In practice, however, there is relatively little public money made available for artisans and the organizations that serve them. Perhaps, this is a result of craftspeople having been viewed traditionally as more market-oriented than other artists. Whatever the reason, there are fewer private or public funding and technical assistance programs for craftspeople. Among those that are available:

The Crafts Center
1001 Connecticut Avenue, Suite 1138
Washington, D.C. 20036
(202) 728-9603
Discounts on services and supplies; bookkeeping and financial planning

Empire State Crafts Alliance
320 Montgomery Street
Syracuse, NY 13202
(315) 472-4245
Discounts on services and supplies; bookkeeping; credit and debt counseling; workshops on business skills; information referrals

Illinois Artisans Program
James R. Thompson Center
100 West Randolph Street
Chicago, IL 60601
(312) 814-4945
Newsletter includes exhibition opportunities

Kentucky Art & Craft Foundation
609 West Main Street
Louisville, KY 40202
(502) 589-0102
Periodic career workshops; scholarships for craftspeople to study with master artisans; discounts on having their work photographed

Kentucky Arts Council
Al Smith Fellowships
31 Fountain Place
Frankfort, KY 40601
(502) 564-3757

Kentucky Craft Marketing Program
39 Fountain Place
Frankfort, KY 40601
(502) 564-8076
Low-interest loans to craftspeople; one-on-one career consultations; business skills workshops

Maine Crafts Association
P.O. Box 228
Deer Isle, ME 04627
(207) 348-9943
Career counseling; workshops on business skills, information referrals

Michigan Guild of Artists & Artisans
118 North Fourth Avenue
Ann Arbor, MI 48104
(313) 662-3382
Workshops on business skills; discounts on services and supplies; information referrals

Minnesota Crafts Council
528 Hennepin Avenue, Suite 308
Minneapolis, MN 55403
(612) 333-7789
Career counseling; workshops on business skills

New Hampshire League of Craftsmen
205 North Main Street
Concord, NH 03301
(603) 224-1471
Grants for materials, study, travel, projects; workshops on business and professional practices

Ohio Arts and Crafts Guild
1676 Millsboro Road
Mansfield, OH 43050
(419) 529-8876
Workshops on business skills

Ohio Designer Craftsmen
1665 West Fifth Avenue
Columbus, OH 43212
(614) 486-7119
Workshops on business skills

Vermont Crafts Council
136 State Street, Drawer 33
Montpelier, VT 05633-6001
(802) 828-3291
Information referral

CANADA

Canada Council
Jean A. Chalmers Fund for the Crafts
Travel, Long- and Short-Term Grants for
 Craftspeople
350 Albert Street
P.O. Box 1047
Ottawa, Ontario K1P 5V8
Canada
(613) 237-3400; (800) 263-5588

**Newfoundland Department of
 Municipal and Provincial Affairs**
Craft Industry Development Program
Viking Building
136 Crosbie Road
St. John's, Newfoundland A1B 3K3
Canada
(709) 729-7182
Apprenticeships; workshops on business skills for artisans and crafts organizations

Ontario Arts Council
Individual Crafts Grants
151 Bloor Street West, Suite 500
Toronto, Ontario M5S 1T6
Canada
(416) 961-1660
(800) 387-0058 (Ontario province)
Fellowships

Small Business Programs
Provincial Government of British Columbia
1405 Douglas Street
Fourth Floor
Victoria, British Columbia V8V 1X4
Canada
(604) 387-9890
Seminars on product evaluation, design
marketability, booth designs

Humanities Councils

All 50 states and United States territories as well as the federal government
have humanities councils, which provide grants to organizations that
sponsor cultural activities, such as documentaries, oral histories, historical
research, and other projects that have an educational purpose. Visual artists,
especially photographers and filmmakers, are eligible for project grants
under the aegis of an umbrella organization. There are individual
fellowships awarded by the federal government and by some states, but these
are almost exclusively intended for historians, usually associated with a
college or university. Some humanities councils also publish directories of
cultural organizations within the states and provide help on how and where
one may submit a proposal for a project. For more information on state
councils, contact the Federation of State Humanities Councils (1600 Wilson
Boulevard, Suite 902, Arlington, VA 22209, tel. 703-908-9700).

National Endowment for the Humanities
1100 Pennsylvania Avenue, N.W.
Washington, D.C. 20506
(202) 606-8400

Alabama Humanities Foundation
2217 Tenth Court South
Birmingham, AL 35205
(205) 930-0540

Alaska Humanities Forum
430 West Seventh Avenue, Suite 1
Anchorage, AK 99501
(907) 272-5341

Arizona Humanities Council
Ellis-Shackelford House
1242 North Central Avenue
Phoenix, AZ 85004
(602) 257-0335

Arkansas Humanities Council
10816 Executive Center Drive, Suite 310
Little Rock, AR 72211
(501) 221-0091

California Council for the Humanities
312 Sutter, Suite 601
San Francisco, CA 94108
(415) 391-1474
 or
315 West Ninth Street, Suite 702
Los Angeles, CA 90015
(213) 623-5993
 or
101 West Broadway, Suite 1120
San Diego, CA 92101
(619) 235-2307

Colorado Endowment for the Humanities
1623 Blake Street, Suite 200
Denver, CO 80202
(303) 573-7733

Connecticut Humanities Council
41 Lawn Avenue
Wesleyan Station
Middletown, CT 06457
(203) 347-6888/3788

Delaware Humanities Forum
1812 Newport Gap Pike
Wilmington, DE 19808-6179
(302) 633-2400

D.C. Community Humanities Council
1331 H Street, N.W., Suite 902
Washington, D.C. 20005
(202) 347-1732

Florida Humanities Council
1514 1/2 East Eighth Avenue
Tampa, FL 33605-3708
(813) 272-3473

Georgia Humanities Council
50 Hurt Plaza, S.E., Suite 440
Atlanta, GA 30303-2936
(404) 523-6220

Guam Humanities Council
123 Archbishop Flores Street, Suite C
Agana, Guam 96910
(671) 472-4507

Hawaii Committee for the Humanities
3599 Wai'alae Avenue, Room 23
Honolulu, HI 96816
(808) 732-5402

Idaho Humanities Council
217 West State Street
Boise, ID 83702
(208) 345-5346

Illinois Humanities Council
618 South Michigan Avenue
Chicago, IL 60605
(312) 939-5212

Indiana Humanities Council
1500 North Delaware Street
Indianapolis, IN 46202
(317) 638-1500

Iowa Humanities Board
Oakdale Campus
University of Iowa
Iowa City, IA 52242
(319) 335-4153

Kansas Humanities Council
112 West Sixth Street, Suite 210
Topeka, KS 66603
(913) 357-0359

Kentucky Humanities Council
417 Clifton Avenue
University of Kentucky
Lexington, KY 40508-3406
(606) 257-5932

Louisiana Endowment for the Humanities
1001 Howard Avenue, Suite 3110
New Orleans, LA 70113
(504) 523-4352

Maine Humanities Council
P.O. Box 7202
Portland, ME 04112
(207) 773-5051

Maryland Humanities Council
601 North Howard Street
Baltimore, MD 21201-4585
(410) 625-4830

Massachusetts Foundation for the Humanities
80 Boylston Street, Suite 1000
Boston, MA 02116
(617) 451-9021
 or
One Woodbridge Street
South Hadley, MA 01075
(413) 536-1385

Michigan Humanities Council
119 Pere Marquette Drive, Suite 3B
Lansing, MI 48912-1231
(517) 372-7770
 or
5201 Woodward Avenue
Detroit, MI 48202-4093
(313) 993-7770

Minnesota Humanities Commission
26 East Exchange Street
St. Paul, MN 55101
(612) 224-5739

Mississippi Humanities Council
3825 Ridgewood Road, Room 311
Jackson, MS 39211-6453
(601) 982-6752

Missouri Humanities Council
911 Washington Avenue, Suite 215
St. Louis, MO 63101-1208
(314) 621-7705

Montana Committee for the Humanities
P.O. Box 8036
Hellgate Station
Missoula, MT 59807
(406) 243-6022

Nebraska Humanities Council
Lincoln Center Building, Room 225
215 Centennial Mall South
Lincoln, NE 68508
(402) 474-2131

Nevada Humanities Committee
1034 North Sierra Street
Reno, NV 89503
(702) 784-6587

New Hampshire Humanities Council
19 Pillsbury Street
P.O. Box 2228
Concord, NH 03302-2228
(603) 224-4071

New Jersey Committee for the Humanities
390 George Street, Suite 602
New Brunswick, NJ 08901-2019
(908) 932-7726

New Mexico Endowment for the Humanities
209 Onate Hall
Albuquerque, NM 87131
(505) 277-3705

New York Council for the Humanities
198 Broadway
New York, NY 10038
(212) 233-1131

North Carolina Humanities Council
425 Spring Garden Street
Greensboro, NC 27401
(919) 334-5325

North Dakota Humanities Council
P.O. Box 2191
Bismarck, ND 58502
(701) 255-3360

Ohio Humanities Council
695 Bryden Road
P.O. Box 06354
Columbus, OH 43206-0354
(614) 461-7802

Oklahoma Foundation for the Humanities
428 West California, Suite 270
Oklahoma City, OK 73102
(405) 235-0280

Oregon Council for the Humanities
812 S.W. Washington, Suite 225
Portland, OR 97205
(503) 241-0543

Pennsylvania Humanities Council
320 Walnut Street, Room 305
Philadelphia, PA 19106
(215) 925-1005

Puerto Rican Foundation for the Humanities
(Fundacion Puertorriquena de las Humanidades)
Apartado Postal S-4307
San Juan de Puerto Rico 00904
(809) 721-2087
 or
Bacon House Mews
606 18th Street, N.W.
Washington, D.C. 20006
(202) 371-8111

Rhode Island Committee for the Humanities
60 Ship Street
Providence, RI 02903
(401) 273-2250

South Carolina Humanities Council
P.O. Box 5287
Columbia, SC 29250
(803) 771-8864

South Dakota Humanities Council
Box 7050
University Station
Brookings, SD 57007
(605) 688-6113

Tennessee Humanities Council
1003 18th Avenue South
Nashville, TN 37212
(615) 320-7001

Texas Committee for the Humanities
3809 South Second Street
Austin, TX 78704
(512) 440-1991

Utah Humanities Council
350 South 400 East, Suite 110
Salt Lake City, UT 84111-2946
(801) 359-9670

Vermont Council on the Humanities
P.O. Box 58
Hyde Park, VT 05655
(802) 888-3183

Virginia Foundation for the Humanities
145 Ednam Drive
Charlottesville, VA 22903
(804) 924-3296

Virgin Islands Humanities Council
P.O. Box 1829
St. Thomas, VI 00803
(809) 776-4044

Washington Commission for the Humanities
615 Second Avenue, Suite 300
Seattle, WA 98104
(206) 682-1770

West Virginia Humanities Council
723 Kanawha Boulevard, Suite 800
Charleston, WV 25301
(304) 346-8500

Wisconsin Humanities Committee
716 Langdon Street
Madison, WI 53706
(608) 262-0706

Wyoming Council for the Humanities
Box 3643
University Station
Laramie, WY 82071-3643
(307) 776-6496

Patronage of Artists by Religious Organizations

While the days of the Pope providing employment for painters and sculptors throughout the Christian world have long past, churches of all denominations continue to commission artists to create new works. As in the past, these works are usually intended to provide decoration for a church, and opportunities become available when new churches are built or old ones are refurbished. Most national headquarters of churches and other religious organizations have art and architecture committees, in charge of selecting artists for churches that are being built or renovated. Among these are:

The Union of American Hebrew Congregations
Department of Synagogue Management
838 Fifth Avenue
New York, NY 10021
(212) 249-0100

Evangelical Lutheran Church of America
Division of Church Music and the Arts
8765 West Higgins Road
Chicago, IL 60631
(312) 380-2700

Unitarian Universalist Association
Worship Resources Offices
Department of Ministry
25 Beacon Street
Boston, MA 02108
(617) 742-2100

United Church of Christ
United Church Board for Homeland Ministries
Secretary for Church Building
132 West 31st Street
New York, NY 10001
(212) 683-5656

Presbyterian Church
Attention: Art Committee
100 Witherspoon Street
Louisville, KY 40202
(502) 580-1900

Episcopal Church
Attention: Director of the Building Fund
815 Second Avenue
New York, NY 10017
(800) 334-7626

United Methodist Church
Fellowship of United Methodists in
 Worship, Music and Other Arts
159 Ralph McGill Bldv., N.E., Suite 501-C
Atlanta, GA 30365
(404) 659-0002

All of these churches accept slides and biographical information from artists and will pass on recommendations to member churches wanting to commission some object for a church. Artists may have just as much luck applying to churches in their areas as well, regardless of whether or not art has ever been purchased, commissioned, or displayed in the past. It also doesn't hurt to ask the clergyman; even if that church is unable or uninterested in having anything to do with art, there may be other churches interested in creating an art presence in their local community.

Churches vary greatly in terms of whether they seek works that are religious in orientation or simply that reflect a favored artist or style. The Union of American Hebrew Congregations looks for Judaica, such as Torah curtains and mantles, while St. Peter's Lutheran Church in New York City commissioned abstract expressionist Willem de Kooning to create a $1 million, three-panel altarpiece. In addition, the Interfaith Forum on Religion, Faith and Architecture (1777 Church Street, N.W., Washington, D.C. 20036, tel. 202-387-8333) keeps a registry of artists' slides and biographies, both for its annual juried show—which awards certificates of merit to 13 winners and puts these works on display at the group's annual spring conference—and for referral, as church officials from all over the country frequently call to find appropriate artists and architects.

Other denominations have less centralized administrations, and individual churches tend to be self-governing. Within Baptist, Catholic, and Christian Scientist faiths, churches need to be contacted individually.

6

Artist-in-Residence Programs

In the minds of many people, being an artist and working as an art teacher are the same, since teaching is the way that all but the relatively few successful artists can support themselves. However, the odds of obtaining a full-time, tenured teaching position are slim, since between 50 and 200 artists apply for every job opening at a college or university, and public school art teachers are required to have education degrees and state teaching certificates.

Art instruction, of course, comes in many varieties and, in fact, some artists prefer to limit their teaching to occasional stints on their own terms, rather than fitting into a school's curriculum. For them, artist-in-residence pro-

grams may be the ideal set-up. Actual instruction tends to be part-time—only a certain number of hours per week or full-time for just a few weeks or months—and may involve simply being seen in the act of creating art while providing a bit of explanation from time to time.

State-Supported Residence Programs

These programs have different names and are found throughout the country. Their names depend upon what the sponsoring institution (for instance, a state or local arts agency, college or university, public school, private foundation, summer workshop program, community or senior center) is looking for. Some are called artist-in-residencies, while others are identified as artists-in-education (or artists-in-the-schools), visiting artists, or touring artists. The names are often interchangeable, and frequently there is overlap. The Maine Arts Commission's Artist Residency and Touring Artist programs are linked, for instance, as resident artists are asked to spend from 10 to 30 days at sites throughout the state, ensuring that certain rural communities will not be overlooked. For the same reasons, those artists involved in the Arkansas Arts Council's Arts in Education program are also placed on the Arts on Tour roster. The Pennsylvania Council on the Arts emphasizes artists-in-education and, in fact, the state's Department of Education helps prepare artists for their placements, yet the program also has established residencies in nonschool settings, such as community and senior citizen centers, museums, and prisons. In the state of Washington, critics and art scholars are eligible for the Arts Commission's artist-in-residence roster.

The art world is filled with labels and characterizations—realism, academic realism, naturalism, expressionism, neo-expressionism, abstract expressionism, abstract impressionism, and many more—that make sense as theories but, on a practical level, tend to separate artists and artworks far more than they are (or were) in life. At other times, once clearly understood terms become fudged. The terms *artist-in-residence* and *artist communities* (or *art colonies*) may be cases in point.

An artist-in-residence program is one in which an institution or some group invites an artist to work at its facility in order to showcase his or her work and manner of working to others; that artist often receives some stipend and, sometimes, accommodations for the duration of the residency. An artist community, on the other hand, brings together a number of artists,

sometimes working in the same media or discipline or more often involved in a variety of artistic endeavors, for the purpose of concentrated work and the possibility of intellectual interaction and cross-fertilization. A few of these live-work communities are free to the artist (or there are fellowship programs to cover the cost), but most charge weekly or monthly fees.

Many artist-in-residence programs and artist communities still fit these distinctions but, increasingly, activities involving artists in some fashion around the United States and Canada are being called *residencies* and *colonies*. Colleges and universities often sponsor artist-in-residencies, which are not included here, as most of these are actually adjunct faculty positions with the perk of free studio or office space (sometimes housing as well). These rarely include a full-time salary. The nine-week summer residency program at the Skowhegan School of Painting and Sculpture in Skowhegan, Maine, on the other hand, is actually a summer school in which the artists are given studio space and room and board but pay tuition ($4,900 plus other fees) and receive instruction from school faculty. The artist-in-residence program of the Sitka Center for Art and Ecology in Otis, Oregon, for instance, offers free accommodations and studio space to artists and naturalists in exchange for providing 20 hours per month of workshops to the community. The term seems to expand to cover whatever program an organization is offering and calls an artist-in-residency. In theory, an artist-in-residence should be paid something and have clearly defined duties. Every arts center, foundation, school, state, and locality runs these programs a little differently but, for convenience sake, we'll call all of them artist-in-residencies.

Many of these programs are funded by the National Endowment for the Arts. In the past, the federal agency has allocated $5 million, which is administered by the arts-in-education coordinator at the state arts agencies. Some of that money is applied to artist-in-residence programs that are run by local arts councils. The main concern of interested artists is where and how to apply for a residency as well as what the various funders and sponsors (public schools, community centers) are hoping to accomplish.

In general, local arts agencies or schools with artist-in-residence programs look for local artists, whose task is to offer instruction, demonstrate the process of creating an artwork, or involve a group in some artistic activity. On occasion, someone who is not from the immediate area may be selected, but long-term artist residents who know the neighborhoods and schools are preferred. Of course, the resident artist is not there to

supplant the regular art teachers—a point of contention in California, where half-time (20 hours per week) school residencies may last up to three years—but to supplement the existing arts activities or develop an entirely new short-term project.

At state arts agencies, in-state artists are usually chosen, but the emphasis is frequently on exposing the schoolchildren to other cultures or experimental art forms. The intention is to bring in different viewpoints, such as an African-American or Native American artist into a predominantly white school. Most states—with the exception of Colorado, Connecticut, Hawaii, Maine, Maryland, Massachusetts, Minnesota, New Mexico, New York, North Carolina, Rhode Island, Vermont and Wyoming—attempt to establish cultural diversity in their programs by including on their rosters artists residing in other states.

Another difference between the artist-in-residence programs administered by local and state arts agencies is the payment. The Bronx Council on the Arts in New York City pays $15 per hour for working in a school or community center, which is at the high end of the pay scale on the local level. Remuneration for state arts agency-sponsored residencies starts closer to $20 or $25 per hour, some exceeding $50 per hour.

One reason for this difference is that most local arts councils do not receive state funding for their artist-in-residence programs and must raise money for these positions elsewhere. The Council for the Arts of Jacksonville, North Carolina, for instance, applies for its money from the county commissioner, while the Arts Assembly of Jacksonville, Florida, receives its money from the school board. Neither source can be counted on for generous and consistent support. Funds are so limited at the Arts Council of Greater Kalamazoo (Michigan) that school residencies only involve one-time performances, such as an artist demonstrating to students how to paint or do calligraphy.

On the state level, arts agencies provide up to half of the cost of the residency in matching grants (working on a 1:1 ratio), and they often prefer longer residencies. The state Division of Cultural Affairs in Florida looks to use artists for full-time residencies of two weeks minimum, paying no less than $19 per hour. The Illinois Arts Council has residencies of between one week and eight months, and one may remain a state-salaried artist-in-resident in California, Louisiana, and Wisconsin for three years, and perhaps longer. Minimum residencies tend to be one week, and some states offer short- or long-term options. Kentucky, for instance, has residencies for either

20 days or 12 weeks or nine months, and Massachusetts offers 1-to-3-day, 4-to-10-day and 11-to-40-day plans; the shorter residency in Ohio is two weeks, while the long option is nine months; both Iowa and West Virginia have one-week and 12-month plans.

With a couple of exceptions, selection as an artist-in-residence is a three-stage process on both the local and state levels. Interested artists must call or write the arts council or state agency for an application, which needs to be completed and returned with a resume, slides, or photographs of one's work, documentation of one's competence (reviews of exhibitions, articles in newspapers or magazines, letters of reference) as well as the specific activity one wishes to pursue during a residency. This proposal should note the age group (elementary school, high school, college age, senior citizens), target population (the disabled, for instance), and type of location (community center, museum, prison, public school) in which this residency might take place. Local arts councils also sometimes ask for the artist to indicate what he or she charges for this service.

One should also adhere to the deadlines for submitting applications, which differ from one arts agency to the next. Both the Idaho Commission on the Arts and the Iowa Arts Council accept applications every two years, while other states and localities make selections annually.

Applications are reviewed by a committee that may be a peer review panel or an interdisciplinary panel, composed of arts administrators and educators, as well as people in other professions. This group evaluates the artistic quality of the applicant. After being accepted by this first group, the application is examined by a second committee, predominantly made up of educators, which judges the feasibility and interest of the proposal. At this stage, there is frequently a meeting between the artist and the second committee, in which the artist's ability to communicate his or her discipline and ideas is assessed. On occasion, an actual demonstration of what the artist would do is requested.

Artists accepted by this second committee are placed on the arts council's or agency's roster, available to schools as well as churches, community centers, homeless and battered women's shelters, museums, prisons, retirement homes, state universities or community colleges, and any other group that might want an artist-in-residence.

The third stage of the selection process is the application by the school or center to the arts agency for the artist's services. These applicants are evaluated in terms of their need, commitment to the program (making

space available to the artist, making the artist's project or presence a part of the overall curriculum, for example) and ability to pay some portion of the cost of the artist's salary and materials.

There are a few exceptions to this three-step procedure—potential artist-in-residence sponsors in both Virginia and West Virginia select artists first and then apply to the state for funding, bypassing the roster system, and the Indiana Arts Commission changed its selection process from two committees to one in 1991—that can be discovered by inquiring of the particular arts agency for its guidelines.

Not everyone who is selected to be listed in the roster will be chosen for a residency, and the rosters themselves are periodically updated, requiring the artist to reapply or submit some additional information. Maine and Pennsylvania, for instance, revise their rosters every year, while the Arkansas Arts Council updates its roster twice a year. Illinois, Michigan, Minnesota, New Mexico, South Dakota, and Utah publish a new roster every two years, and Wisconsin every three. North Dakota and Vermont require artists in their rosters to be reevaluated every four years, and artists remain on the roster of the Colorado Council on the Arts and Humanities for five years or five residencies, whichever comes first. Local arts councils also vary widely in this regard.

The addresses and telephone numbers of the state arts agencies are listed in chapter 5. These programs are called artists in schools in Alaska, Iowa, Kansas and Nebraska; artist-in-residence in Arizona, Colorado, Montana, New York and Washington; and arts in education at all other state arts agencies and territories. The only exception is California, which has three different categories to which one may apply—artists in schools, artists in communities, and artists serving special communities.

The Canadian Artists in the Community Program is similar to those run by the states in the U.S. The Canada Council (see chapter 5 for address) pays for travel (47 cents per mile or 29.5 cents per kilometer, or economy class airfare), the cost of transporting presentation material, $120 per day for food and lodging and a $225 per working day honorarium.

Increasingly, art is not awarded government funds for art's sake; rather, artists receive grants on the basis of a perceived benefit to the community. In general, an artist-in-residence is in the service of the people who use the organization where he or she is in residence. A growing number of artists are qualifying for federal grants—such as community development block grants, administered by the Community Planning and Development

program of the U.S. Department of Housing and Urban Development and the Summer Youth Employment Program of the Job Training and Partnership Act—based on their ability to develop collaborative projects with "underserved" groups, such as rural and inner-city children.

For more information on artist-in-residence programs, one should contact the National Association of State Arts Agencies (1010 Vermont Avenue, N.W., Washington, D.C. 20005, tel. 202-347-6352) or the National Endowment for the Arts (1100 Pennsylvania Avenue, N.W., Washington, D.C. 20506, tel. 202-682-5426) for the kind of program offered in one's state; and Americans for the Arts (927 15 Street, N.W., Washington, D.C. 20005, tel. 202-371-2830) for existing programs on the local level.

Privately Sponsored Residence Programs

States are not the only sponsors of artist-in-residencies. The federal government is an active participant through the National Endowment for the Arts (see address above) and, to a lesser degree, the Federal Bureau of Prisons (Artist-in-Residence Program, Education Division, 320 Fifth Street, N.W., Washington, D.C. 20534, tel. 202-724-3022).

A private organization, COMPAS (308 Landmark Center, 75 West Fifth Street, Room 304, St. Paul, MN 55102, tel. 612-292-3287), has an Artists-in-the-Schools program that places visual artists in K–12 elementary schools throughout Minnesota for one-week residencies. There are also a number of private groups that place writers in public schools, such as California Poets-in-the-Schools in San Francisco, Playwrights Theater of New Jersey, the Geraldine R. Dodge Foundation in Morristown, New Jersey, the New York City–based Teachers and Writers, the Missoula Writers Collaborative in Montana, Seattle Arts and Lectures, Houston Writers-in-the-Schools and Young Audiences (headquartered in New York City with 34 affiliates across the United States). For all of these activities, there is a formal application, and writers who are approved to be in the program must undergo training, at the end of which they will be expected to provide lesson plans. The residencies are occasional and may range from one-hour classroom discussions to five- or ten-week sessions, paying between $30 and $70 per hour.

Very Special Arts programs, which serve people with mental and physical disabilities and are located in every state (see chapter 1 for addresses), also afford artists short- or long-term teaching opportunities. Similar to the state-sponsored artist residencies, each state Very Special Arts chapter maintains

its own roster of artists, establishes its own guidelines for selecting artists, determining the length of residence (a one-day event, 16-week workshop or school year–length program, for example), and the amount of payment for artists. (It is to the state arts agencies' artist-in-residence programs, in fact, that the Very Special Arts affiliates turn when seeking information or suggestions on developing arts activities, and there is occasional collaboration on specific projects.) Artists employed by Very Special Arts receive some training in how to work with people with particular disabilities, and that training is often conducted by artists themselves.

Also, similar to the state-run artist-in-residence program, artists do not apply directly to the state chapter but to an organization, such as a school or community center, which makes a formal application to the state Very Special Arts affiliate for funding. The ability of the state chapter to provide the requested funds is dependent on its ability to raise money, as each affiliate only receives $15,000 annually from the national Very Special Arts headquarters.

Private foundations have also been moderately active in support of residencies. In general, they review applications submitted by schools, community centers, or other nonprofit groups for an artist-in-residence program in which the applicant has found an artist and prepared a curriculum but needs outside money for the residency to take place.

Hundreds of arts and crafts workshops take place throughout the year (most during the summer) in the United States, Canada and Europe, the majority of which hire artists as resident faculty and teach amateurs and aspiring artists in a particular medium or style. The best sources of information about what, where and when workshops take place are the March issues of *American Artist* magazine and *The Artist's Magazine*, which list art workshops, and *The Guide to Art & Craft Workshops* (see bibliography). The American Craft Council (72 Spring Street, New York, NY 10012, tel. 212-274-0630) will also provide to members a free computer search of artist-in-residence programs in the crafts area in which they are interested (nonmembers must pay a fee for this service).

There is no central source of information on college and university residencies, which last from one or two weeks to one or two semesters. These programs tend to pay considerably more than those sponsored by local and state arts agencies and often provide free or discounted room and board. Contact the art departments at these institutions directly to find out whether or not they sponsor artists-in-residence and, if so, how the artists are selected.

Cynthia Navaretta's *Whole Arts Directory*, published by Midmarch Associates (Box 3304 Grand Central Station, New York, NY 10163, tel. 212-666-6990), includes a number of college-sponsored residencies.

It is not much easier to discover which private foundations support artist-in-residence programs as neither the various offices of the Foundation Center nor any of its 180 cooperating libraries or branch offices have this information in a quickly accessible form. Libraries, especially university or research libraries, however, can prove some help through making a computerized search in Dialog, an information service for which the Foundation Center has created two files—Foundation Directory (#26) and the Foundation Grants Index (#27). By indexing the term, "artist-in-residence," on the Foundation Grants Index file, Dialog will fill the computer screen with names of the foundations supporting these programs, the recipients, the amount of the grants, and the year in which the grants were made. From there, a hard (paper) copy can be made with this information on the library's computer printer, and artists will then be able to research the particular foundations from printed sources already in the library, such as the *Foundation Directory*. Some libraries will access Dialog for free, but most will seek reimbursement for the telecommunication charge.

Studio Space for Artists

As evident above, state-supported artist-in-residence programs focus on artists teaching the young or the elderly, either through classes or demonstrations. The term artist-in-residence, in fact, is often broader than that, and some programs closely resemble artist communities (see chapter 7). Usually, the artists don't live at the site where they work. The artists, in fact, are given studio space for a period of time and, perhaps, a monthly stipend and free materials.

Two significant programs that help artists in this way are the Marie Walsh Sharpe Art Foundation and The Elizabeth Foundation for the Arts, which both offer studio space to 14 artists for a period of 12 months in lower Manhattan. Although the two programs are separate, with their own applications and criteria for selection, their respective studios are located in adjoining buildings and both programs are administered by the same person, Dennis Elliott.

The Marie Walsh Sharpe Art Foundation is primarily open to artists in the United States, while the Elizabeth Foundation's program has a greater emphasis on artists outside the U.S. The Marie Walsh Sharpe Art Foundation

offers studios to artists without cost, while those sponsored by the Elizabeth Foundation rent for between $13,000 and $16,000 annually. In some cases, the Elizabeth Foundation awards a grant to cover the cost of the studio, but most artists in its International Studio Program find corporate (for U.S. artists) or governmental (for foreign artists) sponsors to pick up the tab.

Both the Marie Walsh Sharpe Art Foundation and the Elizabeth Foundation's International Studio Program serve to place artists in New York City, making what they can of the opportunity. The underlying assumption of these respective programs is that, while art may be created anywhere, the art world of critics, art dealers, museums and nonprofit exhibition spaces only exists in a relative handful of places. The greatest congregation of these people live and work in New York City, a reason that so many artists around the United States and around the world look to attract the attention of the art world there. The New York question ("Shall I pull up roots and try to establish myself in New York?") is one that every professional fine artist confronts at one time or another in his or her career. Of course, for artists contemplating a move to New York City, other questions follow: How do I find and afford an apartment and studio in New York? How do I get the critics, dealers, exhibition space directors and museum curators to take a look at my work?

"Artists feel a need for a studio in which they can work, or they need the location of our studios in order to show their work to other people," said Joyce Robinson, executive director of the Marie Walsh Sharpe Art Foundation, whose studio program began in 1991. In 1996, 770 artists from 36 states as well as from abroad applied for the 14 studios available, submitting their work to a blind jurying process whose jurors are all artists. The largest number of those applicants were residents of New York City (292) and New York State (63), reflecting the difficulty that even long-time Manhattan residents have in finding a studio they can afford (those artists who already have a studio of 440 square feet or larger are ineligible).

Studio space programs may not be for everyone, as out-of-towners still need to find a place to live and, quite possibly, a job to pay for one's rent and food. "I know that Dennis [Elliott] keeps his ear out for inexpensive sublets for artists," Robinson said. "The biggest problem is finding work in New York. Artists want to earn enough to pay for room and board, but they don't want a job that takes up so much time and energy that there is nothing left for making art."

While similar, the Elizabeth Foundation's intention is more focused on

actively helping artists to develop their careers and visibility. "The premise of the International Studio Program is to help artists get shows and representation in New York," Elliott said. "I work with the artists to create a list of the critics, art dealers, officials from foundations, museum curators and museum directors whom they would like to come see their work. At least twice a month, a prominent curator, writer, gallery owner or even another artist meets privately with each artist for a 45-minute studio visit."

Although the International Studio Program was only created in 1994, it already has earned the respect of many of those critics, curators, dealers and directors who respond to the artists' invitations. Among those who have made these visits are critics from the *Village Voice* and *Art in America,* curators from the Guggenheim Museum, Museum of Modern Art, Whitney Museum of American Art and the New Museum of Contemporary Art, as well as major art dealers, independent curators and writers, and the directors of nonprofit art spaces, such as Dia Center for the Arts, Artists Space and New York Kunsthalle.

In the who-you-know world of the arts, scheduled opportunities to display one's work to people of influence in a spacious studio is an ideal situation. "I've been actively seeking gallery representation in New York," said Clytie Alexander, a Santa Fe, New Mexico painter whose corporate sponsor is an oil and gas company in Santa Fe. She noted that "there is a series of paintings I've been working on since 1991, which I wanted to show in New York," and her studio serves both as a place in which to complete that series and as a showroom for dealers, critics and museum curators.

Similarly, painter Marjorie Welish saw the studio program as an opportunity to meet in "a dignified showroom" critics and dealers "who would have disdained coming to my very shabby studio in my apartment" in New York City's West Village. "The fact that the Elizabeth Foundation saw fit to support me puts a favorable imprimatur on my work."

The positive results of these studio visits are both tangible (an upcoming exhibition) and long-term for Welish. "I received a wide range of responses to my work; I may never again get such an encyclopedic group of interpretations of a given body of work," she said. "Some of it was helpful in terms of my artmaking, helping me follow through on certain ideas. Some of it was helpful in understanding how critics look at art."

Everyone in the Elizabeth Foundation's program is looking to break through to a higher level of success and gain exposure in New York City (both aims merging into one) through developing relationships with powerful art

world figures. Those contacts are what is left after one's year in the program is over, helping an artist find more opportunities to show and sell work either through those particular critics, curators and dealers or by word-of-mouth to yet others. Sculptor Helen Ramsaran, who "found it hard to get people to come to my studio in Brooklyn," said that the main benefit of the program was getting her name passed from one person to another. Dealers and curators, for instance, began to suggest showing her work to others they knew. Tom Eccles, deputy director of the Public Art Fund, who was one of the people on her studio visit list, recommended Ramsaran's work to the Battery Park Redevelopment Authority in lower Manhattan, which provided a $7,500 grant to help pay for casting. Eccles "also got me to start thinking about temporary art," she said. "I might place a work somewhere for just a year, which may be an easier way to present a controversial piece. Up until then, I had only thought about permanent work. He also got me thinking about doing other works than in bronze—concrete and metal, or concrete and wood, for instance—and doing smaller casts."

Other arts agencies, schools, and cultural centers with studio space programs are:

ALABAMA
Space One Eleven
2405 Second Avenue North
Birmingham, AL 35203
(205) 324-4654

CALIFORNIA
Bay Area Video Coalition
111 17th Street
San Francisco, CA 94107
(415) 861-3282
Video production and post-production equipment and assistance

Exploratorium
3601 Lyon Street
San Francisco, CA 94123
(415) 563-7337
Artists-in-residence have use of an electronics and machine shop; Exploratorium, which is a museum, provides between $5,000 and $15,000 in honorarium and materials

Headlands Center for the Arts
Affiliate Program
944 Fort Barry
Sausalito, CA 94965
(415) 331-2787/3857
Studio and work space rentals up to three years ($.50 per square foot); studios are open 24 hours a day but may not be used as living space

Kala Institute
1060 Heinz Avenue
Berkeley, CA 94710
(510) 549-2977
Printmaking studio space rentals range from $198 to $313 per month, with some reductions and fellowships available; supplies some materials

Ojai Foundation
P.O. Box 1620
Ojai, CA 93023
(805) 646-8343
Studio space provided for artists who camp at the site

COLORADO

Marie Walsh Sharpe Art Foundation
The Space Program
711 North Tejon, Suite B
Colorado Springs, CO 80903
(719) 635-3220
*Studio space in Manhattan for one year at
433 Greenwich Street in the TriBeCa section*

Rocky Mountain Women's Institute
Artist-in-Residence Program
7150 Montview Boulevard
Denver, CO 80220
(303) 871-6923
*For Denver resident women, residencies
include office or studio space and a $1,000
stipend*

CONNECTICUT

Griffis Art Center
605 Pequot Avenue
New London, CT 06320
(203) 439-0039; (203) 443-3431
*Nine-month residency includes use of studio,
furnished room and three daily meals;
participants donate an artwork completed
during their residency to the center*

Real Art Ways
Media Residency Program
56 Arbor Street
Hartford, CT 16106
(860) 232-1006
Residencies for media artists

Weir Farm Heritage Trust
Department A.A.
735 Nod Hill Road
Wilton, CT 06897
(203) 761-9945
Up to one-year residency

DELAWARE

**Delaware Center for the
Contemporary Arts**
103 East 16 Street
Wilmington, DE 19801
(302) 656-6466
*Visual artists and professional critics in the
mid-Atlantic region (except Delaware) receive
workspace, housing, costs of transportation
and documentation*

DISTRICT OF COLUMBIA

The Experimental Gallery
Smithsonian Institution
Arts & Industries Building, Room 1240
Washington, D.C. 20560
(202) 786-2850
*Three- to six-month residencies in exhibition
design, with a $2,000 monthly stipend*

Renwick Gallery
James Renwick Fellowships in American
 Crafts
National Museum of American Art
Smithsonian Institution
Washington, D.C. 20560
(202) 357-2531
*Three- to 12-month graduate and senior
residencies, paying $13,000 plus allowances
and $21,000 plus allowances, respectively
(the awards are prorated for the period of a
year)*

Center for the Arts and Religion
Wesley Theological Seminary
4500 Massachusetts Avenue, N.W.
Washington, D.C. 20016
(202) 885-8649
*One-year residency includes paid teaching,
exhibition opportunities and a stipend*

FLORIDA

Atlantic Center for the Arts
1414 Art Center Avenue
New Smyrna Beach, FL 32168
(904) 427-6975
*$5,000, plus up to $1,000 in transportation,
for master artists who work with mid-career
associate artists*

GEORGIA

Alternate Roots
1083 Austin Avenue
Atlanta, GA 30307
(404) 577-1079

Nexus Contemporary Art Center
Nexus Press Residency Program
P.O. Box 54661
Atlanta, GA 30308
(404) 688-1970
*One-month residencies, including 10 working
days on the press, $1,000 honorarium,
$1,800 production budget, and up to $300
for round-trip airfare*

ILLINOIS
Artists Book Works
1422 West Irving Park Road
Chicago, IL 60613
(312) 348-4469
*One-month residencies, available to artists
living within a 100-mile radius of Chicago,
including materials and printing time as well
as a small stipend*

Ox-Bow Summer School of Art
Professional Artists Residencies
c/o School of the Art Institute of Chicago
Office of Summer Programs
37 South Wabash, Room 707
Chicago, IL 60603
(312) 899-5130
*One-week residencies with free use of studios
and equipment in exchange for a $336 fee
to cover room and board*

IOWA
CSPS
1103 Third Street, S.E.
Cedar Rapids, IA 52401
(319) 364-1580
*Up to one-week residencies with "modest"
honoraria*

KANSAS
Lawrence Arts Center
Technical Assistantships in Collaboration
 Lithography
200 West Ninth
Lawrence, KS 66044
(913) 843-2787
*Project grant of between $400 and $800,
which must be matched by the artist (a
Kansas resident)*

LOUISIANA
Contemporary Arts Center
P.O. Box 30498
New Orleans, LA 70130
(504) 523-1216

MAINE
Watershed Center for the Ceramic Arts
RR1, Box 845
Cochran Road
North Edgecomb, ME 04556
(207) 882-6075/4158
*Up to $100 honorarium, plus free materials
and firings*

MARYLAND
Pyramid Atlantic
6001 66th Avenue, Suite 103
Riverdale, MD 20737
(301) 459-7154
*Residencies for those interested in artists'
books, printmaking and papermaking*

School 33 Art Center
1427 Light Street
Baltimore, MD 21230
(410) 396-4641

MASSACHUSETTS
**The Mary Ingraham Bunting Institute
 of Radcliffe College**
Bunting Fellowship Program
34 Concord Avenue
Cambridge, MA 02138
(617) 495-8212
*For women: One-year residency plus a
$33,000 stipend; affiliation program offers
between 10 and 20 women office space with
no stipend*

Jacob's Pillow
Box 287
Lee, MA 01238
(413) 637-1322
Residencies for choreographers

MICHIGAN
Pewabic Pottery
10125 East Jefferson Avenue
Detroit, MI 48214
(313) 822-0954
*Two-year residencies; residents receive a
monthly $100 studio fee and a $600 per
month stipend as well as health insurance*

Urban Institute for Contemporary Arts
Artist-in-Residence Program
88 Monroe Avenue, N.W.
Grand Rapids, MI 49503
(616) 454-7000/7013
*Two-year term, and artists may apply for a
one-year extension*

MONTANA
**The Archie Bray Foundation for the
Ceramic Arts**
2915 Country Club Avenue
Helena, MT 59601
(406) 443-3502/2969
*Short-term and year-round residencies;
studio rent is $150 per month, and glazing
and kiln facilities are shared*

NEW JERSEY
Peter's Valley Craft Center
19 Kuhn Road
Layton, NJ 07851
(201) 948-5200
*One- to four-year residencies, including
living-studio space at modest cost*

NEW MEXICO
Roswell Museum and Art Center
Artist-in-Residence Program
100 West 11th Street
Roswell, NM 88201
(505) 622-6037
*Six- to 12-month residencies, including $500
per month stipend, free housing and studio
space*

NEW YORK
Asian-American Arts Centre
26 Bowery
New York, NY 10003
(212) 233-2154; (212) 766-1287
*Eight-month residency, including studio and
$1,200 per month stipend*

Bronx Council on the Arts
Scholarship Studio Program
1738 Hone Avenue
Bronx, NY 10461
(718) 931-9500
*Studio space at the council's Longwood Arts
Project and a monthly materials stipend of
up to $500*

**CEPA/Center for Exploratory &
Perceptual Art**
700 Main Street, Fourth Floor
Buffalo, NY 14202
(716) 856-2717
*Use of computers, darkroom, studios,
exhibition space, housing and an honorarium*

Dieu Donne Papermill, Inc.
Workspace Program
3 Crosby Street
New York, NY 10013
(212) 226-0573
*Four artists, who have little to no experience
in papermaking or in creating works on
paper, are selected annually for five-day
residencies (bunched together or spread out
over a period of time), with a $500
honorarium.*

Downtown Community Television Center
87 Lafayette Street
New York, NY 10013
(212) 966-4510
Up to $500 worth of equipment use

Elizabeth Foundation for the Arts
International Studio Program
451 Greenwich Street
New York, NY 10013-1757
(212) 431-0381
*Residencies up to one year in the TriBeCa
section of New York City*

Experimental Television Center
RD2, Box 235
Newark Valley, NY 13811
(607) 687-4341
Five-day intensive-study residencies

Franklin Furnace
112 Franklin Street
New York, NY 10013
(212) 925-4671
For performance artists

Harvestworks, Inc.
596 Broadway, Suite 602
New York, NY 10012
(212) 431-1130
*Production grants, including studio time, a
tape supply allowance, and the services of a
professional engineer, to 20 audio artists per
year*

Henry Street Settlement
265 Henry Street
New York, NY 10002
(212) 598-0400
Van Lier Fellowships of $5,000 available to minority artists under 35

Jamaica Arts Center
Workspace
161-04 Jamaica Avenue
Jamaica, NY 11432
(718) 658-7400
One-year residency plus an $8,000 stipend for Brooklyn or Queens residents

New York Experimental Glass Workshop
647 Fulton Street
Brooklyn, NY 11217
(718) 625-3685
Supplies materials

Painting Space 122, Inc.
150 First Avenue
New York, NY 10009
(212) 228-4150

The Studio Museum in Harlem
Artist-in-Residence Program
144 West 125th Street
New York, NY 10027
(212) 864-4500
One-year residency plus a $13,000 stipend; artists must spend at least 20 hours per week in their studios and conduct two public workshops

Visual Studies Workshop
31 Prince Street
Rochester, NY 14604
(716) 442-8676
Supplies all materials

NORTH CAROLINA

Penland School
Penland, NC 28765
(704) 765-2359
One- and two-year residencies, charging $100 per month for studio space and accommodations

OREGON

Oregon School of Arts & Crafts
Summer Residencies for Mid-Career Artists
Program
8245 Southwest Barnes Road
Portland, OR 97225
(503) 297-5544
Ten-week program includes $1,200 fellowship, free on-campus housing, studio space, travel allowance and budget for materials and shipping completed work

Sitka Center for Art and Ecology
Neskowin Coast Foundation
Artist-in-Residence Program
P.O. Box 65
Otis, OR 97368
(503) 994-5485
Four-month residencies include accommodations and studio space in exchange for 20 hours per month of workshops

PENNSYLVANIA

Brandywine Workshop
730–32 South Broad Street
Philadelphia, PA 19146
(215) 546-3657
Week-long residencies for printmakers, including free room and board, travel allowance and a small stipend. Brandywine keeps half of an artist's print run.

Chester Springs Studios
P.O. Box 329
Chester Springs, PA 19425
(215) 827-2722
Three-week residencies (mid-August to early September), principally for ceramicists, including studio and living space, a firing allowance up to $300 and a stipend of $600

The Clay Studio
Evelyn Shapiro Foundation Fellowship
139 North Second Street
Philadelphia, PA 19106
(215) 925-3453
One-year residency, including $400 monthly stipend, materials and firing allowance, access to glaze materials and opportunity to exhibit work in the Studio's gallery

The Fabric Workshop
1100 Vine Street
Philadelphia, PA 19017
(215) 922-7303
*Supplies all materials and an honorarium;
off-site accommodations are available*

Mattress Factory
500 Sampsonia Way
Pittsburgh, PA 15212-4444
(412) 231-3169
*Mattress Factory is a museum that commis-
sions artists, who live (free housing, some
meals, cost of transportation) and work (free
materials) in residence while the piece is in
progress. These residencies last between two
weeks and two months, and a small stipend
is offered*

Moravian Pottery and Tile Works
Swamp Road
Doylestown, PA 18901
(215) 674-0161
*Apprentices work 24 hours per week in
exchange for an hourly wage, studio space,
and the use of materials and facilities for
their own work*

Wood Turning Center
Box 25706
Philadelphia, PA 19144
(215) 844-2188
*Six- to eight-week residencies (free housing
and transportation) with a stipend of $350
per week*

SOUTH CAROLINA
Oyotunji African Village
P.O. Box 51
Sheldon, SC 29941
(803) 846-8900
*One-month residencies that include
accommodations and use of studio in
exchange for community (cultural) work*

TENNESSEE
Arrowmont School of Arts & Crafts
Residence Program
P.O. Box 567
Gatlinburg, TN 37738
(615) 436-5860
*Use of equipment in exchange for 10 hours
per week of work and a $175 monthly
housing and studio fee*

TEXAS
Glassell School of Art
The Core Program
5101 Montrose Boulevard
Houston, TX 77006
(713) 639-7500
Up to $400 per month stipend

Southwest Craft Center
Visiting Artist Program
300 Augusta Street
San Antonio, TX 78205
(210) 224-1848
*Artist-in-Residence and Visiting Artist
programs; negotiable honorarium, travel and
meal money, accommodations, use of studio
and equipment; project grant up to $5,000;
qualified local artists eligible for free studio
space*

VERMONT
Vermont Carving Studio and Sculpture
Center
P.O. Box 495
West Rutland, VT 05777
(802) 438-2097
*Room, meals, studio space, and free stone
provided in exchange for teaching students
during the summer months*

WASHINGTON
Pilchuck Glass School
Emerging Artist-in-Residence Program
1201 316 Street, N.W.
Stanwood, WA 98292-9600
(360) 445-3111
*Eight-week program includes a $1,000
stipend, housing, studio space and access to
kilns*

Pratt Fine Arts Center
Inner City Artists Residencies
1902 South Main
Seattle, WA 98144
(206) 328-2200
*One-month residencies with a $750 stipend
for Washington state residents*

CANADA
Canada Council
350 Albert Street
P.O. Box 1047
Ottawa, Ontario K1P 5V8
Canada

(613) 237-3400; (800) 263-5588
Live-work studio space in Paris, France for up
to 12 months ($330 Canadian per month
rental fee), with a $2,000 per month stipend.

A small number of the 375 national parks in the United States have artist-in-residence programs, allowing composers, filmmakers, painters, performers, photographers, sculptors, video artists and writers to work and live for a period of time within the parks. They are:

Acadia National Park
Artist-in-Residence Program
P.O. Box 177
Eagle Lake Road
Bar Harbor, ME 04609
(207) 288-5459
Residency period: May or early June to
September or October

Apostle Island National Lakeshore
Artist-in-Residence Program
Route One, Box 4
Bayfield, WI 54814
(715) 779-3397
Residency period: late June to mid-
September

Cape Cod National Seashore
Provincetown Community Compact, Inc.
P.O. Box 819
Provincetown, MA 02657
(508) 487-3684
Residency period: July to mid-October

Golden Gate National Recreation Area
Residency Manager
Headlands Center for the Arts
944 Fort Barry
Sausalito, CA 94965
(415) 331-2787
Residency period: throughout the year

Isle Royale National Park
Artist-in-Residence Program
800 East Lakeshore Drive
Houghton, MI 49931-1895
(906) 482-0984
Residency period: June to early September

Rocky Mountain National Park
Artist-in-Residence Program
Estes Park, CO 80517
(303) 586-1399
Residency period: mid-May to mid-
September

Saint-Gaudens National Historic Site
Chief of Interpretation
R.R. 3, Box 73
Cornish, NH 03745
(603) 675-2175
Residency period: June to October

Sleeping Bear Dunes National Lakeshore
Artist-in-Residence Program
9922 Front Street
Empire, MI 49630
(616) 326-5134
Residency period: mid-September through
October

Yosemite National Park
Yosemite Renaissance, Inc.
P.O. Box 100
Yosemite National Park, CA 95389
(209) 732-4946
Residency period: throughout the year

Studio Space for Craftspeople

Graduating art school often comes as a slap in the face to many young artists and craftspeople. Usually leaving without a plan for how to pursue a career as an artisan, students leave behind a world in which they had free studio space and use of expensive equipment, time to develop their techniques, fellow students with whom to share ideas regularly and professional artisans-instructors who paid serious attention to them. They enter a world of high rents, small apartments and low-paying jobs that may have little to do with their skills. Professional craftspeople they encounter may have little interest in, or time to spare for, a mentor relationship, and fellow beginner craftspeople are only likely to offer their own tough-luck tales, of not knowing how to meet the right people, of wanting a better-paying job, of having little money, time or space in which to create their work.

Getting a career started is perhaps the most difficult problem art school graduates face. One possibility that offers some rewards—and perhaps a drawback here or there—is to work as an assistant or apprentice to a professional craftsperson. Working for an established artisan enables young craftspeople to learn both technical skills (for instance, how to blow glass, throw clay or solder metal in a particular manner as well as how to use certain tools or machinery) and career lessons (how to bargain with a dealer, how to apply for a grant, how to organize one's time and inventory, and how to submit work for a juried competition). Assistants are also able to meet collectors, critics, dealers and other artisans—fellow apprentices as well as colleagues of their employer—as well as to create objects (albeit someone else's) every day in a professional studio.

The pay is often not high (starting salaries are not far removed from minimum wage), and health insurance is a rarity. Frequently, the work is more menial than artistic, such as cleaning the studio, crating work and making telephone calls to suppliers or movers, and one's artistic input is only permitted within certain narrow parameters.

Most people who work as artisans' assistants are in their early- to mid-20s, staying for between a few months and five, six or even ten years. They generally obtain these jobs through recommendation, such as from an another professional craftsperson, although some art schools place their students in an artist's studio as part of their degree program.

At other times, artists may be approached directly about taking on an assistant. Jonathan Winfisky, who had previously worked for glassblower Charles Correll by simply calling him up on the telephone, began working

for Josh Simpson after reading a help wanted advertisement that began "Glassblower Needs Assistant. . . ."

Over the years, craftspeople like Josh Simpson and Charles Correll have seen dozens of young assistants come and go. Less than half of these assistants go on to set up their own professional studios; others bounce from one person's studio to another, perhaps renting space here or working as an assistant there, depending upon their financial situation that month. Only rarely do professional craftspeople know what became of their former assistants, which suggests that making and using contacts to further one's career is only a slight possibility. Apprenticeship is clearly not a sure ticket to success; rather, artisans' assistants need both to help the artist—the job for which they were hired—and to learn by the artist's example, identifying which factors enable the artist to achieve success both in a work of art and in a career.

Those lessons may be varied. Peggy Cochrane, who had worked as a dental technician and a furniture maker, claimed that she learned "all the processes and a little bit about design" through an apprenticeship with New Orleans jewelry-maker Tom Mann from 1989 to 1993. Robert Dane, a glassblower in Heath, Massachusetts, who worked for Josh Simpson from 1978 to 1982, stated that he learned "how to deal with galleries, how to set up a business, a lot about marketing. I met different gallery people and made associations with them." He added that "from working for Josh I also learned what I didn't want to do. I didn't want to be a production glassblower, making the same thing day after day, every day. Doing production work eight hours a day, 40 hours a week is very boring."

Charles Correll learned both Italian methods of glassblowing from Michael Nourot, for whom he was an assistant from 1974 to 1976, and techniques for building glassblowing furnaces. That latter skill has been quite useful in Correll's career, as half of his income is derived from building and installing furnaces for individuals and institutions. "I needed to build an efficient furnace that would cut my gas bill in half," he stated.

Frequently, assistants learn their lessons all too well, as their own artwork comes to resemble that of their craftsperson-employer, and a break in the relationship for the assistants is necessary to fully emerge as expressive artisans in their own right. That problem is to be expected in some degree, as it is the job of the assistant who works directly on the work to understand and replicate what the artists mean. "What I learned as a journeyman glassblowing assistant," said Mark Weiner, "is that the customer is always right, and by customer I mean the person I'm then working for. They want

something done in a particular way, I do it that way, regardless of whether or not I could do it a lot better in a different way." All craftspersons' assistants need to keep in mind what their role is, not to indulge in self-expression but to carry out another artist's plans. Remember, though, after a full day of adopting a specific style or approach, it may be difficult to settle down to one's own style or technique of work.

Craftspeople who are in the position to hire apprentices (who must be trained in the fundamentals of the mechanical process) or journeymen assistants (who come skilled and generally require less direction or supervision) claim that they look for three things in an employee. The first is whether or not the potential assistant is self-motivated, interested in the particular field and mature about taking on responsibilities. The second concern is whether or not these two artistic egos work together efficiently. "There is a tacit understanding that most, if not all, of my assistants want to open their own studios," Josh Simpson said. "On occasion, that has led to tensions. There was one person—I call him the Ultimate Graduate Student, because he had gone to grad school—who believed that his work was incalculably more important than my work and that some malevolent God had put him in my employ."

These first two expectations can be a very tall order to fill: Assistants who can ultimately work in another's style, and yet not forget that it was the desire to create their own work in this medium that brought them to work for someone else in the first place are hard to find. Perhaps, this is the reason that most assistants do not stay very long with a particular artist. "At a certain point," Winfisky stated, "I just wanted to stop doing Josh's work and start doing my own. I just had to leave." The more established an artisan is, the less likely he or she will want an ongoing turnover of assistants, each of whom stays a year or two or less.

The third criterion that craftspeople look for in assistants is "longevity," Tom Mann said. "I hire people who are going to be with me for a long time, by which I mean at least four years, and have little or no interest in setting up their own studios. As a business owner, I can't afford to bring someone along who plans to leave soon. I've made that investment in them."

Mann noted that he generally has 14 or 15 studio workers and that there is a turnover of five or six people every year. In order to limit turnover, he stated that he often hires "people who have invested in the area, who have families and homes, and I try to keep them happy with vacation pay, bonuses, paid birthdays."

For the ambitious apprentice or journeyman-assistant, working for someone else may have inherent time-limitations. Randall Darwall, a weaver on Cape Cod, Massachusetts, who employs an occasional apprentice as well as subcontracts home work to several part-time skilled weavers, said that he is "surprised by anyone who works for me for more than two or three years. After the excitement of working with all these colors wears off, the actual work becomes less satisfying after a while. It seems all too mechanical, and there's nothing I can do about it." He added that weaving at home is "lonely work. When people who work for me bring their work in, they tend to linger a while, wanting to talk about this or that. I have to shuffle people in and out, because I still have a lot to do."

Some master craftspeople also find that there are risks in developing too close a relationship with their assistants and employees, for instance, even asking an assistant personal questions is risky, as that action may be reciprocated. Established artists may prefer that their employees not know potentially compromising information about themselves. Josh Simpson said that "in recent years, I've developed more clearcut employer-employee lines. I used to be involved in a friendship way with the people working here, but not so much anymore." One reason that craftsman-apprentice relationships may not become personal is that certain jobs that may be assigned to an assistant are "contrary to friendship, such as telling someone to sweep the floor," Simpson added. Younger craftspeople may assume that they will have an intense, even collegial, relationship with the artisans for whom they are working compared to a traditional employer-employee situation, and those upset expectations may lead to tensions in the studio.

Another assumption that younger craftspeople may have is that they will be able to use the tools and machinery in the established artisan's studio for their own work. Considering the fact that setting up a studio, regardless of how handy the craftsperson is, may cost thousands of dollars, it is not unexpected that a young artisan will have plans to use the equipment in an employer's studio. Sometimes, the established craftsperson will permit it; sometimes not. Some artisans will more subtly discourage this activity by strongly limiting the amount of time or days in which the studio may be used or by charging an hourly rate for using studio machinery or by allowing only certain, long-term assistants to use it. "The practical reality of today is that I'm less willing to help employees set up studios of their own," Harry Bessett, a glassblower in Hardwick, Vermont, said. "I'll substitute more pay for blowing time in the studio." Permission to use the studio and on what terms

as well as a number of other hopes on the part of the would-be apprentice should be discussed before the young artisan agrees to work in the studio.

Many assistants also discover that there are drawbacks to becoming closely identified with another craftsperson. Even when the younger artisans sets up their own studios, they may still be regarded as someone else's protege. Josh Simpson himself has two views on the long-term value of apprenticing. On the one hand, he stated proudly that "my studio has spun off 10 other glass studios," but added that he largely taught himself the art of glassblowing. "I'm rather proud of the fact that I learned independently and am not beholden to someone. No one can point to me and say, 'That's the young protege of so-and-so."

While apprenticeships are not a particularly lucrative activity, they are encouraged through project grants by a number of state arts agencies around the United States (see chapter 5). Most of these subsidized apprenticeships are for "folk arts" or the "traditional arts," terms which are rather broad in themselves and not defined by most of the agencies. In general, apprenticeships are understood as the transferring of skills from a master artist or artisan to an apprentice, without much fussiness about how contemporary the resulting work may look. Some programs focus strongly on either traditional styles or the ethnicity of the applicant.

There are alternatives to either setting up one's own studio or working for another craftsperson. One popular approach is to rent someone else's studio for a limited period of time in which to create pieces for particular shows or to fill orders. The cost of a studio rental ranges from $150 to $250 per day, depending upon the location of the studio, the amount of materials that will be used, and the demands that will be placed on the studio.

Some craftspeople advertise the availability of their studios, while most artisans discover studios with the appropriate tools and equipment by word-of-mouth.

"Not everyone wants to set up his or her own studio," said Mark Weiner, owner of Watermark Glass in Brattleboro, Vermont and a co-owner of Martha's Vineyard Glasswork in Massachusetts. "With your own studio, you've got the mortgage and the price of fuel and maybe employees' salaries. All that overhead pressures you into constantly producing something that you may get tired of making instead of seeing and trying new things."

The opportunity to see and try new things may come from working as a journeyman assistant to several different craftspeople, all of whom have somewhat different techniques and ideas about design and their medium.

Weiner stated that "if you've only worked for one person as an apprentice and not for others as an assistant, you only have one source of information. People who haven't had more than one experience are more exposed and vulnerable when the market goes through a shake-up."

Other opportunities to experience different styles and techniques are available at certain schools, art centers (where workshops for serious craftspeople are regularly held) and artist communities (where studio space as well as food, accommodations and a stipend are available). These include:

ARIZONA

Roberto-Venn School of Luthiery
4011 South 16th Street
Phoenix, AZ 85040
(602) 243-1179
Courses in guitar construction

CALIFORNIA

Baulines Crafts Guild
Schoonmaker Point
Sausalito, CA 94965
(415) 331-8520
Weekend workshops in furniture-making, woodworking, textiles, ceramics, glass design, goldsmithing, papermaking and other crafts as well as an apprenticeship program

Clay in L.A.
2401 Wilshire Boulevard
Los Angeles, CA 90057
(213) 251-0550
Six-week workshop in ceramics

College of the Redwoods
Fine Woodworking Program
440 Alger Street
Fort Bragg, CA 95437
(707) 964-7056
Two- and four-week workshops in wood-working

The Day Studio Workshop
1504 Bryant Street
San Francisco, CA 94103
(415) 626-9300
One-, two- and three-week workshops in surface finishing

Fenton and Gaines Glass Studio
4001 San Leandro Street, Suite 8
Oakland, CA 94601
(415) 533-5515
One- to four-day glassworking workshops

Gemological Institute of America
Dept. PROI, P.O. Box 2110
Santa Monica, CA 90407-2110
(800) 421-7250, ext. 227
(213) 829-2991, ext. 227
Courses in jewelry-making

Mendocino Arts Center
Box 765
Mendocino, CA 95460
Workshops

Revere Academy of Jewelry Arts
760 Market Street , Suite 939
San Francisco, CA 94102
(415) 391-4179
One- to five-day workshops in jewelry-making

The School of Classical Woodcarving
10 Liberty Ship Way, Suite 4116
Sausalito, CA 94965
(415) 332-7563
Courses in woodcarving and gilding

COLORADO

Anderson Ranch Arts Center
P.O. Box 5598
Snowmass Village, CO 81615
(303) 923-3181
Workshops in woodworking, furniture design and ceramics

CONNECTICUT

Guilford Handcrafts, Inc.
P.O. Box 589
411 Church Street
Guilford, CT 06437
(203) 453-5947
*One- to five-day workshops, including a
master class series, in metals, jewelry, glass,
fiber arts and ceramics*

DISTRICT OF COLUMBIA

Handweavers Guild of America
c/o Weavers Guild of Minnesota
2402 University Avenue
St. Paul, MN 55114
*12-day conference, with demonstrations and
hands-on sessions, in fiber arts*

International Sculpture Center
TECHshops
1050 Potomac Street, N.W.
Washington, D.C. 20007
(202) 965-6066
*Three-day workshops held in various
locations around the United States*

GEORGIA

Callaway School of Needle Arts
Callaway Gardens
Pine Mountain, GA 31822
(800) 282-8181
Five-day sessions

KENTUCKY

The Embroiderers' Guild of America, Inc.
335 West Broadway, Suite 100
Louisville, KY 40202
(502) 589-6956
Five-day seminars in embroidery

MAINE

Haystack Mountain School of Crafts
Deer Isle, ME 04627-0087
(207) 348-2306
*One- to three-week sessions in ceramics,
fibert arts, glassblowing, metalworking,
woodworking, papermaking, baskets,
quilting and other crafts*

Watershed Center for the Ceramic Arts
RR 1, Box 845
Cochran Road
North Edgecomb, ME 04556
(207) 882-6075
*Assistantships, residencies and a visiting artist
program*

MARYLAND

Baltimore Clayworks
5706 Smith Avenue
Baltimore, MD 21209
(301) 578-1919
Residencies in ceramics

MASSACHUSETTS

Worcester Center for Crafts
25 Sagamore Road
Worcester, MA 01605
(508) 753-8183
Workshops and courses

MICHIGAN

Pewabic Pottery
10125 East Jefferson Avenue
Detroit, MI 48214
(313) 822-0954
Ceramics workshops

MISSOURI

The Weavers' School
Route One
Fayette, MO 65248
(816) 248-3462/2630
Week-long classes in weaving

MONTANA

Archie Bray Foundation
2915 Country Club Avenue
Helena, MT 59601
(406) 443-3502
Workshops

Grimmstone Pottery
2524 Sycamore
Missoula, MT 59802
(406) 543-7970
Workshops and residencies

NEVADA

Tuscarora Pottery School
P.O. Box 7
Tuscarora, NV 89834
(702) 756-6598
Two-, four- and six-week workshops

NEW JERSEY

Creative Glass Center of America
P.O. Box 646
Millville, NJ 08332-0646
(609) 825-6800, ext. 2733
Paid residencies

Machine Knitters Exchange
75 Elycroft Parkway
Rutherford, NJ 07070
(201) 438-1857
One- to three-day workshops

Peters Valley Craft Center
Layton, NJ 07851
(201) 948-5200
Workshops and residencies

NEW YORK

Alpat Stained Glass Studio
57 Front Street
Brooklyn, NY 11201
(718) 625-6464
Two-day workshops and studio space rental

The Center for Tapestry Arts
167 Spring Street
New York, NY 10012
(212) 431-7500
Two- to five-day workshops

The Cooperstown Textile School
P.O. Box 455
Cooperstown, NY 13326
(607) 264-8400
Two- and four-day workshops

Dieu Donne Papermill, Inc.
3 Crosby Street, Fifth Floor
New York, NY 10013
(212) 226-0573
Classes, workshops, apprenticeships, studio space

Greenwich House Pottery
International Center for the Ceramic Arts
16 Jones Street
New York, NY 10014
(212) 242-4106
One- to five-day seminars

Studio Workshop for the Art of the Painted Finish
177 East 87 Street
New York, NY 10028
(212) 348-4464
Two-week courses in finish painting for furniture and decorations

Pratt Institute School of Professional Studies
200 Willoughby Avenue
Brooklyn, NY 11205
(718) 636-3453
Short and long workshops on jewelry techniques

Quilting-in-the-Valley
29 Jones Road
Warwick, NY 10990
(914) 986-3680
Three-day seminar

Studio Jewelers, Ltd.
32 East 31 Street
New York, NY 10016
(212) 686-1944
Five-day courses in jewelry repair

Thousand Islands Craft School and Textile Museum
314 John Street
Clayton, NY 13624
(315) 686-4123
One- and two-week workshops

World Glass Congresss
Glass Craft Expo
P.O. Box 69
Brewster, NY 10509
(800) 421-8142; (914) 279-7399
Three-day program with seminars, lectures and workshops

NORTH CAROLINA
Penland School
Penland, NC 28765
(704) 765-2359
*One-, two- and eight-week classes in
ceramics, glass, jewelry, weaving and wood*

Watermark Association of Artisans, Inc.
150 U.S. Highway 158
Camden, NC 27921
(919) 338-0853
Workshops

OHIO
Conover Workshops
18125 Madison Road
Parkman, OH 44080
(216) 548-3491
Workshops in woodworking

CraftSummer
Rowan Hall
Miami University
Oxford, OH 45056
(513) 529-7395
*Workshops include stained glass, quiltmaking
and tapestry weaving*

The Loom Shed School of Weaving
14301 Street, Route 58S
Oberlin, OH 44074
(216) 774-3500

OREGON
Camp Colton Glass Program
Colton, OR 97017
(503) 824-3150
Two-week workshops

Oregon School of Arts and Crafts
8245 S.W. Barnes Road
Portland, OR 97225
(503) 297-5544
*Workshops of varying lengths in ceramics,
fiber arts, metal and woodworking*

PENNSYLVANIA
The Fabric Workshop/Museum
1100 Vine Street, 13th Floor
Philadelphia, PA 19107
(215) 922-7303
*Apprenticeships, internships, residencies and
workshops*

Moravian Pottery and Tile Works
Swamp Road
Doylestown, PA 18901
(215) 345-6722
Workshops and apprenticeships

The Pennsylvania Guild of Craftsmen
P.O. Box 820
Richboro, PA 18954
(215) 860-0731
Weekend-long workshops

Sawmill Center for the Arts
P.O. Box 180
Cooksburg, PA 16217
(814) 927-6665; (814) 744-9670
*Workshops in basketry, quilting, rug braiding
and woodcarving*

Touchstone Center for Crafts
P.O. Box 2141
Uniontown, PA 15401
(412) 438-2811
*Workshops in basketry, ceramics, fiber arts,
glassblowing, metals and woodworking*

TENNESSEE
Appalachian Center for Crafts
Route 3, Box 430
Smithville, TN
(615) 597-6801
*Workshops, certificate programs and
graduate courses*

Arrowmont School of Arts and Crafts
P.O. Box 567
Gatlinburg, TN 37738
(615) 436-5860
*One- and two-week courses in basketry,
ceramics, fiber arts, glass blowing, jewelry
making, metal and woodworking*

TEXAS
Glassel School of Art
Museum of Fine Arts
5101 Montrose
Houston, TX 77006
(713) 639-7500
Workshops and classes

Southwest Craft Center
300 Augusta Street
San Antonio, TX 78205
(210) 224-1848
Workshops and classes

VERMONT

The Carving Studio & Sculpture Center
Marble Street
P.O. Box 495
West Rutland, VT 05777
(802) 438-2097
Workshops of varying lengths, residencies and space rentals

Fletcher Farm School for the Arts and Crafts
RR 1, Box 1041
Ludlow, VT 05149
(802) 228-8770
Workshops in fiber arts, needlework, stained glass and woodcarving

VIRGINIA

Hand Workshop
1812 West Main Street
Richmond, VA 23220
(804) 353-0094

One- and two-day workshops in basketry, ceramics, jewelry making, metalsmithing, quilting, weaving and woodworking

The River Farm
Route 1, Box 401
Timberville, VA 22853
(800) 872-9665
Three- to five-day workshops in dyeing, spinning and weaving

WASHINGTON

Pilchuck Glass School
Artist-in-Residence Program
107 South Main Street, Suite 324
Seattle, WA 98104
(206) 621-8422
Workshops, courses and residencies

CANADA

Bamff Center for the Arts
Box 1020
Bamff, Alberta T0L 0C0
Canada
(403) 762-6180
Workshops

There are many more workshops and schools that teach the technical fine points of craftwork than are listed here. A source of more workshop options and locations may be found in *The Guide to Art & Craft Workshops* (published by ShawGuides, Inc., 625 Biltmore Way, Suite 1406, Coral Gables, FL 33134). Many of the other workshops and courses are taught by individual artisans in their own studios or are part of vacation-time packages for people of all ages and levels of skill.

Another alternative to the expense of setting up one's own studio are crafts "production" cooperatives, of which there are a growing number. "Production" coops are different from "marketing" coops in that their primary focus is not exhibiting and selling work but, rather, producing crafts objects. Start-up costs and ongoing expenses, such as utilities and materials, are not eliminated in these production coops but, rather, reduced by being shared by a group. Bulk orders on behalf of many of the coop members may also lower the costs of one's craftwork.

Working in a group situation may not satisfy everyone, of course. There are likely to be meetings to attend and the assignment of shop duties, such

as clean-up or repairing equipment or excursions to buy supplies or just manning a desk for a certain number of hours per month. In addition, if there are a number of potters and only one kiln, a waiting list will be created, and one's position on it may need to be negotiated. Storage space may also be limited. However, there are other benefits to a production studio than simply lowering one's expenses. In cooperatives of all types, one often finds a strong sense of comraderie and a sharing of artistic ideas and technical information. Among these coops are:

ALABAMA
Freedom Quilting Bee
Route One, Box 43
Alberta, AL 36720
(205) 573-2225

CONNECTICUT
Wesleyan Potters, Inc.
350 South Main Street
Middletown, CT 06457
(203) 347-5925

NEW MEXICO
Okeoweenge Crafts Association
P.O. Box 1095
San Juan Pueblo, NM 87566
(505) 852-2372

WASHINGTON
Pottery Northwest
226 First Avenue North
Seattle, WA 98109
(206) 285-4421

WEST VIRGINIA
Cabin Creek Quilts Cooperative
4208 Malden Drive
Malden, WV 25306
(304) 925-9499

Studio Space as Fishbowl

The benefits of artist-in-residence situations are obvious: There is no rent to pay, and one is respected for being an artist. The drawback, of course, is that the studio is actually on loan and will go to another artist after one's residence term is up. Around the United States, there are a number of buildings that have been turned into artist studios—in some cases, both living and working space—by individual artists, arts groups, or by municipalities.

In New York City, whole neighborhoods became artist living-working communities, starting with A.I.R. (Artist-in-Residence) occupancies in buildings in lower Manhattan. The A.I.R. designation, permitted in two spaces per building in order to let the fire department know which tenants might need to be rescued in an after-hours fire, was followed in the 1960s by redistricting the SoHo and NoHo (South of Houston Street, North of

Houston Street) areas as eligible for residential use by certified artists. A bold move that protected vacant factory buildings otherwise slated for demolition as well as providing some stability in the lives of artists, the experiment proved almost too successful. Artists rejuvenated SoHo to such a degree that, by the 1970s and '80s, many of them were priced out of the very buildings they had renovated by developers who rented or sold the spaces to more affluent city dwellers happy to find larger living quarters. Pleased with the rapid rise in real estate values and taxes, city officials were unwilling to enforce the artists certification process of the SoHo-NoHo zoning regulations that protected artists. The same scenario of artists "pioneering" loft space that they would later be forced out of affected artists in Boston, Chicago, and elsewhere.

The effort to secure affordable working (and living) space for artists took a different direction after this experience. Instead of relying on broad zoning ordinances, artists and arts groups have worked with city officials to manage specific buildings—frequently, abandoned factories and public schools—as single- or multiuse arts spaces. These city officials have responded well, in many instances, assisting in the costs of renovation and paying for administrators. In addition, city-sponsored artist-studio units generally charge subsidized rents.

This generosity does not come without some cost to the artist. Many city-sponsored artist studio buildings also are open to the public as a tourist attraction, allowing serious collectors and anyone who is curious to peek in and see what an artist is currently doing.

"Studio tours" are not, in themselves, a brand-new idea in the art world, and traditionally they have come in different varieties. Art dealers, for instance, regularly set up dates to bring potential buyers to the studios of the artists they represent, recognizing that a personal connection between artist and collector may advance a sale. Whereas in the past, artists were often thought of as slightly disreputable characters, more and more, moneyed collectors want to have artists as part of their circle of acquaintances. For many, there is a romance about buying from the artist. "A lot of collectors want to know the artist behind the art," said Arthur Dion, director of Gallery NAGA in Boston, "and we may arrange to bring the collector to the artist's studio." Janelle Reiring, director of New York's Metro Pictures, also occasionally arranges studio visits in order to satisfy curious buyers, since "collectors generally know that artists are somewhat colorful personalities."

"Some collectors boast that they get their paintings directly from the

artist," Christopher Watson, one of the directors of New York's Nancy Hoffman Gallery, said. "They feel like they have some inside scoop."

At times, Watson added, "a visit to the studio tends to bolster enthusiasm for buying the artist's work." However, that is not always the case. According to Christopher Addison, director of the Addison/Ripley Gallery in Washington, D.C., some collectors "get turned off buying the artist's work after meeting the artist. We represent some fairly abrasive artists, and some of our collectors have a particularly imperious manner. The chemistry is all wrong, and it is a great embarrassment to bring together people who obviously won't get along."

Some artists also don't want to be bothered in their studios by collectors, especially ones with whom they do not have a long and personal relationship. "For me, it depends upon who the people are and why they've come," painter Pat Steir said. "Some people just want to look at my work and see my studio. Someone thinks it sounds fun to meet the artist. I don't let people I don't know come into my studio and see unfinished work."

Many museums of contemporary art arrange studio tours for their members as part of membership services, and the artist may receive a small payment (perhaps, $50 or less) for what amounts to between 30 and 45 minutes of talking about their work and answering questions. Private companies, such as Art Tours of Manhattan or Art Tours of New Jersey, as well as public schools, also make similar arrangements with artists to bring a group to their studios for a talk-to-the-artist session.

There are also one-day events, in which artists in a certain city or a section of town open up their studios to the public for, say, six hours. The "Artists' Studio Tour" in Hoboken and Jersey City, New Jersey, and "Open Studios" in the South End of Boston, both of which take place annually in October, are examples of these.

Of course, it may be a very different experience to have visitors stop by once a year than as a regular occurrence, and artists must be prepared for the trade-off of low rents for frequent intrusions. The idea for turning the city-owned Torpedo Factory into artists' workspace, on the other hand, was developed by artists in 1974 but was paid for by the city of Alexandria, Virginia, in the amount of $140,000 in renovation costs as a tourist attraction. The Torpedo Factory currently receives more than 800,000 visitors per year, second in the entire state of Virginia only in attendance to Mount Vernon. The city currently pays for all staffing (a director and two assistants), operating costs (heat, light, power, water, building maintenance,

even toilet paper), and subsidizes half of the fair market rent for the artists.

The building is open to the public seven days a week, 360 days per year, 49 hours per week (from 10:00 A.M. to 5:00 P.M.), and artists are required to be present and working in their studios at least 24 of those 49 hours. Steve Majors, director of the Torpedo Factory, added that another rule for artists there is that "85 percent of a particular piece of art has to be done here. You can't just do the work at home and bring in pieces at the later stages. We are an educational facility, and we want to show the process of making art. We don't want artists sitting around, telling visitors, 'This would look great in your bathroom.' We're not a mall, filled with cute boutiques. These are artists' studios where artists work."

Many artists see open studios as an opportunity to talk with people who are not other artists or dealers or the usual collectors about their art, which they claim is refreshing. "You get a spontaneous reaction from people who aren't the regular art gallery types," said Esther Eder, a painter who has taken part in Boston's "Open Studios" for a number of years. "For a lot of the people who come in, it is a real outing, an adventure, to see an artist's studio, and they will say things to you that no one else will say. That helps to break the isolation of the artist."

Similarly for China Marks, a Hoboken artist who works in a variety of two- and three-dimensional media, the "Artists' Studio Tour" is "as educational for me as for the visitors. There may be something in a work that upsets people that I thought was funny, and it makes me realize that I have to make my intentions clearer. Someone may point out something in a drawing, for instance, that I hadn't seen before, and that adds to the resonance of my work."

Artists, of course, are not wholly selfless, living with intrusions by strangers solely in order to educate the public or add to the tourist industry. Rather, they hope to sell their work to the people who walk through. Opening the studio has a mixed record of generating sales around the country where it has been tried in one form or another, and it may not be an appropriate marketing strategy for everyone.

Both Elizabeth Cahill, president of the board of directors of South End Artists, which organizes the "Open Studios" event in Boston, and Margaret Schmidt noted mostly smaller pieces priced under $100 sell at open studio events. Even in artists' studio buildings that are open regularly to the public, sales are often of the less expensive items, although there are more occasional purchases of higher-priced artworks. "I have a lot of matted

drawings in a bin, priced in the $75–$200 range," said Ann Salisbury, a painter with a studio in Artspace, a city-owned artist studio complex in Raleigh, North Carolina. "Those tend to be the pieces that sell the best."

Low prices and few overall sales should come as no great surprise. Any established art dealer knows that walk-ins are the least likely collectors, certainly the least likely to spend large amounts of money on impulse. Artists seeking sales of their work may find relying on art dealers to be a more successful strategy. In addition, artists who are approached directly may take great offense at being "low-balled" by a potential collector; dealers are used to negotiating price without taking underbids personally.

Collectors and dealers may have more natural affinities than do artists and collectors. For artists far more than for those who buy their work, art is central to their lives; it may also be their only source of income, limiting their willingness to concern themselves with a buyer's budget. Collectors and dealers, on the other hand, are united by the enjoyment of original artworks around them and more frequently by having business backgrounds. In addition, few collectors or dealers limit themselves to the work of just one artist, developing a range of art objects to buy and sell. It may offend some artists to listen to a collector discuss an artist or type of art that is stylistically or conceptually far removed from their own.

Dealers sometimes arrange for collectors to pay for works on an installment plan, perhaps accepting another artwork or valuable object (such as jewelry) in lieu of money, whereas artists—who may have incurred major expenses creating the piece or are behind on the rent—look to be paid up front in full and in cash. "Dealers know how to get money that is owed to them," Marsha Perry Mateyka, owner of the Marsha Mateyka Gallery in Washington, D.C., said. "Many artists have had trouble collecting money owed to them. A collector puts down a deposit and takes the piece, and the artist never receives the rest. Artists generally haven't a clue what to do about it."

Most dealers find that the majority of their collectors show only a limited amount of interest in knowing who the artist is or in meeting that person— for example, attending an exhibition opening where the artist will be present—believing that what the artist has to say is best stated through the artwork itself. "Eighty percent of our collectors never ask a question about the artist," Ivan Karp, director of New York's O.K. Harris Gallery, said. "When I'm talking about a certain work, I may describe the artist as a fine person, add some plaudits to help enhance the sale, but collectors generally buy the work, not the creator."

Artists who open their studios for a one-day event usually recognize that they are introducing themselves to strangers, a small percentage of whom may eventually become one-time or long-term buyers. Artists at these events are glad for any sales that take place and otherwise take down names and addresses for their rolodexes, with the idea that those walk-ins who showed any interest in their work will be notified of upcoming exhibitions.

"On a bad day, I'll have 250 people come through my studio," China Marks said. "A lot of them ask to be put on my mailing list. I've had people come to my studio on that day and buy my work when it's in a gallery or museum show. Someone who visited my studio later opened a gallery and wanted to give me a solo show. I look at studio tours as being like billiard balls striking, and you don't know what kinds of collisions will take place in the future."

In the city-owned artists' studio buildings, more sales are likely on the premises because visitors know that they can come back to examine certain pieces again. Because these buildings have regular public hours, they also attract interior designers, art consultants, and other people who are interested in buying artwork for their homes or offices and know that they will find a lot to choose from.

Besides paying rent for their studios, artists in some of these buildings pay a commission on sales, between 25 and 30 percent. Faye Clark, administrator of the McGuffey Arts Center in Charlottesville, Virginia, which houses 14 studios and 22 artists in various media, stated that gross sales of artwork have been slightly more than $90,000 annually during the 1990s—it was in the $120,000 range in the late 1980s. Her salary and payment for the services of a janitor largely come out of a 25 percent commission on sales, the remainder is derived from art classes that the center offers the community. Some of the 22 artists at McGuffey surely earn more than others, but the average is clearly low for all. If the point of working at McGuffey is to benefit from a city-subsidized studio rental—$170 per month for a 20-by-20-foot room, $85 per month for half of a room—artists there may consider themselves doing quite well. The ability to work near other artists dispels the often inherent feeling of isolation in the field and certainly allows everyone to share information about upcoming shows, grant opportunities, or techniques and even to obtain a quick critique of some new artwork. However, if the reason is the sales opportunity afforded by visitors and potential buyers who may come by, the low sales figures of most artists there may be discouraging.

Other reasons that some artists find an open-to-the-public setting not fully to their liking are that it is working in a fish bowl—Artspace's studios are glass-fronted in the hallways—and artists may be subject to frequent interruptions. The Torpedo Factory's rule that at least 85 percent of the works in the studios be completed at the site is undoubtedly designed to ensure that artists don't save all of the more crucial stages of artmaking for the quiet and solitude of their homes. Most other studio complexes of this type require artists to be working in their studios for a certain prescribed amount of time every week. Artists who frequently work on location, or who need machinery that is either too large for or not available at the studio, may have a difficult time keeping their hours.

Ann Salisbury noted that "some phases of my work just couldn't be done" at Artspace. "I do the beginnings of things at home, because it takes me a long time to start, and I wouldn't want to be interrupted. Often, I do drawings and watercolors at Artspace and do acrylics at home." Marge Alderson, who has had a studio at the Torpedo Factory since it was first opened, also stated that "I do my designing in the morning before the doors open up and the people come in. I need my quiet time." The desire to show the public the process of making art and an artist's own artmaking processes may periodically conflict. The problem is fraught with so much tension at Berkshire Artisans in Pittsfield, Massachusetts, which has 10 studios, that artists there permit their studios to be open for tours only once every two or three years. "The subject of tours is kind of touchy with artists here," said Dan O'Connell, Berkshire Artisans' artistic director.

Besides working in their studios a certain prescribed number of hours and (another rule most studio complexes enforce) being cordial and willing to talk about their work with tour groups and passers-by, artists must also serve on committees, such as a gallery or standards committee. There are benefits of being part of an artists' community, and drawbacks, too.

Selling From One's Studio

Another potential problem for artists is that many art dealers are not happy with the idea of the artists they represent competing with them for sales. Those artists in studio complexes who have dealer or gallery representation must work out their own agreements in this area. In some cases, artists in these studios have arrangements with dealers that do not name the dealers as the exclusive selling agent for the artists; in other instances, the dealers do not take a commission on studio sales. Having to pay a commission both

to one's dealer and, in some cases, to the studio complex would convince most artists either to drop the dealer or drop out of the studio. Since a large percentage of the pieces that sell to visitors tend to be in the lower-priced range, artists are likely to either lower their prices below what dealers charge or forego paying a commission entirely.

As a rule, artists should never undersell their dealers. "If you want to establish and maintain a good relationship with a dealer, you don't cut his throat," said Calvin J. Goodman, an artists' advisor and author of *The Art Marketing Handbook.* However, some artist–dealer issues are less clear-cut, especially when the artist also sells his or her work directly.

For instance, dealers frequently, or even regularly, offer discounts off the stated price—usually, 10 percent—to encourage potential buyers. Is it equally permissible for the artist selling out of his or her studio to offer the same percentage discount?

Artists and their dealers tend to have opposing views on this. Painter William Beckman, noting that "dealers wouldn't have a job, wouldn't exist, without artists," stated that "it is just as viable for the artist to sell work with a discount as the dealer." On the other hand, Gilbert Edelson, administrative vice-president and counsel of the Art Dealers Association of America, said that "a discount by the artist undercuts the dealer, even if the discount and the final price is the same as what the collector would get at the gallery. Collectors talk to each other, 'Don't buy from the dealer. You'll get a better price from the artist.' This hurts the dealer and eventually the artist, when the dealer decides he no longer wants to handle the artist because the artist has become his competitor. Artists should tell people who want to buy their work directly, 'I don't sell from my studio. You should go to my dealer.'" In general, the only time that artists might sell work at a larger discount would be to their dealers, known as a trade discount, which may be as large as 40 or 50 percent, in effect the regular gallery price minus the regular dealer commission.

No less thorny is the question of whether or not an artist owes his or her dealer a commission on the sale of a work from that artist's studio. For instance, a work is exhibited in the dealer's gallery and then returned to the artist; if someone who may have seen that work on display approaches the artist directly to purchase it, is the dealer owed a commission?

Again, artists and dealers view this issue differently, although there is no unanimity of opinion on either side. "If the dealer can't sell it," painter Gregory Gillespie said, "I wouldn't owe him anything," while sculptor Alice

Aycock stated that "I would owe the dealer a commission, but maybe not the full 50 percent. I would try to figure out what the dealer has done and what I've done, basing the amount of the commission on that."

However, George Adams, co-owner of New York City's Frumkin/Adams Gallery, took the view that the dealer is owed the regularly agreed-upon commission because "the sale would not have been made but for the patronage of the gallery. A gallery provides all kinds of support services as well as a forum for presenting the artist's work, and the dealer would rightly expect that these costs would be paid for by the commission."

At times, an artist who is in a long-standing relationship with a gallery or dealer privately sells a work that was never displayed in the gallery, and the commission question arises again. In this instance, most artists tend to agree with Denver, Colorado, artist's advisor Sue Viders that "you shouldn't have to pay a commission on a sale when the dealer had nothing to do with it," although artists who receive a regular (often monthly) stipend from their dealers are more likely to feel an obligation to pay the commission. "I literally owe my dealer money because of the stipend he pays me," Gillespie said. "The dealer has to make up the money he has advanced me somewhere." Dealers themselves, even those who do not pay stipends, consider that some commission may be due them. "The artist's name and reputation was presumably made by the dealer," Gilbert Edelson stated. "But for the dealer's efforts, no one would have tracked down the artist to buy from him or her directly."

The issue of whether or not to pay the dealer's commission, of course, only applies to artists who are not in "exclusive" relationships with their dealers—that is, they have not formally agreed to name the dealer as their sole agent for sales. In some instances, artists write into the consignment agreements with their dealers that collectors whom the artist has personally cultivated are an aspect of the market that fall outside the realm of exclusivity.

In general, artists should discuss these and other issues with their dealers at the beginning of their relationship, formalizing their agreements in either a letter or formal contract, and as circumstances arise. As an example of this kind of negotiation, the artist (who has the final word on the prices for his or her work) sometimes allows the gallery to discount works at a certain percentage but demands that this discount be deducted entirely from the dealer's commission.

Some dealers do far more than others for the artists they represent, of

course, and some artist-dealer relationships seem more adversarial than mutual. In order to minimize direct competition between the two, for instance, many dealers discourage their artists from selling privately in the same market area. In an ideal and a practical sense, the two should be working toward the same goals; the payment of a commission tests this bond as does an artist making direct sales.

"Sales that the dealer may have helped to generate going to the artist leaves a bad taste in the dealer's mouth," Calvin Goodman said. "Artists need dealers; you don't want to jeopardize a situation that puts money in an artist's pocket. You don't want the dealer to find out that something has been taking place behind his back."

Confirming this point of view, Marge Alderson said that "dealers believe that artists at the Torpedo Factory will undersell them for the same work. I have sensed a certain amount of resentment about the Torpedo Factory by dealers and galleries. Dealers have tended to write up strict contracts with artists here in order to prevent being undersold. I personally gave up trying to find gallery representation in Washington [D.C.] because of dealers not trusting Torpedo Factory artists. I'm part of a coop gallery in Washington now."

Not every artist will want to allow visitors into their studios or join a studio complex that makes this interruption mandatory. However, those who have tried it successfully have learned that, for certain buyers, getting to know the artist is often a precursor to a sale, even if the sale doesn't happen immediately. Artwork is made mystical by the art world, too often priced out of the range of most people, talked about in language that is frequently incomprehensible to the lay public, and exhibited in white-washed gallery or museum echo chambers that make many people uncomfortable and nervous about being overheard. A visit to a studio reminds those interested in art that artists are real people whose worksite is sometimes a mess and who are attempting to communicate with the outside world in their own unique ways. It is a simple fact but one that, when put into use, may help artists to sell their work.

A number of buildings around the United States are primarily or exclusively set up for studio or studio-living spaces for artists. In general, they are multidisciplinary, with a variety of artistic media and disciplines found together under one roof. Jan Plimpton, former board president of Artspace Projects and a principal owner of Plimpton and Partners, both of which have developed more than 200 units of artist live-work space in

Minnesota, said that "We don't take a top-down approach. Artists decide things for themselves and handle the problems that arise. We had one unit where someone made knives, and the grinding was hard for some other artists to take, but the artists together decided what hours the knife-maker could do grinding."

Arthouse is a nonprofit organization that provides listings of live-work and studio spaces in Los Angeles, Oakland and San Francisco on a 24-hour basis. Information is updated monthly. The cost for using this service is $10 for a two-month period for members of California Lawyers for the Arts, and $20 for nonmembers. Arthouse is listed below, among a selection of artist buildings in the United States.

CALIFORNIA

Arthouse
315 West Ninth Street, Suite 1101
Los Angeles, CA 90015
(213) 623-5849
 or
Arthouse
P.O. Box 31474
Oakland, CA 94604
(510) 444-6351
 or
Arthouse
Fort Mason Center, Building C
San Francisco, CA 94123
(415) 885-1194

Emeryville Artists Cooperative
1420 45th Street
Emeryville, CA 94608
(415) 655-2880
Studio and living space

Project Artaud
499 Alabama Street
San Francisco, CA 94110
(415) 621-8430
Studio and living space

COLORADO

**Colorado Center for Contemporary
 Art & Craft**
513 Manitou Avenue
Manitou Springs, CO 80829
(719) 685-1861
Studio space

CONNECTICUT

Old Library Art Center
7 Post Road East
Westport, CT 06889
(203) 226-9620
Studio space

DELAWARE

**Delaware Center for the Contemporary
 Arts**
103 East 16th Street
Wilmington, DE 19801
(302) 656-6466
Studio space

DISTRICT OF COLUMBIA

A. Salon, Ltd.
R Street and Avon Place, N.W.
Washington, D.C. 20007
(202) 882-0740
Studio space

Jackson School Arts Center
R Street between 30th and 31st Streets, N.W.
Washington, D.C. 20007
(202) 342-9778
Studio space

Takoma Metro Arts Center
6925 Willow Street, N.W.
Washington, D.C. 20012
(202) 882-0740
Studio space

Bakehouse Art Complex
561 N.W. 32nd
Miami, FL 33127
(305) 576-2828
Studio space

South Florida Art Center
924 Lincoln Road
Miami Beach, FL 33139
(305) 674-8278
Studio space

Towles Court
Morrill and Links
Sarasota, FL 34236
(941) 365-0450

The Arts Exchange
750 Kalb Street, S.E.
Atlanta, GA 30312
(404) 624-4211
Studio space

Nexus Contemporary Art Center
535 Means Street, N.W.
Atlanta, GA 30318
(404) 688-1970
Studio space

Also: Rolland D. Swain
National Parks Service superintendant
Cumberland Island National Park
P.O. Box 806
St. Mary's, GA 31558
(912) 882-4335
*Contact concerning the proposed artists'
retreat at the park.*

Pilsen East Artists' Complex
1831 South Halstead
Chicago, IL 60608
(312) 923-1804
Studio and living space

Also: Artists Incubator
One Artist Row
1809-17 East 71st Street
Chicago, IL 60649
(312) 288-3068
*Contact regarding leasing studio and gallery
spaces, enabling artists to be part of a
marketing cooperative.*

Also: J. Happy-Delpech Foundation
c/o Around the Coyote
1579 North Milwaukee
Chicago, IL 60622
(312) 342-9928
*The J. Happy-Delpech Foundation offers
discounted rental studio space for artists with
AIDS.*

3001 Building
3001 North Jersey Street
Indianapolis, IN 46205
(317) 923-1804
Studio space

Art Center
7381 Florida Boulevard
Baton Rouge, LA 70806
(504) 343-2787
Contact for studios for artists

Artist Housing Cooperative
1442 East Baltimore Street
Baltimore, MD 21231
(301) 675-9807
Studio and living space

Montpelier Cultural Arts Center
12826 Laurel-Bowie Road
Laurel, MD 20708
(301) 953-1993
Holds a studio space competition

Berkshire Artisans
28 Renne Avenue
Pittsfield, MA 01201
(413) 499-9348
Studio space

Boston Center for the Arts
551 Tremont Street
Boston, MA 02116
(617) 426-5000
Studio space

Brickbottom Artists Building
Box C-125
One Fitchburg Street
Somerville, MA 02143
(617) 628-1018
Studio space

**Fort Point Arts Community, Inc. of
 South Boston**
249 A Street
Boston, MA 02210
(617) 423-4299
Studio space

MINNESOTA
Calhoun Building
711 Lake Street
Minneapolis, MN 55402
(612) 339-4372
Studio space

The Depot Building
506 West Michigan
Duluth, MN 55802
(218) 727-8013
Studio space

Frogtown Family Lofts
653 Galtier Street
St. Paul, MN 55101
(612) 332-0042
Studio and living space

The Lincoln Library
2227 West Second Street
Duluth, MN 55806
(218) 727-8013
Studio space

Lowertown Lofts Artists' Cooperative
255 East Kellogg
St. Paul, MN 55101
(612) 224-6711
Studio and living space

Studios at 700
700 North Washington
Minneapolis, MN 55401
(612) 333-7913
Studio space

**The Northern Warehouse Artists'
 Cooperative**
308 Prince Street
St. Paul, MN 55401
(612) 224-0048
Studio and living space

Tilsner Artists' Cooperative
319 Kellogg
St. Paul, MN 55101
(612) 339-4372
Studio space

Whittier Studio Homes
12-18 East 27th Street
 and
2640-2642 First Avenue South
Minneapolis, MN 55404
(612) 871-7756
Studio and living space

Also: Contact Artspace Projects, Inc., which owns Lowertown Lofts, Studios at 700, The Northern Warehouse Artists' Cooperative, and Tilsner Artists' Cooperative and assists artists of all disciplines and media in locating affordable live-work and studio space in the Twin Cities area. The fee for the listing of available spaces (three listings and one update) is $15 or, for those who cannot afford the $15, three hours of volunteering at Artspace. For more information, contact the Duluth Art Institute, which operates The Depot Building and The Lincoln Library.

Artspace Projects, Inc.
400 First Avenue North, Suite 518
Minneapolis, MN 55401
(612) 339-4372
(800) 229-5715

Duluth Art Institute
506 West Michigan
Duluth, MN 55802
(218) 727-8013

MISSOURI

Artspace
218 Delaware
Kansas City, MO 64105
(816) 471-6789
Studio and living space

NEBRASKA

Alternative Worksite/Bemis Foundation
614 South Eleventh Street
Omaha, NE 68102
(402) 341-7130
Studio space

NEW JERSEY

Jersey City Arts Center
111 First Street
Jersey City, NJ 07302
(201) 792-2787
Studio space

NEW YORK

Artlofts Condo Projects
c/o Peekskill Chamber of Commerce
Attn.: Ralph Dibart
One South Division Street
Peekskill, NY 10566
(914) 723-7813
Studio and living space

The Center for Book Arts
626 Broadway
New York, NY 10012
(212) 460-9768
Studio space

Charas, Inc.
605 East Ninth Street
New York, NY 10009
(212) 982-0627; (212) 533-6835
Studio space

The Clocktower
108 Leonard Street
New York, NY 10013
(212) 233-1096
Studio space

Hostos Center for the Arts & Culture
Hostos Community College
500 Grand Concourse
Bronx, NY 10451
(718) 518-4242
Studio space

Lower East Side Printshop, Inc.
Artists Workspace Keyholder Program
59-61 East 4th Street, Sixth Floor
New York, NY 10003
(212) 673-5390
*Studio space, with use of darkroom and
storage rooms*

Manhattan Plaza
400 West 43rd Street
New York, NY 10036
(212) 971-0660
Living space

P.S. One
46-01 21st Street
Long Island City, NY 11101
(718) 784-2084
Studio space

P.S. 122, Inc.
150 First Avenue
New York, NY 10009
(212) 228-4150
Studio space

Puerto Rican Workshop, Inc.
Taller Boricua
1685 Lexington Avenue
New York, NY 10029
(212) 831-4333
*Live-work space at 1685 Lexington Avenue;
studio space at 121 East 106th Street*

Westbeth Corp.
463 West Street
New York, NY 10014
(212) 691-1500
Studio and living space

Also: Contact the Artist Certification Program at the New York City Department of Cultural Affairs (Two Columbus Circle, New York, NY 10019, tel. 212-841-4227), which maintains a listing of available studio spaces in the five boroughs of New York City as well as provides information on low- and moderate-income housing opportunities.

NORTH CAROLINA

Artspace
P.O. Box 27331
Raleigh, NC 27611
(919) 821-2787
Studio space

The McKeever School
643 West Lee Street
Greensboro, NC 27403
(919) 274-3775
Studio space

The Sternberger Artists Center
712 Summit Avenue
Greensboro, NC 27405
(919) 333-7440
Studio space

PENNSYLVANIA

The Artworks at Doneckers
100 North State Street
Ephrata, PA 17522
(717) 738-9503
Studio space

Greene Street Artists' Cooperative
5225 Greene Street
Philadelphia, PA 19144-2903
(215) 546-1146
Studio and living space

Old Manayunk
Studio Building
123 Leverington Avenue
Philadelphia, PA 19127
(215) 482-2100
 or
126 Leverington Avenue
Philadelphia, PA 19127
(215) 482-2110

RHODE ISLAND

AS 220
115 Empire Street
Providence, RI 02903
(401) 831-9327
Studio and living space

UTAH

Artspace
325 West Pierpont
Salt Lake City, UT 84101
(801) 531-9378
Studio and living space

VIRGINIA

Arlington Arts Center
3550 Wilson Boulevard
Arlington, VA 22201
(703) 524-1494
Studio space

McGuffey Arts Center
Charlottesville, VA
(804) 295-7973
Studio space

Torpedo Factory Art Center
105 North Union Street
Alexandria, VA 22314
(703) 838-4199
Studio space

WEST VIRGINIA

Tamarack Craft Center
One Tamarack Park
Beckley, WV 25801
(304) 256-6843
Studio space

7

Artist Communities

The differences between artist-in-residence programs, art colonies, and subsidized studio spaces for artists are not always clear. Presumably, someone employed in an artist-in-residence program is paid regularly while, in the other situations, artists must (or usually) pay something; some colonies provide stipends and some resident artists are "paid" through the use of facilities and free materials.

The Residential Complex

An artist colony may be located in some get-away-from-it-all rural setting or in a major city. Those that cloister artists in areas where there are few or no distractions (or even working telephones) are likely to be ideal for creators

needing to rid themselves of the excuses for not getting their work done. Colonies in cities are less likely to be residential complexes and, instead, highlight the equipment and facilities that may be put to the service of an artistic endeavor. In all cases, however, at an artist community, the artist is central, and creating art is the main business of the day.

There are many differences among artist communities existing around the United States and Canada, but they are all united by their determination to provide artists with uncluttered time and space in which to work. Distractions are pared down by the rural settings of most of the colonies and the paucity of telephones, which are usually not located in any of the living areas or studios assigned to artists. It's actually difficult to get in touch with someone at The MacDowell Colony in Peterborough, New Hampshire, as telephones are almost nonexistent, and colony rules prohibit anyone from entering an artist's studio uninvited during the main 9:00 A.M.–5:00 P.M. work period. Literary readings, performances, exhibitions and just talk itself tend to happen on an ad hoc basis, arising from the mix of people who happen to be in residence at any one time.

Residencies at colonies range from two weeks to two or three months, with some lasting six or eight months. The Millay Colony in Austerlitz, New York, for instance, invites 60 people a year for one-month residencies with no more than five writers, composers or visual artists at any given time, while the Virginia Center for the Creative Arts at Sweet Briar takes in an annual 294 artists of all media for stays of between 30 days and several months with 21–24 people in residence at a time. The Millay Colony is also notable for its refusal to ask artists for application fees (between $10 and $20 at most colonies) or for contributions toward the cost of their stay. Most other communities ask or demand something—the Hambridge Center for Creative Arts in Rabun Run, Georgia charges between $60 and $75 a week, for instance. The fees in no way cover the actual costs of these retreats but are contributions toward the total operating budget.

Various review committees, comprising notable artists, editors, curators and others with expertise, evaluate applications from artists wishing to have a residency. The quality of the candidate's work and whether or not a case has been made for the artist needing a block of uninterrupted time to begin or complete a new project are generally the main criteria for selection.

Some communities also specialize in particular areas of the arts: Real Art Ways in Hartford, Connecticut, for example, is oriented toward video and mixed media artists; the Institute of Contemporary Art in Long Island, New

York is intended for sculptors and printmakers; Curry Hill Plantation Writer's Retreat in Hattiesburg, Mississippi, and the Shenandoah Valley Playwrights Retreat in Staunton, Virginia focus on novelists, poets and playwrights. Most communities, however, are interdisciplinary.

"There's a wonderful thing that happens at colonies when people from different disciplines get together at dinnertime," Ann-Ellen Lesser, executive director of The Millay Colony, stated. "Artists find that they learn a lot about their own art forms by talking with others about their work. People begin to see that they have basic attitudes in common. That gives a three-dimensional quality to the colony."

Another difference among colonies is whom they choose for residencies. MacDowell and Yaddo in Saratoga Springs, New York may be more apt than others to select artists who have substantial professional standing, having published, performed or exhibited work and received some notice. Others focus on the emerging artist. Even among those aimed at emerging artists, there are criteria. "We focus on emerging artists," Mary MacArthur, executive director of The Fine Arts Work Center in Provincetown, Massachusetts, said, adding that "emerging" means "some publishing but no book yet or some exhibiting but no major shows yet."

Yet others attempt to establish a mix between the better-known and lesser-known artists in order to balance innovation and professional standing. The Virginia Center for the Creative Arts, on the other hand, according to its executive director William Smart, welcomes "serious amateurs," defining "serious" as showing a "seriousness of purpose. Keep in mind that Anthony Trollope was a school inspector and wrote 40 novels on trains traveling between schools. T.S. Eliot worked in a bank most of his life. We don't assume that having a job and only being a Sunday painter makes anyone less serious, or less of an artist, if the work is good."

While offering the chance to work without distractions is the aim of all artist colonies, none keep tabs on anyone to ensure that work is being done. Different artists respond to this freedom in different ways, most taking the opportunity to work hard. Some people work too hard and burn-out within a month.

Other artists find the secluded colony locations and the lack of diversions to be claustrophobic. "Some people are very much city types, thriving on things to do and phone calls," writer Peter Viereck, who has had residencies at MacDowell, Millay and the Virginia Center for the Creative Arts, said. "Hart Crane needed loud jazz music to write his poetry; that would drive

me crazy. But you do get people coming to these colonies who spend their time playing cards or ping-pong, maybe talking about their art but not doing anything. They come here and think, 'Golly, now I've got to be creative. What do I do?' For some people, that could be the kiss of death."

He added that there are also "colony bums" who go from one colony to the next, less for the desire to have the time and space in which to work than because they are professors on sabbatical who "line up one colony after another" to fill up the year. These people, he stated, tend not to do very much work and "by the second or third colony have lost their freshness."

Artist communities also get their share of repeaters who are invited back year after year—almost 40 percent of those who go to Yaddo, for instance, have been there before—although an increasing tendency is to bring in new faces, representing more women, minorities and a geographical mix.

There are many reasons, however, why artist communities are not for everyone. Often, artists spend a week trying to get used to their surroundings and the freedom before getting down to work. Colony staff members also try to spot people who seem lost and to help them get on track. Most do, but some don't or not completely. Those people generally leave early.

Both sculptor Mary Frank and painter Jules Olitski left Yaddo before their respective residencies were up; she because "it was a difficult time in my life and I found it hard to settle down to work, especially since I didn't know what kind of work I wanted to do," and he because "it was not my studio. It was not my air, not my choice of whom I was talking with or listening to. It wasn't a problem with Yaddo—Yaddo was fine, it was a lovely setting and everything was taken care of—but a personal thing at that time in my life. I did a little painting there, but it didn't really work for me. I found myself doing more writing than painting, writing a short novel about a lesbian witch."

The kind of person who may benefit from an art colony is someone who has something specific to do or who simply needs unfettered time to pursue ideas. "It takes about a week to adjust from what you came from to having everything done for you, but then your work really gets going," Benny Andrews, a painter, said. "People serving you food, leaving you alone when you want. Man, I could get used to that."

Unless otherwise noted, the colonies maintain a mix of visual, performing, craft, and literary artists. The addresses for the main colonies around the country are:

Act 1 Creativity Center
Box 10153
Kansas City, MO 64111
(816) 753-0208

Adamant Program
P.O. Box 73
Adamant, VT 05640-0073
(802) 223-2324

Edward F. Albee Foundation
14 Harrison Street
New York, NY 10013
(212) 226-2020
The colony itself is located in Montauk, Long Island, New York

Mary Anderson Center for the Arts
101 St. Francis Drive
Mount St. Francis, IN 47146
(812) 923-8602

Anderson Ranch Arts Center
P.O. Box 5598
Snowmass Village, CO 81615
(303) 923-3191

Annual Molasses Pond Writers Retreat/ Workshop
Box 85C
Milbridge, ME 04658
(207) 546-2506
Part traditional art colony, with undisturbed writing time, and part critique group. The retreat is held for five days in June

Art Awareness
Box 177
Route 42
Lexington, NY 12452
(518) 989-6433

ART/OMI
55 Fifth Avenue
New York, NY 10003
(212) 206-6060
The community is located in the Hudson River Valley

Artpark
P.O. Box 371
Lewiston, NY 14092
(716) 745-3377 or (716) 754-9001

Arts International
Lila Wallace-Reader's Digest International Artists
Institute of International Education
809 United Nations Plaza
New York, NY 10017
(212) 984-5330
Three- to six-month overseas residencies, intended to encourage connections between artists in the United States and those abroad

Association for Visual Artists
615 Lindsay Street
Chattanooga, TN 37403
(615) 265-4282
Summer-long residencies

Atlantic Center for the Arts
1414 Art Center Avenue
New Smyrna Beach, FL 32168

Baltimore Clayworks
5706 Smith Avenue
Baltimore, MD 21209
(310) 578-1919
For ceramicists

The Bemis
614 South 11th Street
Omaha, NE 68192

Bernheim Forest
536 Starks Building
455 South Fourth Street
Louisville, KY 40202
(502) 543-2451

Blue Mountain Center
Blue Mountain Lake, NY 12812
(518) 352-7391

Brandywine Workshop
1520-22 Kater Street
Philadelphia, PA 19146
(215) 546-3657
For those working in offset printmaking

Byrdcliffe Arts Colony
The Woodstock Guild
34 Tinker Street
Woodstock, NY 12498
(914) 679-2079

Career Advance of Visual Artists (CAVA)
c/o National Foundation for Advancement
 in the Arts
3915 Biscayne Boulevard
Miami, FL 33137
(305) 573-0490

Carina House
Farnsworth Art Museum
P.O. Box 466
Rockland, ME 04841
(207) 596-6467
For Maine artists

Centrum Foundation
Fort Warden State Park
P.O. Box 1158
Port Townsend, WA 98368
(206) 385-3102
For printmakers

Chester Springs Studios
P.O. Box 329
1668 Art School Road
Chester Springs, PA 19425
(215) 827-7277

Cold Hollow Cross Discipline Project
RD 2, Box 3480
Enosburg Falls, VT 05450
(802) 933-2518

Contemporary Artists Center
189 Beaver Street (Route 8 North)
North Adams, MA 01247
(413) 663-9555

Creative Glass Center of America
P.O. Box 646
Glasstown Road
Millville, NJ 08332
(609) 825-6800, ext. 2733

Curry Hill Plantation Writers Retreat
404 Crestmont Avenue
Hattiesburgh, MS 49401
(601) 264-7034

Djerassi Foundation
Resident Artist Program
2325 Bear Gulch Road
Woodside, CA 94062
(415) 851-8395

Dobie Paisano Fellowship Project
University of Texas
Office of Graduate Studies
Main Building 101
Austin, TX 78712
(512) 471-7213

Doghaven Centre for the Arts
P.O. Box 283
Three Oaks, MI 49128
*Residencies are free, but one must contribute
time to farming or carpentry work at the
premises*

Dorland Mountain Colony
P.O. Box 6
Temecula, CA 92390
(714) 676-5039

Dorset Colony House
Box 519
Church Street
Dorset, VT 05251
(802) 487-9960

Alden B. Dow Creativity Center
Northwood Institute
Midland, MI 48640
(517) 832-4403

The Farm—An Art Colony for Women
RD 3, Old Overlook Road
Poughkeepsie, NY 12603
(914) 473-9267
*In exchange for housing, residents contribute
five hours of work each weekday (8:00 A.M.–
1:00 P.M.)*

Fine Arts Work Center
Box 565
24 Pearl Street
Provincetown, MA 02657
(508) 487-9960

Franciscan Canticle, Inc.
Canticle Arts Center
675 North Palm Canyon Drive
Palm Springs, CA 92262
(619) 416-1338

Gell Writers Center of the Finger Lakes
c/o Writers & Books
740 University Avenue
Rochester, NY 14607
(716) 473-2590
Gell Writers Center is located in Naples, NY

Grand Marais Art Colony
Box 626
Grand Marais, MN 55604

Hambridge Center for the Arts
P.O. Box 339
Rabun Run, GA 30568
(404) 746-5718

Headlands Center for the Arts
944 Fort Barry
Sausalito, CA 94965
(415) 746-5718

Cottages at Hedgebrook
2197 East Milluian Road
Langley, WA 98260
Intended for women writers only

**Kalani Honua Intercultural and Retreat
 Center**
P.O. Box 4500
Kalapana, HI 96778
(808) 965-7828; (800) 800-6886

John Michael Kohler Arts Center
608 New York Avenue
Sheboygan, WI 53082-0489
(414) 458-6144
*For artists (ceramicists and sculptors, largely)
interested in the application of industrial
materials and technology to artmaking*

Lakeside Studio
Lakeside Group
600 North McClurg Court, Suite 1302A
Chicago, IL 60611
(312) 787-6858

D.H. Lawrence Fellowship Committee
University of New Mexico
Albuquerque, NM 87131
(505) 277-6347

Ledig House International Writers Colony
43 Letter S Road
Ghent, NY 12975
(518) 392-7656/4766

Lightwork
316 Waverly Avenue
Syracuse, NY 13210
(315) 443-1300
*For artists working in photography,
computers, and related arts*

The MacDowell Colony
163 East 81st Street
New York, NY 10028
(212) 966-4860
 or
100 High Street
Peterborough, NH 03458
(603) 924-3886

Medicine Wheel Artists Retreat
54 Nod Road
P.O. Box 1088
Groton, MA 01450
(508) 448-3717

The Millay Colony for the Arts
Steepletop, East Hill Road
P.O. Box 3
Austerlitz, NY 12017
(518) 392-3103

Montana Artists Refuge
Box 8
Basin, MT 59631
(406) 225-3525

Mount Sequoyah New Play Retreat
Drama Department
Kimpel Hall 406
University of Arkansas
Fayetteville, AR 72701
(501) 575-2953
*Three-week workshop in the Ozark Moun-
tains for playwrights*

**Nantucket Island School of Design &
 the Arts**
23 Wauwinet Road
P.O. Box 958
Nantucket, MA 02554
(508) 228-9248/2451

Napanoch Inter-Arts Colony
Box 308
Napanoch, NY 12458
(914) 647-3608

**The National Foundation for the
 Advancement of the Arts**
800 Brickell Avenue, Suite 500
Miami, FL 33137
(305) 573-0490
For artists between the ages of 19 and 39

National Musical Theater Conference
305 Great Neck Road
Waterford, CT 06385-3825
(203) 443-5378

National Playwrights Conference
234 West 44th Street
New York, NY 10036
(212) 382-2790

New York Mills Arts Retreat
RR 1, Box 217
New York Mills, MN 56567
(218) 385-3339

Nexus Press
535 Means Street
Atlanta, GA 30318
(404) 688-1970
*For artists interested in learning about, or
producing, artists' books*

Eugene O'Neill Theater Center
National Critics Institute
234 West 44th Street
New York, NY 10036
(212) 382-2790

Oregon Writers Colony
P.O. Box 15200
Portland, OR 97215
(503) 771-0428

Palenville Interarts Colony
2 Bond Street
New York, NY 10012
(212) 254-4614

The Ragdale Foundation
1260 North Green Bay Road
Lake Forest, IL 60045
(312) 234-1063

Saint James Colony
Beaver Island
Box 71
St. James, MI 49782

Sculpture Space
12 Gates Street
Utica, NY 13502
(315) 724-8381
Sculptors

Shenandoah Playwrights Retreat
Pennyroyal Farm
Route 5, Box 167-F
Staunton, VA 24401
(703) 248-1868
Playwrights

Squaw Valley Community of Writers
P.O. Box 2352
Olympic Valley, CA 95730
(916) 583-5200
Writers

Studios Midwest
P.O. Box 291
Galesburg, IL 61401
(309) 344-1177; (309) 342-2010
Summer residencies, free to visual artists

Ucross Foundation
2836 U.S. Highway 14—16 East
Clearmont, WY 82835
(307) 737-2291
Solely for visual artists

University of Arizona
Poetry Center
1216 North Cherry Avenue
Tucson, AZ 85719
*For writers who have not published more
than one full-length work*

Vallecitos Retreat
P.O. Box 226
Vallecitos, NM 87581
(505) 582-4226

**Vermont Carving Studio and Sculpture
Center**
P.O. Box 495
West Rutland, VT 05777
(802) 438-2097

Vermont Studio Center
P.O. Box 613N
Johnson, VT 05656
(802) 635-2727

Villa Montalvo Center for the Arts
P.O. Box 158
Saratoga, CA 95071
(408) 741-3421

Virginia Center for the Creative Arts
Mt. San Angelo
Sweet Briar, VA 24595
(804) 946-7236

Volcano Art Center
P.O. Box 104
Hawaii National Park, HI 96718-0104
(808) 967-8222

Walden Residency Program
Northwest Writing Institute
Box 100
Lewis and Clark College
Portland, OR 97219
(503) 768-7745
For Oregon-resident playwrights

Watershed Center for the Ceramic Arts
RR 1, Box 845
Cochran Road
Edgecomb, ME 04556
(207) 882-6075
Primarily for ceramicists

Wexner Center for the Arts
North High Street at 15th Avenue
Columbus, OH 43210
(614) 292-0330

Friends of Weymouth
Weymouth Center
P.O. Box 839
Southern Pines, NC 28387
(919) 692-6261
For North Carolina writers

Wolf Pen Women Writers Colony
Hopscotch House
8221 Wolf Pen Branch Road
Prospect, KY 40059
(502) 228-4875
During the month of June

Helene Wurlitzer Foundation of New Mexico
P.O. Box 545
Taos, NM 87571
(505) 758-2413

The Corporation of Yaddo
P.O. Box 395
Saratoga Springs, NY 12886
(518) 584-0746

The Yard
P.O. Box 405
Chilmark, MA 02535
(617) 645-9662
 or
890 Broadway
New York, NY 10003
(212) 228-0911

Yellow Springs Institute
1645 Art School Road
Chester Springs, PA 19425
(610) 827-9111
For artists involved in dance, sound research, performance art, experimental theater, and interdisciplinary forms

There are also a number of art colonies abroad, run by Americans or which will accept Americans for residencies. They are:

Altos de Chavron
c/o Parsons School of Design
2 West 13 Street, Room 707
New York, NY 10011
(212) 229-5370

American Academy in Rome
7 East 60 Street
New York, NY 10022-1001
(212) 751-7200

Bellagio Study and Conference Center
c/o Rockefeller Foundation
1133 Avenue of the Americas
New York, NY 10036
(212) 869-8500

Berllanderi Sculpture Workshop
Usk Road
Raglan, Gwent NP5 2HR
Wales
(44-291) 690268

British School at Rome
Regent's College
Inner Circle
Regent's Park
London NW1 4NS
England
(071) 4877603

The Camargo Foundation
P.O. Box 32
64 Main Street
East Haddam, CT 06423
(203) 873-3239

Chateau de Lesvault
Onlay
58370 Villapourcon
France
(011-33) 866-84-32-91

DAAD—Germany
Artists-in-Berlin Program
German Academic Exchange Service
Bureau Berlin, P.O. Box 126240
Steinplatz 2
D-1000 Berlin 12
Germany

**Hawthornden Castle International
 Retreat for Writers**
Lasswade, Midlothian
Scotland EH18 1EG
Great Britain
(011-31) 440-2180

Heli
Israeli Center for the Creative Arts
212 Beni Ethraim Street
Naoz Aviv
Tel Aviv, Israel 69985

**Institut des Hautes Etudes en Arts
 Plastiques**
75 Rue du Temple
75003 Paris
France
(011-331) 48-87-05-00
*Year-long interdisciplinary research programs
for artists, aged 20–33, who speak French*

Japan Foundation
• *For applicants residing east of the Rocky
Mountains:*
142 West 57th Street, 39th floor
New York, NY 10019
(212) 489-0299

• *For applications from residents of Alaska,
Arizona, California, Colorado, Hawaii, Idaho,
Montana, Nevada, New Mexico, Oregon,
Utah, Washington and Wyoming, contact:*
The Water Garden
2425 West Olympic Boulevard, Suite 6205
Santa Monica, CA 90404-4034
(310) 449-0027
*Not a specific site, but aimed at providing
U.S. artists with an opportunity to develop
artistic projects in Japan*

La Napoule Art Foundation
21 East 68 Street, Suite 1F
New York, NY 10023
(212) 496-1039
(011-03) 478704
*Chateau La Napoule is located on the Cote
d'Azur in France*

Leighton Artist Colony
c/o The Banff Centre
P.O. Box 1020
Banff, Alberta T0L 0C0
Canada
(403) 762-6180
(800) 565-9989

Mish Kenot Sha'anaim
P.O. Box 8215
Jerusalem 91081
Israel

NALL (Nature, Art & Life League)
232 Boulevard de Lattre
01640 Vence
France

Saskatchewan Writers/Artists Colony
P.O. Box 3986
Regina, Saskatchewan S4P 3R9
Canada
(306) 757-6310; (306) 565-8554

Scottish Sculpture Workshop
1 Main Street
Lumsden, Aberdeenshire AB5 4JN
Scotland
(011) 04648 372

The Tyrone Guthrie Center
Annaghmakerrig, Newbliss
County Monaghan
Ireland
(011) 047-54003

A number of places call themselves artist communities or artist-in-residencies but are clearly not in the same league as those in the list above. Established artist communities generally require those wishing to come to submit an application, including samples of their work and a description of the project that will be pursued during the residency, and this material will be reviewed by the board of directors of the community. These directors wish to ensure that the applicants are serious artists and that a diversity of interests and media (not all realist painters, for instance) will participate so that a potential cross-fertilization of ideas may take place. This is a far cry from the Cleaveland House B&B on Martha's Vineyard in Massachusetts, which "caters to poets and writers" in that the proprietor hosts a local poetry get-together on Wednesday afternoons that B&B guests are welcome to attend. Otherwise, the inn itself has no private work studios and books rooms rather than accepts (or rejects) applications. At the Guest House at New Light Studios, the owners have from time to time accepted paintings as partial payment of guests' bills. Maine Retreat sometimes allows a fee reduction in exchange for farm work. The owner of My Retreat in South Fallsburg, New York holds workshops for writers, and each guest room has a desk, but the inn is booked "on a first-come, first-served basis" for nonsmoking "poets, writers, and artists of life." A mostly women-only retreat in Santa Fe, New Mexico called Hawk, I'm Your Sister holds an annual Writing Retreat that allows everything but making art—this is a canoeing and camping trip that encourages one to experience nature. Does a camp or a bed-and-breakfast that prefers artists and writers as guests become an artist community? If they rent exclusively to artists and writers, are they any closer to the standard use of the term? A number of these inns and guest houses are included because they do specifically seek writers and artists (although they may accept reservations from nonartists as well), and some offer the use of a chalkboard, work room and certain materials (typing paper, for example):

Cleaveland House B&B
P.O. Box 3041
West Tisbury, MA 02575
(508) 693-9352

Glenessence
Arts Associates International, Inc.
1447 West Ward
Ridgecrest, CA 93555
(619) 446-5895
Writers

Guest House at New Light Studios
Box 343
Turtle Town Hall Road
Beloit, WI 53511
(608) 362-8055/1417

Hawk, I'm Your Sister
P.O. Box 9109
Santa Fe, NM 87504-9109
(505) 984-2268

Maine Retreat
c/o Nightshade Press
P.O. Box 76
Ward Hill
Troy, ME 04987-0076
(207) 948-3427; (800) 497-9258
Writers

My Retreat
P.O. Box 1077
Lincoln Road
South Fallsburg, NY 12779
(914) 436-7455; (800) 225-0256

Pudding House B&B for Writers
60 North Main Street
Johnstown, OH 43031
(614) 967-6060
Writers

Yucatec Farm
Williamsville, VA 24487
(703) 925-2234
Writers

Most artist communities focus on the presumed need for an artist to make a clean break with the outside world (there may be no telephones or televisions). However, the MacDowell Colony in New Hampshire and DAAD in Berlin, Germany, offer accommodations for an artist's spouse and children, and some other communities make provisions for child and pet care.

Scholarships and Grant Programs for Communities

Artist communities, as noted above, are not usually free of charge for artists. As in the case of all arts organizations, artist communities are continually involved in the effort to raise funds to maintain their operations. They often offer subsidized rents for artists needing peace and quiet in order to begin or complete a work. A number of artist communities have scholarship programs that pay all or some costs for an artist—such as travel, materials, room and board and training—as well as provide stipends. Vallecitos Retreat in New Mexico, which is open to visual artists and writers, for instance, has a scholarship program specifically for poets. Interested artists should request information on the kinds of financial assistance available at artist communities and for whom they are intended. At some communities, artists themselves are not permitted to apply for these scholarships; they must be nominated by someone associated with the colony and be selected by the

colony's board of directors. They include Bernheim Forest (Isaac W. Bernheim Foundation), DAAD (DAAD's Artists-in-Berlin program), National Foundation for Advance in the Arts (Career Advancement program), Pilchuck Glass School (Summer Artist-in-Residence program), Watershed Center for the Ceramic Arts (Guest Artist program), and Wexner Center for the Arts (Wexner Center Residency Awards).

Even at discounted rates, many artists are still unable to afford to stay at a community. ACTS Institute (P.O. Box 10153, Kansas City, MO 64111, tel. 816-753-0208) has a cash grant program for would-be colony residents with no other sources of support. Sculpture Space has a limited number of $2,000 stipends for two-month residencies, and many other artist communities offer discounts or fellowships to low-income participants who apply in advance. In addition, both the Minnesota State Arts Board (432 Summit Avenue, St. Paul, MN 55102, tel. 612-297-2603) and the North Carolina Arts Council (Department of Cultural Resources, Raleigh, NC 27611, tel. 919-733-2111) have programs enabling state resident artists to attend Headlands Center for the Arts in Sausalito, California. Minnesota's Headlands Residency Project provides a travel allowance and a living stipend as well as paying for housing and studio space at Headlands Center for the Arts, while North Carolina pays for a stay there of up to eight weeks.

A number of state and local arts agencies also have programs that pay for an artist to travel for professional development (see chapter 5), which may be used to cover transportation to a colony. Two other state arts agencies provide money for artists invited to attend an art colony:

Idaho Commission on the Arts
304 West State Street
Boise, ID 83720
(208) 334-2119
WORKSITE awards up to $5,000 for attendance at a colony, as well as other possible uses

Ohio Arts Council
Professional Development Assistance
 Award
727 East Main Street
Columbus, OH 43205-1796
(614) 466-2613
Up to $1,000, which may be used for a stay at an art colony

8

Public Art Programs

Public art is an umbrella term covering a wide group of artistic activities. Traditionally, it is a statue or other sculptural piece, which will become a permanent part of the public landscape, yet one sees a growing number of temporary (for instance, a month or two) sculptural installations and even performances, readings or just art shows taking place in public places. Either through mandated Percent-for-Art programs (in which one percent, or half of one percent of the money used on constructing or renovating a government building must be applied to the purchase of artwork for that building) or simply through an interest in making art available (and visible) to more people, public art programs have

been growing as has the number of pieces commissioned through various private and state agencies for public display. Most state and local public art sponsors accept applications from residents of other states and localities.

Governmental Programs

An artist may contact the National Endowment for the Arts or a state arts agency for information on current or upcoming federal or state governmental commissions of artworks (arts agencies are frequently involved in the selection process) or may begin searching the Internet, using such keywords as *arts, commissions* or *government*. A couple of web sites that may be helpful are http://www.law.csuohio.edu/lawlibrary/usgovernment/index.html or http://wings.buffalo.edu/libraries/units/line/collections/docs/grants.html. Among the main buyers of public art on the government side are:

FEDERAL GOVERNMENT

General Services Administration
Art-in-Architecture Program
Seventh and D Street, S.W., Room 7618
Washington, D.C. 20405
(202) 708-5334

Veterans Administration
Art-in-Architecture Program
110 Vermont Avenue, N.W.
Washington, D.C. 20420
(202) 233-4000

ALASKA

Alaska State Council on the Arts
411 West 4th Street, Suite 1E
Anchorage, AK 99501-2343
(907) 269-6610
E-mail: asca@alaska.net

Municipality of Anchorage Public Art Program
Anchorage Museum of History and Art
P.O. Box 196650
Anchorage, AK 99501-6650
(907) 343-6473

ARIZONA

Arizona Commission on the Arts
417 West Roosevelt
Phoenix, AZ 85003
(602) 255-5882

Casa Grande Arts & Humanities Commission
300 East Fourth Street
Casa Grande, AZ 85222
(602) 836-7471

City of Chandler
250 North Arizona Avenue
Chandler, AZ 85224
(602) 786-2683
E-mail: jbaudoin@primenet.com

City of Sierra Vista
2400 East Tacoma Street
Sierra Vista, AZ 85635

Glendale Arts Commission
5850 West Glendale Avenue
Glendale, AZ 85301
(602) 930-2829

Peoria Arts Commission
P.O. Box C-4038
Peoria, AZ 85345
(602) 412-7300

Phoenix Arts Commission
200 West Washington
Phoenix, AZ 85003
(602) 262-4637

Scottsdale Cultural Council
7380 East Second Street
Scottsdale, AZ 85251
(602) 874-4636

Sedona Department of Arts and Culture
P.O. Box 3002
Sedona, AZ 86336

Sky Harbor Art Program
3400 Sky Harbor Boulevard
Phoenix, AZ 85034
(602) 273-8863

Tempe Arts Commission
Library Building
3500 South Rural Road
Tempe, AZ 85282

Tucson/Pima Arts Council
240 North Stone Avenue
Tucson, AZ 85701-1212
(602) 624-0595

ARKANSAS

Arkansas Arts Council
1500 Tower Building
323 Center Street
Little Rock, AR 72201
(501) 324-9348

CALIFORNIA

Berkeley Civic Arts Commission
2180 Milvia Street
Berkeley, CA 94704
(510) 644-6080

California Arts Council
1300 I Street, Suite 930
Sacramento, CA 95814
(916) 322-6555

Capp Street Project/AVT
525 Second Street
San Francisco, CA 94107
(415) 626-7747

Carlsbad Cultural Arts
City of Carlsbad
1200 Calrsbad Village Drive
Carlsbad, CA 92008
(619) 434-2920

City of Beverly Hills
444 North Rexford Drive
Beverly Hills, CA 90210
(310) 288-2205
E-mail: ls-admin@earthlink.net

City and County of San Francisco
Department of City Planning
450 McAllister Street
San Francisco, CA 94102
(415) 558-2266

City of Brea
One Civic Center Circle
Brea, CA 92621
(714) 990-7735

City of Chico
Arts Commission
P.O. Box 3420
Chico, CA 95927-3420
(916) 895-4820
E-mail: BKoch@ci.chico.ca.us

City of Concord
Planning Department
Concord, CA 94519
(415) 671-3152

South Coast Metro Alliance
600 Anton Boulevard, Suite 120
Costa Mesa, CA 92626
(714) 435-2109

City of Davis
Parks & Community Service Department
23 Russell Boulevard
Davis, CA 95616
(916) 757-5626

**Del Norte Association for Cultural
 Awareness**
P.O. Box 1480
Crescent City, CA 95531
(707) 464-1336

City of Escondido
201 North Broadway
Escondido, CA 92025
(619) 738-4331

Fresno Arts Council
2425 Fresno Street, Room 102
Fresno, CA 93721
(209) 237-9734

City of Garden Grove
11391 Acacia Parkway
Garden Grove, CA 92640
(714) 741-5040

Humboldt Arts Council
214 E Street
Eureka, CA 95501
(707) 442-0278

City of Irvine
P.O. Box 19575
2815 McGaw
Irvine, CA 92713
(714) 660-3801

Laguna Beach Arts Commission
505 Forest Avenue
Laguna Beach, CA 92651
(714) 497-5882

Lake County Arts Council
325 Main Street
Lakeport, CA 95453
(707) 263-6658

Public Corporation for the Arts
Public Art Program
100 West Broadway, Suite 360
Long Beach, CA 90802
(310) 570-1362
artpca@aol.com

City of Los Angeles
433 South Spring Street
Los Angeles, CA 90013
(213) 485-9570
cadpublicart@earthlink.net

Community Redevelopment Agency of the City of Los Angeles
354 South Spring Street, Seventh floor
Los Angeles, CA 90013-1258
(213) 977-1771

Los Angeles County Transportation Commission
818 West 7th Street, Suite 1100
Los Angeles, CA 90017
(213) 879-2973

Metro Art
P.O. Box 194
Los Angeles, CA 90053
(213) 922-2727

Madera County Arts Council
315 West Olive Avenue
Bethard Square
Madera, CA 93637
(209) 661-7005
nclute@valleynet.com

City of Manhattan Beach
1400 Highland Avenue
Manhattan Beach, CA 90266
(310) 545-5621, ext. 326
SpectorH@aol.com

City of Mountain View
Planning Department
P.O. Box 7540
Mountain View, CA 94039
(415) 903-6306

City of Palm Desert
73-510 Fred Waring Drive
Palm Desert, CA 92260
(619) 346-0611

City of Palm Springs
Public Arts Commission
P.O. Box 2743
Palm Springs, CA 92263-2743
(619) 778-8408

City of Palo Alto
1313 Newell Road
Palo Alto, CA 94303
(415) 329-2218

City of Pasadena
Cultural Planning Division
175 North Garfield Avenue
Pasadena, CA 91101-1704
(818) 683-6770

City of Pleasanton
Public Art Program
200 Old Bernal Avenue
Pleasanton, CA 94566
(510) 484-8292

**Sacramento Metropolitan Arts
Commission**
Art in Public Places
800 10th Street
Sacramento, CA 95814
(916) 264-5971

City of San Diego
Commission for Arts and Culture
1010 Second Avenue, Suite 555
San Diego, CA 92101-4904
(619) 533-3051

San Francisco Arts Commission
25 Van Ness Avenue, Suite 240
San Francisco, CA 94102
(415) 252-2585

City of San Jose
Office of Cultural Affairs
291 South Market Street
San Jose, CA 95113
(408) 277-2789

San Luis Obispo County Arts Council
P.O. Box 1710
San Luis, CA 93406
(805) 544-9521

Public Art Works
P.O. Box 150435
San Rafael, CA 94915-0435
(415) 457-9744

City of Santa Barbara
Arts Commission
P.O. Box 2369
Santa Barbara, CA 93120
(805) 568-3432

County of Santa Cruz
323 Church Street
Santa Cruz, CA 95062
(408) 429-3778

Santa Cruz Metropolitan Transit District
230 Walnut Avenue
Santa Cruz 95060
(408) 479-0441
georges@cats.ucsc.edu

Santa Monica Arts Commission
215 Santa Monica Pier
Santa Monica, CA 90401
(213) 393-9975

City of Sunnyvale
Arts & Youth Services Division
P.O. Box 3707
Sunnyvale, CA 94088-3707
(408) 730-7758

City of Thousand Oaks
401 West Hillcrest Drive
Thousand Oaks, CA 91360
(805) 497-8611, ext. 200

City of Ventura
Percent for Art Program
P.O. Box 99
Ventura, CA 93002-0099
(805) 658-4760

Dean Lesher Regional Center for the Arts
1601 Civic Drive
Walnut Creek, CA 94596
(510) 295-1417

COLORADO

**Arvada Center for the Arts and
Humanities**
6901 Wadsworth Boulevard
Arvada, CO 80003
(303) 431-3939

City of Arvada
City Hall
8101 Ralston Road
Arvada, CO 80001-8101
(303) 431-3000

City of Aurora
Art in Public Places Commission
13655 East Alameda Avenue
Aurora, CO 80012
(303) 344-1776

City of Denver
Mayor's Office of Culture and Film
Public Art Program
280 14th Street
Denver, CO 80202
(303) 640-2696

**Denver International Airport Art
Program**
8500 Pena Boulevard, Room 9870
Denver, CO 80249-6340

Denver Urban Renewal Authority
1555 California Street, Suite 200
Denver, CO 80202
(303) 534-3872

**Colorado Council on the Arts
& Humanities**
750 Pennsylvania Street
Denver, CO 80203
(303) 894-2617

Commission on Cultural Affairs
303 West Colfax, Suite 1600
Denver, CO 80204
(303) 575-2678

**Longmont's Art in Public Places
Program**
375 Kimbark Street
Longmont, CO 80501
(303) 651-8374

City of Loveland
Art in Public Places Program
c/o Loveland Museum and Gallery
Fifth and Lincoln
Loveland, CO 80537
(970) 962-2411

Town of Vail
Art in Public Places Program
75 South Frontage Road
Vail, CO 81657
(303) 479-7990

CONNECTICUT

Connecticut Commission on the Arts
Gold Building
755 Main Street
Hartford, CT 06103
(860) 566-4770

City of Hartford
Office of Cultural Affairs
550 Main Street, Room 300
Hartford, CT 06103
(203) 722-6493

City of Middletown
Commission on the Arts and Cultural
Activities
P.O. Box 1300
Middletown, CT 06457
(860) 344-3520

City of New Haven
Department of Cultural Affairs
770 Chapel Street
New Haven, CT 06510
(203) 787-8956

City of Stamford
Percent for Art Program
888 Washington Boulevard
Stamford, CT 06954-2152

DELAWARE

Wilmington Arts Commission
City/County Building
800 North French Street, Ninth floor
Wilmington, DE 19801
(302) 571-4100

DISTRICT OF COLUMBIA

Art in Embassies Program
U.S. Department of State
Room B258
Washington, D.C. 20520
(202) 647-5723

**District of Columbia Commission on
the Arts and Humanities**
410 8th Street, N.W., Fifth floor
Washington, D.C. 20004
(202) 724-5613

FLORIDA

Broward Cultural Affairs Council
Public Art and Design Program
100 South Andrews Avenue
Fort Lauderdale, FL 33301
(954) 357-7458

Lee County Alliance of the Arts
10091-A McGregor Boulevard
Fort Meyers, FL 33919
(914) 939-2787

Brevard Cultural Alliance
2725 Saint Johns Street
Building C-2
Melbourne, FL 32940
(407) 690-6817

Metro-Dade County Cultural Affairs Council
Art in Public Places
111 N.W. First Street, Suite 610
Miami, FL 33128
(305) 375-5362

City of Miami Planning Department
275 Northwest Second Street
Miami, FL 33218
(305) 579-6086

Florida Department of State
Division of Cultural Affairs
The Capitol
Tallahassee, FL 32399-0250
(904) 487-2980

City of Orlando
Public Art Program
400 South Orange Avenue
Orlando, FL 32806
(407) 246-3351

Arts Council of Northwest Florida
P.O. Box 731
Pensacola, FL 32594
(904) 432-9906

City of Sarasota
Public Art Program
P.O. Box 1058
Sarasota, FL 34230
(941) 954-4195

Sarasota County Art in Public Places
P.O. Box 8
Sarasota, FL 34230-0008

City of St. Petersburg
Box 2842
St. Petersburg, FL 33731
(813) 893-7627

City of Tampa
Art in Public Places
1420 North Tampa Street
Tampa, FL 33602
(813) 274-7736

Community Action and Planning Agency
601 East Kennedy Boulevard, 28th Floor
Tampa, FL 33602
(813) 276-2536

Hillsborough County Public Art Committee
505 East Jackson Street, Suite 207
Tampa, FL 33602

Palm Beach County Council of the Arts
Art in Public Places Committee
P.O. Box 3366
West Palm Beach, FL 33401-2371
(305) 471-2905

Pasco Fine Arts Council
2011 Moog Road
Holiday, FL 33590
(813) 942-3955

City of West Palm Beach
Art in Public Places
P.O. Box 3366
West Palm Beach, FL 33402
(407) 659-8025

GEORGIA

City of Atlanta
Bureau of Cultural Affairs
City Hall East, Fifth Floor
675 Ponce de Leon Avenue, N.E.
Atlanta, GA 30308
(404) 817-6815

Clarke County Community Relations Division
P.O. Box 352
Athens, GA 30603
(404) 354-2670

Fulton County Arts Council
42 Spring Street, S.W.
Plaza Level 16
Atlanta, GA 30303
(404) 586-4941

HAWAII

Mayor's Office on Culture & the Arts
City Hall
530 South King Street, Room 404
Honolulu, HI 96813
(808) 523-4674

State Foundation on Culture & the Arts
44 Merchant Street
Honolulu, HI 96813
(808) 586-0306

IDAHO
Boise City Arts Commission
P.O. Box 1015
Boise, ID 83701-1015
(208) 336-4936

ILLINOIS
Aurora Public Art Commission
44 East Downer Place
Aurora, IL 60507
(708) 844-3640

Art-in-Architecture Program
Illinois Capital Development Board
401 South Spring, Third Floor
Springfield, IL 62706
(217) 782-9561

Beacon Street Gallery
4520 North Beacon
Chicago, IL 60640
(312) 561-3500

City of Chicago
Department of Cultural Affairs Public Art
 Program
78 East Washington Street
Chicago, IL 60602
(312) 744-6410

Chicago Public Art Group
1255 South Wabash Avenue
Chicago, IL 60605
(312) 427-2724

Evanston Arts Council
Noyes Center
927 Noyes
Evanston, IL 60201
(847) 491-0266

IOWA
Cedar Rapids/Marion Arts Council
P.O. Drawer 4860
Cedar Rapids, IA 52407
(319) 398-5322

Iowa Arts Council
Capitol Complex
600 East Locust
Des Moines, IA 50319-0290
(515) 281-4451

KANSAS
City of Wichita
Public Art Advisory Board
2601 North Arkansas
Wichita, KS 67204
(316) 838-9663

KENTUCKY
Louisville Visual Art Association
3005 Upper River Road
Louisville, KY 40207
(502) 896-2146

LOUISIANA
Arts Council of New Orleans
Percent for Arts
821 Gravier Street, Suite 600
New Orleans, LA 70112
(504) 523-1465

Shreveport Regional Arts Council
800 Snow Street
Shreveport, LA 71101
(318) 673-6515

MAINE
**Maine Commission on the Arts and
 Humanities**
55 Capitol Street, Station 25
Augusta, ME 04333
(207) 287-2726

MARYLAND
City of Baltimore
Civic Design Commission
Wolman Building, Room 9
Holiday and Lexington Street
Baltimore, MD 21202
(301) 396-3671

**Mayor's Advisory Committee on Art &
 Culture**
21 South Eutaw Street
Baltimore, MD 21201
(410) 396-4575

Maryland State Arts Council
601 North Howard Street
Baltimore, MD 21201
(410) 333-8232

City of Rockville
Art in Public Places
Glenview Mansion
603 Edmonston Drive
Rockville, MD 20851
(301) 309-3357

**Montgomery County Art in Public
Architecture**
Department of Facilities & Services
110 North Washington Street
Rockville, MD 20850
(301) 217-6040

**Montgomery County Planning
Department**
8787 Georgia Avenue
Silver Springs, MD 20907
(301) 495-4570

**Prince George's County Art in Public
Places**
CAB Room 5032
Upper Marlboro, MD 20772
(301) 985-5132

MASSACHUSETTS

Boston Art Commission
Boston City Hall
Room 716
Boston, MA 02201
(617) 635-3245

Arts on the Line
Cambridge Arts Council
57 Inman Street
Cambridge, MA 02139
(617) 864-5150

Massachusetts Cultural Council
120 Boylston Street, Second floor
Boston, MA 02116-4600
(617) 727-3668; (800) 232-0960

Office of the Arts & Humanities
City Hall
Room 720
Boston, MA 02201
(617) 725-3850

UrbanArts, Inc.
140 Clarendon Street
Boston, MA 02116
(617) 536-2880

MICHIGAN

Cultural Arts Division
Parks & Recreation Department
26000 Evergreen
Southfield, MI 48037
(313) 354-4717

**Michigan Commission on Art in Public
Places**
1200 Sixth Avenue, P-120
Detroit, MI 48226
(313) 256-2800

City of Southfield
Cultural Arts Division
23450 Southfield Road
Southfield, MI 48075
(812) 424-9029

MINNESOTA

Duluth Public Arts Commission
City Hall
Room 317
Duluth, MN 55802-1196
(218) 723-3385

Forecast Public Artworks
2955 Bloomington Avenue South
Minneapolis, MN 55407
(612) 721-4394

Minneapolis Arts Commission
City Hall
Room 200
350 South Fifth Street
Minneapolis, MN 55415-1385
(612) 673-3006

Minnesota State Arts Board
Department of Administration
400 Sibley Street, Suite 200
St. Paul, MN 55102
(612) 215-1618

Public Art Saint Paul
Minnesota Building
Suite 828
46 East Fourth Street
St. Paul, MN 55101
(612) 290-0921

MISSOURI

Arts in Transit Program
Bi-State Development Agency
707 North First Street
St. Louis, MO 63102
(314) 982-1400, ext. 1386
http://www.bi-state.org

Kansas City Municipal Arts Commission
City Hall
17th Floor
Kansas City, MO 64106
(816) 274-1515

Regional Arts Commission
329 North Euclid Avenue
St. Louis, MO 63108
(314) 361-7441

Allied Arts Council
118 South Eighth Street
St. Joseph, MO 64501-2231
(816) 233-0231
Wbloss@smartnet.net

MONTANA

Montana Arts Council
316 North Park Avenue, Room 252
P.O. Box 202201
Helena, MT 59620-2201
(406) 444-6430

NEBRASKA

Lincoln Arts Council
920 O Street
Lincoln, NE 68508
(402) 434-2787

Nebraska Arts Council
3838 Davenport
Omaha, NE 68131-2329
(402) 595-2122

Metropolitan Arts Council
P.O. Box 1077 DTS
Omaha, NE 68101-1077
(402) 341-7910

NEVADA

Las Vegas Arts Commission
749 Veterans Memorial Drive
Las Vegas, NV 89101
(702) 229-4631

NEW HAMPSHIRE

City of Manchester
Department of Recreation
635 Mammouth Road
Manchester, NH 03104
(603) 624-6565

New Hampshire State Council on the Arts
40 North Main Street
Concord, NH 03301
(603) 271-2789
sylvester@NHSL.LIB.NH.US

NEW JERSEY

Atlantic County Office of Cultural Affairs
1333 Atlantic Avenue, Seventh Floor
Atlantic City, NJ 08401
(609) 625-2776; (609) 646-8699

Cape May County Cultural & Heritage Commission
DN 101 Library Office Building
Cape May Court House, NJ 08210
(609) 465-7111, ext. 419

New Jersey State Council on the Arts
20 West State Street
Third Floor, CN 306
Trenton, NJ 08625-0306
(609) 292-6130

NEW MEXICO

City of Albuquerque
Public Art Program
CIP/OMB
P.O. Box 1293
Albuquerque, NM 87103
(505) 768-3829

City of Las Cruces
200 North Church
Las Cruces, NM 88001
(505) 526-0280

Los Alamos County
Art in Public Places Program
P.O. Box 30
Los Alamos, NM 87544
(505) 662-8080

New Mexico Arts Division
228 East Palace Avenue
Santa Fe, NM 87501
(505) 827-6490

Santa Fe Arts Commission
Percent for Art Program
P.O. Box 909
Santa Fe, NM 87504-0909
(505) 984-6707

Santa Fe Council for the Arts
109 Washington Avenue
Santa Fe, NM 87501
(505) 988-1878

NEW YORK

Buffalo Arts Commission
920 City Hall
Buffalo, NY 14202
(716) 851-5027

Battery Park City Redevelopment Authority
One World Financial Center, 18th Floor
New York, NY 10281-1097
(212) 416-5376

Dormitory Authority of the State of New York
161 Delaware Avenue
Delmar, NY 12054-1398
(518) 475-3079

Metropolitan Transportation Authority
Arts for Transit
347 Madison Avenue, Fifth Floor
New York, NY 10017
(212) 878-7250

New York City Board of Education
Public Art for Public Schools
28-11 Queens Plaza North, Room 513
Long Island City, NY 11101
(718) 706-3477

New York City Department of Cultural Affairs
Percent for Art Program
2 Columbus Circle
New York, NY 10019
(212) 841-4180

New York City Health & Hospitals Corporation
Public Art Program
City Hall, Third Floor
New York, NY 10007
(212) 788-3089

New York State Council on the Arts
915 Broadway
New York, NY 10010
(212) 387-7000

Niagara Council of the Arts
Box 93 Fall Station
Niagara Falls, NY 14303
(716) 284-6188

Port Authority of New York & New Jersey
One World Trade Center, Room 82W
New York, NY 10048
(212) 435-3387

Westchester Public Art
271 North Avenue
New Rochelle, NY 10804

Arts in Public Places Committee of Rockland County
7 Perlman Drive
Spring Valley, NY 10977
(914) 426-3660

NORTH CAROLINA

Charlotte-Mecklenburg Public Art Commission
227 West Trade Street, Suite 250
Charlotte, NC 28202
(704) 372-9667

City of Raleigh Arts Commission
P.O. Box 590
Raleigh, NC 27602
(919) 890-3477

North Carolina Arts Council
Department of Cultural Resources
Raleigh, NC 27601-2807
(919) 733-2111, ext. 15

The Arts Council, Inc.
305 West Fourth Street
Winston-Salem, NC 27611
(919) 733-2821

OHIO

Committee for Public Art
1220 West Sixth Street, Suite 300
Cleveland, OH 44113
(216) 621-5330

Ohio Arts Council
Art in Public Places
Percent for Art
727 East Main Street
Columbus, OH 43205-1796
(614) 466-2613
Two separate programs

City of Dayton
Public Arts Commission
P.O. Box 22
Dayton, OH 45401
(513) 443-3670

Miami Valley Arts Council
P.O. Box 95
Dayton, OH 45402

Dublin Arts Council
129 South High Street
Dublin, OH 43017
(614) 889-7444

Arts Commission of Greater Toledo
2201 Ottawa Parkway
Toledo, OH 43606
(419) 475-2266

OKLAHOMA

Oklahoma City Arts Commission
420 West Main, Suite 210
Oklahoma City, OK 73102
(405) 297-3882

Tulsa Arts Commission
2210 South Main
Tulsa, OK 74114
(918) 584-3333

OREGON

Beaverton Arts Commission
P.O. Box 4755
Beaverton, OR 97076
(503) 526-2288

City of Eugene
Department of Parks, Recreation and
 Cultural Services
One Eugene Center
Eugene, OR 97401
(503) 687-5074

Eugene Art in Public Places Program
Public Works Department
855 Pearl
Eugene, OR 97401
(503) 687-5262

Arts Council of Southern Oregon
33 North Central Avenue, Suite 308
Medford, OR 97501
(503) 779-2820

Metropolitan Arts Commission
City Percent for Art
(also County Percent for Art)
1120 S.W. Fifth Avenue
Portland, OR 97204
(503) 796-5111

Regional Arts and Culture Council
309 S.W. Sixth Avenue, Suite 100
Portland, OR 97204
(503) 823-5400

Oregon Arts Commission
775 Summer Street, N.E.
Salem, OR 97310
(503) 986-0082

Springfield Arts Commission
225 North Fifth
Springfield, OR 97477
(503) 726-3775

PENNSYLVANIA

Abington Art Center
515 Meetinghouse Road
Jenkintown, PA 19046
(215) 887-4882

Fairmount Park Art Association
1616 Walnut Street, Suite 2012
Philadelphia, PA 19103
(215) 546-7550

City of Philadelphia
Office of Arts & Culture
Percent for Art Program
1600 Arch Street
Philadelphia, PA 19103
(215) 686-2800

Philadelphia Redevelopment Authority
1234 Market Street, Eighth floor
Philadelphia, PA 19107
(215) 854-6692

City of Pittsburgh
Department of City Planning
200 Ross Street, Fourth Floor
Pittsburgh, PA 15219
(412) 255-2201

Rhode Island State Council on the Arts
95 Cedar Street, Suite 103
Providence, RI 02903-1034
(401) 277-3880

Warwick Consortium of the Arts &
 Humanities
3275 Post Road
Warwick, RI 02886
(401) 738-2000, ext. 372

South Carolina Arts Commission
1800 Gervais Street
Columbia, SC 29201
(803) 734-8696

South Dakota Arts Council
800 Governors Drive
Pierre, SD 57501
(605) 773-3131

Association for Visual Artists
Masonry Works in Public
744 McCallie Avenue, Suite 321
Chattanooga, TN 37403
(423) 265-4282

Arts Council of Greater Knoxville
P.O. Box 2506
Knoxville, TN 37901
(423) 523-7543

Memphis Arts Council
2714 Union Avenue Extended, Suite 601
Memphis, TN 38112
(901) 452-2787

Tennessee Arts Commission
404 James Robertson Parkway
Parkway Towers, Suite 160
Nashville, TN 37243-0780
(615) 741-1701

City of Austin
Art in Public Places
Parks & Recreation Department
P.O. Box 1088
Austin, TX 78767
(512) 397-1455

Texas Commission on the Arts
Box 13406 Capitol Station
Austin, TX 78711
(512) 463-5535

Arts Council of Brazos Valley
111 University, Suite 217
College Station, TX 77840
(409) 268-2787

City of Corpus Christi
Public Art Program
P.O. Box 9277
Corpus Christi, TX 78469-9277
(512) 880-3461

DART Arts Bank
Dallas Area Rapid Transit
601 Pacific Avenue, Suite 300
Dallas, TX 75202
(214) 749-3278

City of Dallas
Office of Cultural Affairs
Majestic Theatre
1925 Elm Street, Suite 500
Dallas, TX 75201
(214) 670-3284

Navarro Council of the Arts
P.O. Box 2224
119 West Sixth Avenue
Corsicana, TX 75110
(903) 872-5411

Cultural Affairs Council of Houston/
 Harris County
1964 West Gray, Suite 224
Houston, TX 77019
(713) 524-0842

City of San Antonio
Department of Arts & Cultural Affairs
222 East Houston, Suite 500
San Antonio, TX 78205
(210) 222-2787

UTAH

Salt Lake City Arts Council
54 Finch Lane
Salt Lake City, UT 84102
(801) 596-5000

Utah Arts Council
617 East South Temple Street
Salt Lake City, UT 84102
(801) 533-5895

VERMONT

Vermont Council on the Arts
136 State Street, Drawer 33
Montpelier, VT 05633-6001
(802) 828-3291

VIRGINIA

Alexandria Commission for the Arts
1108 Jefferson Street
Alexandria, VA 22314
(703) 838-6348

Chesapeake Fine Arts Commission
P.O. Box 15225
Chesapeake, VA 23328
(757) 382-6639

City of Richmond
Public Art Program
Department of Community Development
900 East Broad Street
Richmond, VA 23219
(804) 780-7425

Virginia Beach Arts & Humanities
Commission
Municipal Center
Virginia Beach, VA 23456
(804) 427-4701

WASHINGTON

Bainbridge Island Arts & Humanities
Council
261 Madison Avenue South
Bainbridge Island, WA 98110
(206) 842-7901

City of Bellevue
Bellevue Arts Commission
P.O. Box 90012
Bellevue, WA 98009
(206) 451-4105

Western Washington University
Bellingham, WA 98225
(206) 650-3000

Edmonds Arts Commission
700 Main Street
Edmonds, WA 98020
(206) 771-0228

City of Everett
Cultural Commission
1507 Wall Street
Everett, WA 98201
(206) 259-0383

City of Kent
Arts Commission
220 Fourth Avenue South
Kent, WA 98032-5895
(206) 859-3991

City of Lynwood
Arts Commission
P.O. Box 5008
Lynwood, WA 98046-5008
(206) 670-6254

Mountlake Terrace Fine Arts Council
5303 228th Street, S.W.
Mountlake Terrace, WA 98043
(206) 776-8956

City of Olympia
Arts Commission
Cultural Services Division
222 North Columbia
Olympia, WA 98501
(360) 753-8380

Washington State Arts Commission
P.O. Box 42675
Olympia, WA 98504-2675
(360) 753-5894

Renton Municipal Arts Commission
200 Mill Avenue South
Renton, WA 98055
(206) 235-2580

City of Seattle
Department of Construction and Land Use
400 Municipal Building
Seattle, WA 98104
(206) 625-4591

Metropolitan King County Public Art Program
506 Second Avenue, Room 1115
Seattle, WA 98104-2311
(206) 684-1569

Seattle Art Commission
312 First Avenue North
Seattle, WA 98109-4501
(206) 684-7311

Municipality of Metropolitan Seattle
MetroArts Program
821 Second Avenue
Seattle, WA 98199
(206) 684-1406

Seattle-Tacoma International Airport
Port of Seattle
Exhibitions and Acquisitions Program
P.O. Box 68727
Room 301
Seattle, WA 98168

Spokane Arts Commission
West 808 Spokane Falls Boulevard
Spokane, WA 99201-3333
(509) 625-6050

Wenatchee Arts Commission
P.O. Box 2111
Wenatchee, WA 98801
(509) 662-6991

WEST VIRGINIA

West Virginia Arts & Humanities Commission
Department of Culture & History Center
1900 Kanawha Boulevard East
Charleston, WV 25305
(304) 558-0240

WISCONSIN

Madison CitiARTS Commission
215 Martin Luther King Jr. Boulevard
Room 200
Madison, WI 53710
(608) 261-9134

Wisconsin Arts Board
101 East Wilson Street
Madison, WI 53702
(608) 266-9737

Milwaukee Art Commission
809 North Broadway
Milwaukee, WI 53202
(414) 286-5796

WYOMING

Wyoming Council on the Arts
Art in Public Buildings
2320 Capitol Avenue
Cheyenne, WY 82002
(307) 777-7742

CANADA

City of Ottawa
Department of the City Clerk
Visual Arts Program
111 Sussex Drive
Ottawa, Ontario K1N 5A1
Canada

Private Initiatives

There are also a number of private, nonprofit organizations around the country that sponsor public works of art. As with the government agencies, these organizations have their own policies with regard to whether public art projects are open to all artists or only those living within the state or municipality. These include:

CALIFORNIA

Capp Street Project/AVT
525 Second Street
San Francisco, CA 94107
(415) 626-7747

Foundation for Art Resources
P.O. Box 38145
Los Angeles, CA 90038
(213) 661-2290

Installations
930 E Street
San Diego, CA 92101
(619) 232-9915

Inter-Arts of Marin
1000 Sir Francis Drake Boulevard
San Anselmo, CA 94960
(415) 457-9744

Landmark Art Projects, Inc.
P.O. Box 3172
La Jolla, CA 92038
(619) 277-7321

Los Angeles Festival
P.O. Box 5210
Los Angeles, CA 90055-0210
(213) 689-8800

Otis Art Institute
Parsons School of Design
2401 Wilshire Boulevard
Los Angeles, CA 90051
(213) 251-0556

Palm Desert Civic Arts Committee
73-510 Fred Waring Drive
Palm Desert, CA 92260

Public Art Works
Falkirk Cultural Center
P.O. Box 150435
San Rafael, CA 94915-0435
(415) 485-3328

Social and Public Art Resource Center
Great Walls Unlimited: Neighborhood
 Pride (Murals)
685 Venice Boulevard
Venice, CA 90291
(310) 822-9560

Stanford University
Art Department
Panel on Outdoor Art
Crown Quadrangle
Stanford, CA 94305
(415) 723-3404

DISTRICT OF COLUMBIA

International Sculpture Center
1050 Potomac Street
Washington, D.C. 20007
(202) 965-6066

Washington Project for the Arts
434 Seventh Street, N.W.
Washington, D.C. 20004
(202) 347-4813

FLORIDA

Pasco Fine Arts Council
2011 Moog Road
Holiday, FL 33590
(813) 845-7322

GEORGIA

Arts Festival of Atlanta
1404 Spring Street, Suite 1
Atlanta, GA 30309
(404) 885-1125

IOWA

Cedar Arts Forum, Inc.
415 Commercial, Suite 310
Waterloo, IA 50701
(319) 291-6333

KENTUCKY

Louisville Visual Art Association
3005 Upper River Road
Louisville, KY 40207
(502) 896-2146

MASSACHUSETTS

Contemporary Sculpture at Chesterwood
P.O. Box 827
Stockbridge, MA 01262
(413) 298-3579

Urban Arts
P.O. Box 1658
Boston, MA 02205
(617) 864-2880

MINNESOTA
Forecast Public Artworks
2955 Bloomington Avenue South
Minneapolis, MN 55407
(612) 721-4394

Public Art St. Paul
867 Fairmount Avenue
St. Paul, MN 55105
(612) 290-0921

MISSOURI
Laumeier Sculpture Park
12580 Rott Road
St. Louis, MO 63127
(314) 821-1209

NEW JERSEY
City Without Walls
One Gateway Center, Plaza Level
Newark, NJ 07102-5311
(201) 622-1188

NEW YORK
Cityarts, Inc.
225 Lafayette Street, Suite 911
New York, NY 10012
(212) 966-0377

Creative Time, Inc.
131 West 24 Street
New York, NY 10011-1942
(212) 206-6674

Food Center Sculpture Park at Hunt's Point
The Bronx Council on the Arts
1738 Hone Avenue
Bronx, NY 10461
(212) 931-9500

Health and Hospitals Corporation Public Art Program
City Hall
New York, NY 10007
(212) 788-3089

Lower Manhattan Cultural Council
One World Trade Ceter, Suite 1717
New York, NY 10048
(212) 432-0900

New York City Department of General Services
Operation Greenthumb/Artists in the Gardens
49 Chambers Street, Room 1020
New York, NY 10007

Organization of Independent Artists
19 Hudson Street, Room 412
New York, NY 10013
(212) 219-9213

Prospect Park Alliance
95 Prospect Park West
Brooklyn, NY 11215
(718) 965-8951

Public Art Fund
1 East 53 Street
New York, NY 10022
(212) 980-4575

The Sculpture Center
167 East 69 Street
New York, NY 10021
(212) 879-3500

Socrates Sculpture Park
P.O. Box 6259
Long Island City, NY 11106
(718) 956-1819

Storm King Art Center
Old Pleasant Hill Road
Mountainville, NY 10953
(914) 534-3190

NORTH CAROLINA
Committee for Public Art
P.O. Box 1004
Hickory, NC 28603-1004
(704) 328-6111

OREGON
Art in Public Places
511 N.W. Drake Road
Bend, OR 97701

PENNSYLVANIA
Mattress Factory
500 Sampsonia Way
Pittsburgh, PA 15212
(412) 231-3169

VIRGINIA
Portsmouth Museum
Civic Arts Program
P.O. Box 850
Portsmouth, VA 23705
(804) 393-8983

Although there is a growing number of public artworks being commissioned around the country, there is no regularity to the process: Proposals by artists to build artworks aren't due in a government agency's offices on certain dates each year. Instead, there is usually a call for proposals that, for municipalities and states with Percent-for-Art laws, takes place when a government building is to be built or renovated. Private businesses in the market for public art may not even publicize their search. They use art consultants instead. This makes having up-to-date information on who is doing what all the more crucial. A number of associations and organizations keep tabs on developments and make that information available to artists. They include:

International Sculpture Center
1050 Potomac Street, N.W.
Washington, D.C. 20007
(202) 965-6066
The Center's International Sculpture
publication lists opportunities in public art

National Conference of Mayors
1620 I Street, N.W.
Washington, D.C. 20006
(202) 293-7330
Referral information on city public arts programs

National Conference of State Legislatures
1125 17th Street, Suite 1500
Denver, CO 80202
(303) 623-7800
Publishes Arts in the States, *offering an overview of arts-related legislation*

Partners for Livable Places
1429 21st Street, N.W.
Washington, D.C. 20036
(202) 887-5990
Has a visual artist database of public art grants that have been awarded

Project for Public Spaces, Inc.
153 Waverly Places
New York, NY 10014
(212) 620-5660
Assists city agencies, community groups, private developers, and planners in commissioning, installing, and maintaining public art projects

Taking Care of Public Art

Outdoor works of art need not only to be created but to be properly maintained and conserved. For artists, this statement may seem too obvious to be worth making but, if one is to judge by the immense and growing number of discolored, eroding, and rusting public sculptures in parks and

city plazas around the country, the concept of providing ongoing care for public art can seem revolutionary. These problems are even worse in Europe, where many ancient sculptures have been taken off their pedastals and moved inside, with replicas put in their place.

The degree to which a sponsoring organization or governmental agency has financial resources or knowledge in the area of art conservation varies widely. Many institutions that commission public art have developed an association with a museum whose conservation department will look after the pieces. Others rely on janitors or maintenance workers, who may clean a sculpture in the same manner they would a park bench. Artists would likely want to write into a contract for a public art commission the type and frequency of ongoing care that is needed (such as cleaning, repainting, repatination, and restoration) and who should supply it (the artists themselves or museum conservators, for instance). A deteriorating artwork does an artist's reputation no good.

A growing recognition of this problem has developed among both artists and institutions that sponsor the creation of public artwork. The Department of Cultural Affairs of New Haven, Connecticut, established a conservation program for that city's public artworks in the late 1980s, and a small line item in the fiscal 1993 budget of the Vermont Council on the Arts set aside $5,000 for the preservation of outdoor sculpture in that state.

A larger step has been taken by the Ohio Arts Council, which is establishing public sculpture conservation as a new category of funding by fiscal 1995. Both arts organizations and individual artists are eligible to apply to the state council's Art in Public Places program for a "condition assessment" of a particular artwork (the council will pay for a museum conservator to examine the piece) and to the Visual Arts program for actual conservation money. As this new plan develops, it is hoped that the Art in Public Places program will take responsibility for both condition assessment and actual conservation costs.

A number of public and private groups have made it their mission to restore existing outdoor artworks either through raising money for this purpose or by providing information and referrals on reputable conservators and conservation techniques, including:

CALIFORNIA

Arts Commission
City and County of San Francisco
25 Van Ness Avenue, Suite 240
San Francisco, CA 94102-6933
(415) 252-2593
Adopt-a-Sculpture program

Public Art Works
P.O. Box 150435
San Rafael, CA 94915-0435
(415) 457-9744
Adopt-a-Sculpture program

John Collentine
Governors Square West
Sacramento, CA 95814-5305
(916) 441-0510

Julie Silliman
1079 South Orange Grove
Los Angeles, CA 90019-6510
(213) 954-9409

COLORADO

Department of Fine Arts
University of Colorado
Box 177—P.O. Box 173364
Denver, CO 80217-3364
(303) 556-4891
Identifies and seeks money for sculptures in need of conservation

CONNECTICUT

City of New Haven
Department of Cultural Affairs
770 Chapel Street
New Haven, CT 06510
(203) 787-8956
Conserves public artworks in New Haven, Connecticut

Connecticut Historical Commission
State Historic Preservation Office
59 South Prospect Street
Hartford, CT 06106-5110
(203) 566-3005
Adopt-a-Sculpture program

DELAWARE

Delaware State University
Department of History and Political
Science
Dover, DE 19901-2275
(302) 739-2321/5751

DISTRICT OF COLUMBIA

American Institute for Conservation of Historic and Artistic Works
1717 K Street, N.W., Suite 301
Washington, D.C. 20006
(202) 452-9545
Conservation services referrals

National Institute for the Conservation of Cultural Resources
3299 K Street, N.W., Suite 403
Washington, D.C. 20007
(202) 625-1495
Information referral

National Park Service
Preservation Assistance Division
P.O. Box 37127
Washington, D.C. 20013-7127
(202) 343-9573
Conserves federally owned public artworks

National Trust for Historic Preservation
1785 Massachusetts Avenue, N.W.
Washington, D.C. 20036
(202) 673-4000
Information referral

FLORIDA

Metro-Dade Art in Public Places
111 N.W. First Street, Suite 610
Miami, FL 33128-1982
(305) 375-5362
Adopt-an-Artwork program

Art in Public Places
City of Tampa
1420 North Tampa Street
Tampa, FL 33602-2927
(813) 274-7736
Conservation fund created

ILLINOIS
Friends of Lincoln Park
4753 North Broadway
Chicago, IL 60640
(312) 275-1000
Conserves public artworks in Chicago

KANSAS
Kansas State Historical Society
3621 West 63 Street
Shawnee Mission, KS 66208-1942
(913) 262-1869
Conservation fund created

MARYLAND
**Commission for Historical and
 Architectural Preservation**
City of Baltimore
417 East Fayette Street, Room 1037
Baltimore, MD 21202-3431
(410) 396-4866
Adopt-a-Sculpture program

MICHIGAN
Saginaw Valley State University
Marshall M. Fredericks Sculpture Gallery
University Center, MI 48710-0001
(517) 790-5667
Adopt-a-Sculpture program

MISSOURI
Historic Kansas City Foundation
201 Wyadotte Street, Suite 101
Kansas City, MO 64105-1250
(816) 471-3391
Adopt-a-Sculpture program

Regional Arts Commission
3540 Washington Aveue
St. Louis, MO 63103-1019
(314) 652-5511
Adopt-a-Sculpture program

University of Missouri
Museum of Art and Archaeology
One Pickard Hall
Columbia, MO 65211-0001
(314) 882-3591
Conservation fund created

NEW MEXICO
New Mexico Arts Division
228 East Palace Avenue
Santa Fe, NM 87501-2013
(505) 827-6490
*Developed guidelines for sculpture
maintenance*

NEW YORK
Municipal Art Society
457 Madison Avenue
New York, NY 10022
(212) 935-3960
Conserves public artworks in New York City

OHIO
The Sculpture Center
12206 Euclid Avenue
Cleveland, OH 44106-4311
(216) 229-6527
Adopt-a-Sculpture program

Greater Columbus Arts Council
55 East State Street
Columbus, OH 53215-42216
(614) 224-2606
Adopt-a-Sculpture program

OREGON
Regional Arts and Culture Council
309 S.W. Sixth Aveue, Suite 100P
Portland, OR 97204-1751
*Developed sculpture maintenance training
videotape*

PENNSYLVANIA
Fairmount Park Art Association
1530 Locust Street, Suite 3A
Philadelphia, PA 19102-4418
(215) 546-7550
Conserves public artworks in Philadelphia

Lackawanna Historical Society
232 Monroe Avenue
Scranton, PA 18510
(717) 344-3841
Adopt-a-sculpture program

Commonwealth Conservation Center
Pennsylvania Historical and Museum
 Commission
908 Market Street
Harrisburg, PA 17101-2810
(717) 787-2292
Conservation services referrals

RHODE ISLAND
Historical Preservation Commission
150 Benefit House
Old State House
Providence, RI 02903-1299
(401) 277-2678

WASHINGTON
Artech, Inc.
2609 First Avenue
Seattle, WA 98121
(206) 728-8822
Manages Seattle's public art holdings

WISCONSIN
Milwaukee Arts Board
P.O. Box 324
809 North Broadway
Milwaukee, WI 53202-3617
(414) 964-8681
Adopt-a-Sculpture program

CANADA
Canadian Conservation Institute
1030 Innes Road
Ottawa, Ontario K1A 0C8
Canada

**International Institute for Conservation
 of Historic and Artistic Works**
Canadian Group
P.O. Box 9195
Ottawa, Ontario, K1G 3T9
Canada

The National Institute for the Conservation of Cultural Resources, in conjunction with the National Museum of American Art of the Smithsonian Institution, has also developed a project called Save Outdoor Sculpture, which is designed to inventory public sculpture around the country as well as to raise money for the treatment of works in greatest need of restoration. Artists may want to inform the SOS project of public sculptures that they have created or are in the process of making as well as to enlist its help to insure that their work is properly conserved. Organizations that have affiliated themselves with the SOS project exist in 43 states and the District of Columbia. They are:

ALABAMA
Alabama State Council on the Arts
(334) 242-4076

ALASKA
Alaska State Museum
(907) 465-2901

ARIZONA
Arizona Commission of the Arts
(602) 255-5882
Tucson-Pima Arts Council
(602) 624-0595

ARKANSAS
Arkansas Historic Preservation
(501) 324-9880

CALIFORNIA
**Institute for Design and Experimental
 Art**
(916) 452-0949

Urban Corps of San Diego
(619) 235-0137

City of San Francisco
(415) 554-9671

COLORADO
Colorado Springs Parks and Recreation Department
(719) 578-6972

Children's Museum of Denver
(303) 433-7444

University of Colorado
(303) 556-4891

CONNECTICUT
Connecticut Historical Commission
(203) 566-3005

DELAWARE
Delaware State University
(302) 739-2321

DISTRICT OF COLUMBIA
D.C. Preservation League
(202) 737-1519

FLORIDA
Florida Arts Council
Division of Cultural Affairs
(904) 487-2980

CityART of Jacksonville
(904) 296-4234

Metro-Dade Art in Public Places
(305) 375-5362

City of Tampa Art in Public Places
(813) 227-7736

GEORGIA
University of Georgia
School of Environmental Design
(706) 542-4731

City of Atlanta
Bureau of Cultural Affairs
(404) 766-9049

HAWAII
Mayor's Office of Culture & the Arts
(808) 523-4674

IDAHO
Idaho Commission on the Arts
(208) 387-0772

ILLINOIS
Illinois Capitol Development Board
(217) 524-5439

Historic Preservation
Chicago Park District
(312) 294-2226

INDIANA
Historic Landmarks Foundation
(317) 639-4534

IOWA
Iowa State University
(515) 294-7427

KANSAS
Kansas State Historical Society
(913) 262-1869

Project Beauty, Inc.
(316) 686-6250

KENTUCKY
Kentucky Arts Council
(502) 564-3757

LOUISIANA
Arts Council of New Orleans
(504) 523-1465

Louisiana State University
(504) 388-5408

Northwestern State University
(318) 357-6464

MAINE
Maine Arts Commission
(207) 287-2710

MARYLAND
Governor's Office of Art and Culture
(410) 225-4712

Baltimore City Commission for
Historical and Architectural
Preservation
(410) 396-4866

MASSACHUSETTS
National Memorial Trust
(617) 593-5631

MICHIGAN
Marshall M. Fredericks Sculpture
Gallery
(517) 790-5667

MINNESOTA
Public Art St. Paul
(612) 290-0921

St. Paul University Club
(612) 221-9765

MISSISSIPPI
Mississippi Department of Archives
and History
(601) 359-6940

MISSOURI
Historic Kansas City Foundation
(816) 471-3391

St. Louis Regional Art Commission
(314) 652-5511

University of Missouri
(314) 882-3591

MONTANA
Montana Historical Society
(406) 442-3058

NEBRASKA
Nebraska Arts Council
(402) 595-2122

NEVADA
Nevada State Council on the Arts
(702) 687-6680

NEW HAMPSHIRE
Inherit New Hampshire
(603) 968-7716

NEW MEXICO
New Mexico Arts Division
(505) 827-6490

NEW YORK
New York State Association of Museums
(518) 273-3416

City of Buffalo Arts Commission
(716) 851-5027

City of New York Arts Commission
(212) 788-3071

NORTH CAROLINA
North Carolina Museums Council
(910) 341-4350

NORTH DAKOTA
North Dakota Museum of Art
(701) 746-7900

OHIO
Ohio Arts Council
(614) 466-2613

Contemporary Arts Center
(513) 481-5745

The Sculpture Center
(216) 229-6527

Greater Columbus Arts Council
(614) 224-2606

Arts Commission of Greater Toledo
(419) 475-2266

OKLAHOMA
Oklahoma Museums Association
(405) 424-7757

OREGON
Regional Arts and Culture Council
(503) 823-4196

PENNSYLVANIA
Fairmount Park Art Association
(215) 546-7550

RHODE ISLAND
Rhode Island Historical Commission
(401) 277-2678

SOUTH CAROLINA
South Carolina Federation of Museums
(803) 737-4921

SOUTH DAKOTA
University of South Dakota
(605) 677-5713

TENNESSEE
Association for Tennessee History
(800) 288-0403

TEXAS
Department of Arts and Cultural Affairs
(512) 222-2787

Art in Public Places Program
Division of Cultural Affairs
City of Austin Parks and Recreation
 Department
(512) 397-1455

Texas Historical Commission
(512) 463-6094

Adopt-a-Monument (Dallas)
(214) 748-4440

Urban Strategies for Tarrant County
 (Fort Worth)
(214) 748-4440

UTAH
Nora Eccles Harrison Museum of Art
(801) 797-0613

VERMONT
Vermont Museum and Gallery Alliance
(802) 533-2561

VIRGINIA
Virginia Department of Historic
 Resources
(804) 225-4252

WASHINGTON
Seattle Arts Commission
(206) 684-7312

Conservation Associates of the Pacific
 Northwest
(206) 866-6000

WEST VIRGINIA
State Historic Preservation Office
(304) 558-0220

WISCONSIN
State Historical Society of Wisconsin
(608) 264-6512

Milwaukee Arts Board
(414) 964-8681

WYOMING
National Wildlife Art Museum
(307) 587-4022

Selling Art to Corporations

In the high-flying 1980s, artists were frequently directed to market their work to corporations, which paid top dollar and found in art collecting (and arts sponsorship, in general) a source of prestige. These days, some of the major art collecting companies are selling off, rather than buying, artwork, and even those buying are doing so rather quietly, not wanting to advertise these

kinds of purchases when they may be laying off employees. Corporate art advisors used to revel in their sought-after position, but nowadays they tell artists, "Don't call us, we'll call you."

"The association stopped giving out the names and addresses of our member advisors years ago," said Mary Anne Golen, president of the Denver, Colorado–based Association of Professional Art Advisors. "We don't want to be inundated by artists' slides, especially when there is just not so much call for art. Our members are much more involved in managing corporate art collections, and in some cases helping corporations deaccession works, than in helping companies buy new works."

Corporate art collecting did not stop in the 1990s, although the downsizing of many large companies and the general slowdown in the economy disproportionately affected the arts. One reflection of that effect is the 20 percent decline in sales for 1993, '94, and '95 of the bible of the corporate art market, *ARTnews* magazine's *International Directory of Corporate Art Collections*. "When we saw our orders dropping like that," said Shirley Howarth, editor of the *Directory*, we knew something serious was going on."

There are signs of life—even renewed life—in the corporate art market, she noted. "In our survey of companies, we ask them, 'Is your collection ongoing?' (meaning, do you still buy artworks) or 'Is your collection completed?' (meaning, are you no longer buying for the collection). We were heartened to see that few companies had written in 'completed.' Our survey has also found a respectable number of new collections at law firms, hotels, private clubs and manufacturing companies."

The trends that she and others have spotted in corporate art collecting are the purchase of smaller and less expensive works, for instance, the work of regional artists as opposed to nationally renowned stars, and an interest in media other than painting and sculpture, such as the crafts (ceramics and textiles) and photography. Howarth also sees as a positive sign that orders for the 1996 edition of the *Directory* were up to 1990 levels.

Artists who are interested in selling their work to corporate collectors should keep their hopes in check, but there are certain avenues that may help their chances of success. "You have to make personal contact with someone in the company," said Margaret Matthews Berenson, a New York City–based corporate art advisor. "You don't send a packet of slides to someone cold."

Some corporations would rather buy art through professional art advisors, while others prefer to be contacted by artists directly and not by

advisors. The 700-page *Directory*, which may be ordered through *ARTnews* (48 West 38 Street, New York, NY 10018, tel. 212-398-1690, $79.95) or found at public and art libraries, indicates for each of the 1,300 corporations listed how the works in the collection are purchased. An in-house corporate staff person at the New York City–based PaineWebber, for instance, buys artwork directly from artists or through art dealers or at auction houses, while Ore-Ida Foods in Boise, Idaho relies solely on an outside art advisor (whose name, address and telephone number is listed in the *Directory*). Artists looking to sell work to either of those companies should contact by telephone or letter the respective people involved in the collections. This may lead to an invitation to submit a packet of slides or even a studio visit.

There are four main associations whose members are involved in corporate art collecting, which artists may contact for assistance:

Association of Professional Art Advisors
2150 West 29th Avenue
Denver, CO 80211
(800) 243-1233

Association of Corporate Art Advisors
544 West Queen Lane
Philadelphia, PA 19144
(215) 848-5791

National Association for Corporate Art Management
P.O. Box 78, Church Street Station
New York, NY 10008
(212) 435-3397

Association of Corporate Art Curators
P.O. Box 11369
Chicago, IL 60611

In addition, the American Institute of Architects (1735 New York Avenue, N.W., Washington, D.C. 20006, tel. 202-626-7300) and the American Society of Interior Designers (608 Massachusetts Avenue, N.E., Washington, D.C. 20002-6006, tel. 202-546-3480) are useful referral sources, as their members are often involved in helping select artworks for newly built and newly renovated office buildings.

Certainly, artists would save time to know in advance of contacting the in-house buyer or outside art advisor what type of art a particular company collects. The NAFCO Financial Group in Naples, Florida, for example, collects works in a variety of media but exclusively devoted to the subject of wildlife, making it an unlikely buyer of abstract sculpture or street scene photography.

Beginning in 1996, the *ARTnews Directory* comes not only as a book but in computer disk form (IBM-compatible only), which may speed up the process of wading through the myriad of corporate entries. One may type in, say, "Prints" and "Ongoing" to find which companies have ongoing

collections of prints. Also, an artist may type in a particular locality—for example, "Albany, New York"—to see which art collecting corporations have headquarters or branch offices there.

Artists might also want to keep tabs, as do professional art advisors, on which companies are moving into new offices—perhaps as a result of expansion or downsizing, which is often reported in the real estate section of a newspaper or in a business periodical such as *Crain's*. Those that are expanding may be in the market for new art purchases.

Obtaining specific information about what a particular corporation may be interested in buying is more difficult these days. Companies are not trumpeting their latest art purchases with press releases as had been frequently the case in the 1980s. In addition, there are fewer acquisitions by corporations of entire collections and more works made to order. "A number of our clients these days are commissioning work, specifying the size, colors and subject matter," Woody Rollins, principal owner of Boston Corporate Art in Boston, Massachusetts, said.

He noted that "what companies are calling art collections now is different" from in the 1980s. The distinction between the categories of "office decoration" and an "art collection" have been blurred, with some companies foregoing original art for reproductions in expensive frames. "A company moves into new offices, and they need art to go in it," Rollins said. "So they buy a frame that goes with the mahogany desk and buy a $30 reproduction for it. We try to convince them that original art creates a better business environment and will actually help their business."

That kind of convincing was not so necessary in the 1980s, as the economic and social value of acquiring art seemed self-evident to companies large and small. "Investment purchases are clearly down, but the decoration market is very alive, and we're doing fabulously there," said Barry Cohen, co-owner of Soho Editions, a print publisher in Owings Mills, Maryland. "Building a quote-unquote art collection is a sore subject at companies where employees are being laid off and share-holders are getting edgy about what the company is doing with its money. If the company can't claim the purchases are for an art collection but only for office decoration, they're not going to spend a lot of money."

The signs of a reversal of fortune for artists, who in the 1980s looked to the corporate art market as a means of supporting themselves, are clear. Six years ago, eight people were employed full-time to buy for, and tend to, the 13,000-piece art collection of the Prudential Insurance Co. of America. Now

there are only two. "We used to buy art to fill entire buildings," said Helene Zucker Seeman, director of the collection, "but now I may have just a floor or only an executive office to fill, and there is still a lot of artwork in storage. In the past, I would come upon something—it could be huge—and think, 'This is a wonderful work. I'm sure I could use it somewhere.' That thinking has changed, and now I need to have a specific setting for anything I might want to buy. I still have a storeroom of enormous paintings from the days when we had huge lobby walls."

A number of corporate art advisors either left the field or turned their attentions to private individuals who collect. Rosemary Cronin and her partner Candy Ellis ran the Hartford, Connecticut art consulting firm Corporate Curators, but dissolved the company in the early 1990s because "most of the corporations in this area stopped buying art," Cronin said. "They began laying off employees and moving to smaller offices. And then there were all these mergers, where you never know who's in charge or where the company is now headquartered, and the art collection is the last thing on anyone's mind."

9

Health and Safety in the Arts

Since the early 1970s, there has been a growing understanding of the potentially hazardous materials in art supplies and therefore of the specific health concerns of artists in all media and disciplines. One of the most visible signs of this understanding was the enactment in 1989 of the federal Labeling of Hazardous Art Materials Act, which requires that art material ingredients that are known chronic hazards be listed on the label with appropriate hazard warnings.

Obtaining Reliable Information

Manufacturers of products containing toxic elements are also bound by state and federal right-to-know laws to fill out Material Safety

Data Sheets, which must be provided to those in employer–employee relationships. Artists may write to these manufacturers for these data sheets. In addition, the Occupational Safety and Health Act requires employers to provide safety measures in order to insure the health and well-being of their employees.

Another source of information on what is in art materials and how they should be properly used are several private and public agencies concerned with these and other related issues. One can receive written material and advice over the telephone. Among the agencies are:

Occupational Safety and Health Administration
U.S. Department of Labor
200 Constitution Avenue, N.W., Room N3101
Washington, D.C. 20210
(202) 523-8151 (information)
(202) 523-0055 (publications)

American Society for Testing and Materials
1716 Race Street
Philadelphia, PA 19103
(215) 299-5400

Centers for Disease Control
1600 Clifton Road, N.E.
Atlanta, GA 30333
(404) 639-3311

American Industrial Hygiene Association
45 White Pond Drive
Akron, OH 44320
(216) 873-2442

Arts, Crafts and Theater Safety
181 Thompson Street, No. 23
New York, NY 10012
(212) 777-0062

Arts and Crafts Materials Institute
715 Boylston Street
Boston, MA 02116
(617) 426-6400

Center for Hazardous Materials Research
University of Pittsburgh Applied Research Center
320 William Pitt Way
Pittsburgh, PA 15238
(412) 826-5320; (800) 334-CHMR

Center for Safety in the Arts
155 Avenue of the Americas
New York, NY 10013-1507
(212) 366-6900, ext. 333
http://www.artswire.org/1/Artswire/csa/

Chemical Referral Center
2501 M Street, N.W.
Washington, D.C. 20037
(800) 262-8200

Eastman Kodak Company
800 Lee Road
Rochester, NY 14650
(716) 722-5151 (24-hour hotline)
(800) 242-2424 (8:00 A.M.–6:30 P.M.: Material safety data sheet, technical information)

Environmental Research Foundation
P.O. Box 73700
Washington, D.C. 20056-3700
(202) 328-1119

Graphic Arts International Union
1900 L Street, N.W.
Washington, D.C. 20036
(202) 833-3970

Hazardous Substance Fact Sheets
New Jersey Department of Health
CN 364
Trenton, NJ 08625-0368
(609) 984-2202

Ilford Photo
West 70 Century Road
Paramus, NJ 07653
(201) 265-6000 (technical information)
(800) 842-9660 (24-hour hotline for medical emergencies)

International Arts-Medicine Association
3600 Market Street
Philadelphia, PA 19104
(215) 525-3784

MSDS Pocket Dictionary
Genium Publishing Corporation
1145 Catalyn Street
Schenectady, NY 12303-1836
(518) 377-8854

National Art Materials Trade Association
178 Lakeview Avenue
Clifton, NJ 07011
(201) 546-6400

National Fire Protection Association
P.O. Box 9101
One Batterymarch Park
Quincy, MA 02269-9101
(800) 344-3555

National Institute for Occupational
Safety and Health
4676 Columbia Parkway
Cincinnati, OH 45226
(800) 356-4674

National Safety Council
444 North Michigan Avenue
Chicago, IL 60611
(312) 527-4800

Polaroid Resource Center
(800) 255-1384

RACHEL (Remote Access Chemical
Hazards Electronic Library)
Environmental Research Foundation
P.O. Box 73700
Washington, D.C. 20056-3700
(202) 328-1119

RCRA/Superfund/Oust Assistance
Hotline
(800) 424-9346
*Source of information on Environmental
Protection Agency regulations on solid- and
hazardous-waste disposal*

Society of Toxicology
1101 14th Street, N.W.
Washington, D.C. 20005
(202) 371-1393

Water Pollution Control Federation
601 Wythe Street
Alexandria, VA 22314-1994
(703) 684-2400

CANADA
Canadian Centre for Occupational
Health and Safety
250 Main Street East
Hamilton, Ontario L8N 1H6
Canada
(416) 572-2981

Ontario College of Art
Director of Health and Safety
100 McCaul Street
Toronto, Ontario M5T 1W1
Canada
(416) 977-5311

Ontario Crafts Council
35 McCaul Street
Toronto, Ontario M5T 1V7
Canada
(416) 977-3551

Health Practitioners Specializing in the Arts

Despite the increasing amount of research into regularly used art materials
and their effects on artists, many health providers are still unlikely to
recognize an occupational ailment or injury. A number of physicians and
health centers around the country specialize in the physical problems that
are peculiar to artists. Most of them are oriented toward the performing arts,
but many will treat visual artists or provide suitable referrals. In certain
instances, these physicians have reduced, or sliding income scale, fee

policies for artists; on a one-on-one level, some may also accept artwork in barter for all or part of the charges.

CALIFORNIA

Southern California Arts
Medicine Program
3413 West Pacific Avenue, Suite 204
Burbank, CA 91505
(818) 953-4430

Peter Ostwald
Performing Artists Health Program
San Francisco Medical Center
University of California
400 Parnassus Avenue, Fifth Floor
San Francisco, CA 94143
(415) 476-7465

Performing Arts Medicine Program
Glendale Adventist Medical Center
1509 Wilson Terrace
Glendale, CA 91206
(818) 409-8076

COLORADO

Stuart Schneck
Health Sciences Center
Neurology Department
University of Colorado, Box B 183
4200 East Ninth Avenue
Denver, CO 80262
(303) 270-7566

ILLINOIS

Alice Brandfonbrenner
Medical Program for Performing Artists
The Rehabilitation Institute of Chicago
345 East Superior Street, Room 1129
Chicago, IL 60611
(312) 908-ARTS

Division of Performing Arts Medicine
Evanbrook Orthopaedic and Sport
Medicine Association Ltd.
1144 Wilmette Avenue
Wilmette, IL 60091
(708) 853-9400

INDIANA

Performing Arts Medical Program
Indiana University School of Medicine
541 Clinical Drive
Indianapolis, IN 46202
(317) 274-4225

KENTUCKY

Arts-in-Medicine Program
The Genesis Center
Department of Psychiatry
University of Louisville School of Medicine
Louisville, KY 40292
(502) 588-7353

MASSACHUSETTS

Musical Medicine Clinic
Massachusetts General Hospital
One Hawthorne Place, Suite 105
Boston, MA 02114
(617) 726-8657

Performing Arts Clinic
Brigham and Women's Hospital
45 Francis Street
Boston, MA 02115
(617) 732-5771

MARYLAND

Performing Arts Medicine Program
Bennett Institute for Sports Medicine &
 Rehabilitation
Children's Hospital
3835 Greenspring Avenue
Baltimore, MD 21211-1398
(317) 669-2015

National Arts Medicine Center
NRH Rehabilitation Center
3 Bethesda Metro Center, Suite 950
Bethesda, MD 20814-5356
(301) 654-9160

MICHIGAN

Arts Health Interlock
University Health Center
Wayne State University
4201 St. Antoine, Suite 4J
Detroit, MI 48201
(313) 543-4410

ARTs Doctor Program
Beaumont Medical Office Building
3535 West Thirteen Mile Road
Royal Oak, MI 48073
(313) 288-2243; (313) 828-6134

Arts Medicine/Medical Rehabilitation
355 Briarwood Circle Drive
Ann Arbor, MI 48108
(313) 998-7899

MINNESOTA

Instrumental Artists Hotline
Sister Kenny Institute
800 East 28th Street
Minneapolis, MN 55407
(612) 863-4481

MISSOURI

Simon Horenstein
3655 Vista Avenue
St. Louis, MO 63110
(314) 776-8100

Performing Arts Program
Jewish Hospital
216 South Kings Highway, Third Floor KB
St. Louis, MO 63110
(314) 454-STAR

NEW YORK

Doctors for Artists
105 West 78th Street
New York, NY 10024
(212) 496-5172

Neurological Consultants of Central New York
P.O. Box 505
5730 Commons Park
Dewitt, NY 13214
(315) 449-0011

Kathryn & Gilbert Miller Health Care Institute for St. Lukes/Roosevelt Hospital
Performing Artists
425 West 59th Street, Suite 6A
New York, NY 10019
(212) 523-6200

Harkness Center for Dance Injuries
Hospital for Joint Diseases
301 East 17th Street
New York, NY 10003
(212) 598-6022

Center for Osteopathic Medicine
41 East 42nd Street, Suite 200
New York, NY 10017
(212) 685-8113

Institute of Rehabilitation Medicine
New University School of Medicine
400 East 34th Street
New York, NY 10016
(212) 263-6105

Performing Arts Center for Health
Mental Hygiene Clinic
Bellevue Hospital
400 East 30th Street
New York, NY 10016
(212) 562-4073

Performing Arts Physical Therapy
2121 Broadway, Suite 201
New York, NY 10023
(212) 769-1423

Vasoma Challenor
Department of Rehabilitation Medicine
Blythedale Children's Hospital
Valhalla, NY 10595
(914) 592-7555

NORTH CAROLINA

Arts Medicine Program
Cultural Services Medical Center
Duke University, Box 3017
Durham, NC 27710
(919) 684-2027

David Goode
Bowman Gray School of Medicine
Medical Centre Boulevard
Winston-Salem, NC 27157-1087
(919) 716-2011

OHIO

Center for Orthopedic Care
2123 Auburn Avenue, Suite 235
Cincinnati, OH 45219
(513) 651-0094

Cleveland Clinic Foundation
Performing Artists Medical Center
9500 Euclid Avenue
Cleveland, OH 44195
(216) 444-5545

Clinic for the Performing Arts
2651 Highland Avenue
Cincinnati, OH 45219
(513) 281-3224

PENNSYLVANIA

Arts Medicine Center
Thomas Jefferson University Hospital
11th and Walnut Streets
Philadelphia, PA 19107
(215) 955-8300

International Arts-Medicine Association
3600 Market Street
Philadelphia, PA 19104
(215) 525-3784

Pennsylvania Pain Rehabilitation Center
Bailiwick 12
Routes 313 and 611 Bypass
Doylestown, PA 18901
(215) 348-5104

Medical Center for Performing Artists
Suburban General Hospital
2705 Dekalb Pike, Suite 105
Norristown, PA 19401
(215) 279-1060

SOUTH CAROLINA
The Vitality Center
St. Francis Hospital
One St. Francis Drive
Greenville, SC 29601
(803) 255-1843

TENNESSEE
Vanderbilt Voice Center
1500 21st Avenue South, Suite 2700
Nashville, TN 37212-3102
(615) 343-SING

TEXAS
Austin Regional Clinic
1301 West 38th Street, Suite 401
Austin, TX 78705
(512) 458-4276

Sports Arts Center
TIRR Institute for Rehabilitation and
 Research
1333 Moursand Avenue
Houston, TX 77030-3405
(713) 799-5000 or (800) 44REHAB

WASHINGTON
Clinic for Performing Artists
Physical Medicine & Rehabilitation Section
Virginia Mason Medical Center
P.O. Box 900
1100 Ninth Avenue
Seattle, WA 98111
(206) 223-6600

CANADA
**Center for Human Performance and
 Health Promotion**
Sir William Osler Health Institute
565 Sanitorium Road
Hamilton, Ontario L9C 7NA
Canada
(416) 574-5444

Artists who work in print studios, sculpture foundries, or other shops in which they are exposed to hazardous materials for long periods of time also need to be safeguarded from disease or accident by their employers. The National Institute of Occupational Safety and Health sponsors educational resource centers, which research issues in occupational safety and provide information to employers on what potentially toxic ingredients are in various products, such as art materials, and how to use them safely. These educational resource centers are:

ALABAMA

Deep South Center for Occupational Health & Safety
School of Public Health
501 Tidwell Hall
University of Alabama at Birmingham
Birmingham, AL 35294-0008
(205) 934-7209

CALIFORNIA

Center for Occupational & Environmental Health
Richmond Field Station
1301 South 46th Street, Building 102
Richmond, CA 94804
(510) 231-5645

Institute of Safety & Systems Management
ISSM Building, Room 108
University of Southern California
University Park
Los Angeles, CA 90089-0021
(213) 740-4038

ILLINOIS

Occupational Health & Safety Center
School of Public Health (M-C922)
Illinois University at Chicago
2121 West Taylor Street
Chicago, IL 60612
(312) 996-7887

MARYLAND

School of Hygiene & Public Health
Johns Hopkins University
615 North Wolfe Street
Baltimore, MD 21205
(410) 955-2609

MASSACHUSETTS

Occupational Safety & Health
Harvard Educational Resource Center
665 Huntington Avenue
Boston, MA 02115
(617) 432-3314

MICHIGAN

Center for Occupational Health and Safety Engineering
IOE Building
1205 Beal Avenue
Ann Arbor, MI 48109-2117
(313) 763-2243

MINNESOTA

Midwest Center for Occupational Health & Safety
Ramsey Foundation
640 Jackson Street
St. Paul, MN 55101
(612) 221-3992

NEW YORK

Mt. Sinai School of Medicine
Box 1057
One Gustave L. Levy Place
New York, NY 10029
(212) 241-6173

NORTH CAROLINA

OSHERC
University of North Carolina
109 Conner Drive, Suite 1101
Chapel Hill, NC 27514
(919) 962-2101

OHIO

University of Cincinnati
3223 Eden Avenue
Cincinnati, OH 45267-0056
(513) 558-5701

TEXAS

Texas University Health Science Center
Houston School of Public Health
Box 20186
Houston, TX 77225
(713) 792-4648

UTAH

**Rocky Mountain Center for Occupa-
 tional and Environmental Health**
Building 512
University of Utah
Salt Lake City, UT 84112
(801) 581-5710

WASHINGTON

**Northwest Center for Occupational
 Health and Safety**
Department of Environmental Health, SC-34
University of Washington
Seattle, WA 98195
(206) 543-1069

The Occupational Safety and Health Administration enforces safety in the workplace by conducting inspections and levying fines for those violating OSHA standards.

**Occupational Safety and Health
 Administration**
United States Department of Labor
200 Constitution Avenue, N.W.
Washington, D.C. 20210
(202) 219-8148

REGION 1

OSHA
133 Portland Street, First Floor
Boston, MA 02114
(617) 565-7164
Covering Connecticut, Maine, Massachusetts,
New Hampshire, Rhode Island, and Vermont

REGION 2

OSHA
201 Varick Street, Room 670
New York, NY 10014
(212) 337-2378
New York, New Jersey, and Puerto Rico

REGION 3

OSHA
Gateway Building
3535 Market Street, Suite 2100
Philadelphia, PA 19104
(215) 596-1201
Delaware, the District of Columbia,
Maryland, Pennsylvania, Virginia, and West
Virginia

REGION 4

OSHA
1375 Peachtree Street, N.E., Suite 587
Atlanta, GA 30367
(404) 347-3573
Alabama, Florida, Georgia, Kentucky,
Mississippi, North Carolina, South Carolina,
and Tennessee

REGION 5

OSHA
230 South Dearborn Street, Room 3244
Chicago, IL 60604
(312) 353-2220
Indiana, Illinois, Michigan, Minnesota, Ohio,
and Wisconsin

REGION 6

OSHA
525 Griffin Street, Room 602
Dallas, TX 75202
(214) 767-4731
Arkansas, Louisiana, New Mexico, Oklahoma,
and Texas

REGION 7

OSHA
911 Walnut Street, Room 406
Kansas City, MO 64106
(816) 426-5861
Iowa, Kansas, Missouri, and Nebraska

REGION 8
OSHA
Federal Building
1961 Stout Street, Room 1576
Denver, CO 80294
(303) 844-3061
Colorado, Montana, North Dakota, South Dakota, Utah, and Wyoming

REGION 9
OSHA
71 Stevenson Street, Room 420
San Francisco, CA 94105
(415) 744-6670

American Samoa, Arizona, California, Guam, Hawaii, Nevada, and Pacific Island Trust Territory

REGION 10
OSHA
1111 3rd Avenue, Suite 715
Seattle, WA 98101-3212
(206) 553-5930
Alaska, Idaho, Oregon, and Washington

Insurance Plans for Artists

Obtaining adequate and affordable health care and health insurance has become a major problem for a sizeable portion of the population. Artists of all media and disciplines are among the most likely groups not to have any health insurance coverage. According to a 1991 survey conducted by the American Council on the Arts and sponsored by the National Endowment for the Arts, less than 75 percent of the composers, filmmakers, photographers, and video artists questioned had any form of coverage. Of all artists in larger cities, the survey found that 30 percent lacked health insurance. One of the reasons for this is the fact that most artists earn too little money to afford insurance; 68 percent of the artists in the survey had household incomes of $30,000 or less.

Perhaps, the current debate in the United States on how to provide coverage for the millions of people without health insurance will result in significant improvements. Perhaps, the increasing prevalence of health maintenance organizations may put out of business many of the arts service organizations that currently offer group-rate plans to their members, as artists may believe that they have less of a need to join such organizations. In this latter scenario, a lot of the career services that only service organizations provide will be lost to artists as well.

Until the health care situation is improved to include all citizens of the United States, regardless of their ability to pay, artists will continue to rely on their own sources of help and coverage. A number of literary, media, performing, visual arts, and crafts organizations provide group-rate health insurance plans for their members. Membership in some of these organizations is confined to artists residing permanently within the particular city or state, while extending nationwide in others. The insurance

industry is regulated by each state. Many of the larger, performing arts unions offer insurance packages for their members, but the coverage plans tend to differ widely from one local chapter to the next, and local chapters are spread around the country geographically. Here and there, a local chapter may have no health insurance program to offer. On the other hand, the Denver Musical Association, Local 20-623 of the American Federation of Musicians, offers members insurance on their instruments—coverage that musicians frequently claim is next to impossible to find and exclusive to this union chapter—along with dental, health, and life insurance.

Many of the organizations offering health insurance programs rarely ask detailed questions about what prospective members do in the arts or otherwise, and it is unlikely that, say, a musician would be denied a medical insurance claim for belonging to a primarily visual artist group. The American Craft Association, an arm of the American Crafts Council, wants its members to be involved in "the crafts or some related profession," and the Maine Writers and Publishers Alliance requires members to be self-employed.

Membership itself is usually not free, as annual dues range from $25 to $50, sometimes more. The costs of individual or group insurance coverage range widely, depending upon the particular plan and its benefits, the insurance carrier, state laws and the number of people enrolled in the plan. Artists generally have been a more difficult group to insure because of industry concerns that they do not earn enough money to pay their premiums as well as that they do not generally take adequate preventive care—a result of their poverty—and require more expensive treatments. More recently, a number of insurance carriers have come to believe that artists as a whole are more likely to contract acquired immunodeficiency syndrome, or AIDS, than many others and have dropped, or exorbitantly raised premiums for, plans that cover artists in all media and disciplines. There is no factual basis for this belief, but the subject of AIDS and negative ideas about artists in our society generally tend to exist well outside rational discussion.

Becoming a member does not immediately enroll an artist in an organization's health care program, and insurance carriers are permitted to deny coverage to any individual. Insurance carriers usually require new members to complete a questionnaire or take a physical, and enrollees in a health plan sometimes must wait for a period of months. The reason for this is that, over the years, insurance companies have seen people join a

group's insurance program in order that someone else pay for a needed operation and then drop the health plan after they have recovered. Artists need to look at health insurance as a long-term commitment, and they also should shop around for the most suitable membership groups that they are eligible to join. The organizations offering health (and perhaps accident, dental, life, liability, studio, and disability) insurance include:

PERFORMING ARTS

Actors Equity
Pension & Welfare Department
165 West 46th Street
New York, NY 10036
(212) 869-9380
*Union membership open to professional
actors*

American Federation of Musicians
1501 Broadway, Suite 600
New York, NY 10036
(212) 869-1330
*Union membership open to professional
musicians*

**American Federation of Television &
Radio Artists**
Pension & Welfare Department
260 Madison Avenue
New York, NY 10016
(212) 213-2022
*Union membership open to those working in
radio and television*

American Guild of Musical Artists
Pension & Health Funds
1841 Broadway, Room 507
New York, NY 10023
(212) 765-3664
*Union membership open to professional
opera and concert choral singers, ballet and
modern dancers as well as professional
musicians*

**American Society of Composers,
Authors & Publishers**
One Lincoln Plaza
New York, NY 10023
(212) 595-3050
*Union membership open to composers and
musicians*

Chamber Music America
545 Eighth Avenue
New York, NY 10018
(212) 244-2772
*Union membership open to freelance
musicians, ensembles, and presenting
organizations*

Chicago Dance Coalition
67 East Madison, Suite 2112
Chicago, IL 60603
(312) 419-8384

Chorus America
Association of Professional Vocal
 Ensembles
2111 Sansom Street
Philadelphia, PA 19103
(215) 563-2430
*Union membership open to professional
singers, conductors, and choral musicians*

Dance Bay Area
2141 Mission, Suite 303
San Francisco, CA 94110
(415) 255-2794

The Dramatists Guild
234 West 44th Street
New York, NY 10036
(212) 398-9366

Early Music America
30 West 26th Street, Suite 1001
New York, NY 10010-2011
(212) 366-5643

**Musicians Association of San Diego—
Local 325**
1717 Morena Boulevard
San Diego, CA 92110
(619) 276-4324

Philadelphia Dance Alliance
1315 Walnut Street, Suite 1505
Philadelphia, PA 19107
(215) 545-6344

Screen Actors Guild
Pension & Welfare Plans
New York Branch Office:
1515 Broadway
New York, NY 10036
(212) 382-5643
*Union membership open to professional
actors*

**Society of Stage Directors &
 Choreographers**
Pension & Welfare Office
1501 Broadway
New York, NY 10036
(212) 391-1070
*Union membership open to stage directors
and choreographers*

Theatre Bay Area
657 Mission Street, Suite 402
San Francisco, CA 94105
(415) 957-1557

United Scenic Artists
Pension & Welfare Department
575 Eighth Avenue, Third floor
New York, NY 10018
(212) 736-6260
*Membership in the union is open to scenic,
costume, and lighting designers*

Wichita Musicians Association
530 East Harry, Suite 112
Wichita, KS 67211
(316) 265-6445

LITERARY

**American Society of Journalists and
 Authors**
1501 Broadway, Suite 1907
New York, NY 10032
(212) 997-0947

Authors Guild
330 West 42nd Street
New York, NY 10036
(212) 563-5904

California Poets in the Schools
870 Market Street, Suite 657
San Francisco, CA 94102
(415) 399-1565

Maine Writers and Publishers Alliance
12 Pleasant Street
Brunswick, ME 04011
(207) 729-6333

National Writers Union
873 Broadway, Suite 203
New York, NY 10003
(212) 254-0279

PEN American Center
468 Broadway
New York, NY 10012
(212) 334-1660

Washington Independent Writers
220 Woodward Building
733 Fifteenth Street, N.W.
Washington, D.C. 20005
(202) 347-4973

VISUAL ARTS AND CRAFTS

Albany League of Arts
19 Clinton Avenue
Albany, NY 12207
(518) 449-5380

American Association of Museums
1225 I Street, N.W., Suite 200
Washington, D.C. 20005
(202) 289-1818/6575; (800) 323-2106
*Health insurance available to independent
curators, consultants, professional staff, and
volunteers. Insurance coverage currently not
offered to those living in New Hampshire or
Kansas.*

American Craft Association
21 South Eltings Corner Road
Highland, NY 12528
(914) 883-5218
(800) 724-0859

American Institute of Graphic Arts
1059 Third Avenue
New York, NY 10021
(212) 752-0813

American Society of Artists
American Artisans of American Society of
 Artists
Box 1326
Palatine, IL 60078
(312) 751-2500; (312) 991-4748

American Society of Interior Decorators
608 Massachusetts Avenue, N.E.
Washington, D.C. 20002-6006
(202) 546-3480

Arkansas Arts Council
1500 Tower Building
323 Center Street
Little Rock, AK 72201
(501) 324-9150

Artist Trust
1402 Third Avenue, Suite 415
Seattle, WA 98101
(206) 467-8734

Arts Council for Chautauqua County
116 East Third Street
Jamestown, NY 14701
(716) 664-2465

Arts Council of Greater New Haven
110 Audubon Street
New Haven, CT 06511
(203) 772-2788

Arts for Greater Rochester, Inc.
335 East Main Street, Suite 200
Rochester, NY 14604-2185
(716) 546-5602

Boston Visual Artists Union
P.O. Box 399
Newtonville, MA 02160
(617) 695-1266

Chicago Artists' Coalition
5 West Grand Avenue
Chicago, IL 60610
(312) 670-2060
 or
Janecek & Associates (the coalition's
 insurance agent)
4433 West Touhy Avenue, Suite 405
Lincolnwood, IL 60646
(312) 763-8898; (847) 673-8778
*Health insurance for artists in the states of
Arizona, Connecticut, Iowa, Illinois, Indiana,*

*Massachusetts, Michigan, Minnesota,
Missouri and Wisconsin*

College Art Association of America
275 Seventh Avenue
New York, NY 10001
(212) 691-1051; (800) 323-2106
*Offering major medical, hospital indemni-
fication, professional liability, cancer and
disaster insurance coverage*

Cultural Alliance of Greater Washington
410 Eighth Street, N.W., Suite 600
Washington, D.C. 20004
(202) 638-2406

Empire State Crafts Alliance
320 Montgomery Street
Syracuse, NY 13202
(315) 472-4245

Graphic Artists Guild
11 West 20th Street
New York, NY 10011
(212) 463-7730

International Sculpture Center
1050 17th Street, N.W., Suite 250
Washington, D.C. 20036
(202) 785-1144

Maine Crafts Association
P.O. Box 228
Deer Isle, ME 04627
(207) 348-9943

Marin Arts Council
251 North San Pedro Road
San Raphael, CA 94903
(415) 499-8350

Michigan Guild of Artists & Artisans
118 North Fourth Avenue
Ann Arbor, MI 48104
(313) 662-3382

**Montana Institute of the Arts
 Foundation**
P.O. Box 1456
Billings, MT 59103
(406) 245-3688

National Artists Equity Association
P.O. Box 28068 Central Station
Washington, D.C. 20038-8068
(202) 628-9633; (800) 727-NAEA

New York Artists Equity Association
498 Broome Street
New York, NY 10013
(212) 941-0130
Group insurance coverage currently available
only to residents of Connecticut, New Jersey,
New York, and Pennsylvania

Society of Illustrators
128 East 63rd Street
New York, NY 10021
(212) 838-2560

Texas Fine Arts Association
3809-B West 35th Street
Austin, TX 78703
(512) 453-5312
Available to residents of Texas

Women's Caucus for Art
Moore College of Art
20th & The Parkway
Philadelphia, PA 19103
(215) 854-0922
Insurance coverage currently unavailable for
members living in Connecticut, North
Carolina, Oregon, and Utah

FILM AND VIDEO
American Society of Media Photographers
419 Park Avenue South
New York, NY 10016
(212) 889-9144

**Association of Independent Video and
 Filmmakers**
625 Broadway
New York, NY 10012
(212) 473-3400
Insurance available only to those working a
minimum of 30 hours per week in the field
of film and video

International Documentary Association
1551 South Robertson Boulevard, Suite 201
Los Angeles, CA 90035
(310) 284-8422

Media Alliance
Fort Mason, Building D
San Francisco, CA 94123
(415) 441-2559

**San Francisco Bay Area Film/Tape
 Council**
P.O. Box 151503
San Rafael, CA 94915-1503
(415) 457-9701

Group-rate health insurance plans are also offered by organizations of self-employed people, and artists may be qualified for membership:

Co-op America
2100 M Street, N.W., Suite 403
Washington, D.C. 20036
(202) 872-5307; (800) 424-9711

**National Association for the Self-
 Employed**
Box 612067
Dallas, TX 75261-9968
(800) 232-6273

National Small Business United
1155 15th Street, N.W., Suite 710
Washington, D.C. 20005
(800) 345-NSBU

Small Business Service Bureau
P.O. Box 1441
544 Main Street
Worcester, MA 01601
(508) 756-3513; (800) 343-0939

Support Services Alliances
P.O. Box 130
Schoharie, NY 12157
(518) 295-7966; (800) 322-3920

10

A Code of Ethical Conduct for Artists

Technical assistance programs, sources of fellowships and project grants, career seminars, group-rate health insurance, free business and legal services, sources of public art commissions, art colonies, artist-in-residence programs, living and working space for artists—all of these have quite practical applications to artists, and the best efforts have been made to insure that these listings are as complete and as up-to-date as possible.

How artists should behave and how they should respond to professional challenges posed by arts administrators, charitable groups, collectors, dealers, exhibition sponsors, museum officials, and others who may affect their careers are questions that seem more

abstract, more personal, and less nitty-gritty. However, the answers that artists find to these questions are what determine the degree to which they are, in fact, professionals. Artists whose practices are sloppy, or who allow others to take advantage of them, are not destined for success. A professional attitude is not to be put off until after the artist finally is self-supporting through the sale of his or her art. Rather, that attitude commences on the first day of an artist's career.

A number of arts service organizations have developed ethical guidelines for their members. No artist is drummed out of the organization for violating one, but they offer a sense of the professional standards to which artists should generally adhere. Among these groups are:

American Federation of Arts
1083 Fifth Avenue
New York, NY 10028
(212) 988-7700

American Institute of Graphic Arts
1059 Third Avenue
New York, NY 10021
(212) 752-0813

Boston Visual Artists Union
P.O. Box 399
Newtonville, MA 02160
(617) 695-1266

Canadian Artists' Representation/Le Front des Artistes Canadiens (CAR/FAC)
21 Forest Drive
Aylmer, Québec J9F 4E3
Canada
(819) 682-4183

Chicago Artists Coalition
5 West Grand Avenue
Chicago, IL 60610
(312) 670-2060

Graphic Artists Guild
11 West 20th Street, Eighth floor
New York, NY 10011
(212) 463-7730

Joint Ethics Committee
P.O. Box 179 Grand Central Station
New York, NY 10017
(212) 966-2492

National Artists Equity Association
P.O. Box 28068 Central Station
Washington, D.C. 20038
(202) 628-9633; (800) 727-NAEA

The ethical code of each group is as broad or specific as the particular membership. Below is a general statement of principles, which I have developed, that may be of value to artists as they proceed down their career paths.

Moral and ethical concerns have been on the rise for visual artists in this country over the past decade. Actually, these days, every professional group is looking at ethical questions, but the process is still somewhat different for artists. Confronted by attornies who use legal maneuvers to shield their guilty clients from justice, for instance, many law schools have established ethics courses for students. Major hospitals are themselves

increasingly employing the services of medical ethicists. Accountants, appraisers, doctors, and therapists have added codes of ethical conduct to their membership associations, a result of legislative actions to curb abusive practices.

There are also ethical considerations for artists yet, in contrast to the codes of conduct that are intended to regulate questionable behavior of other professionals, the codes involving artists are less concerned with the evils they do than what is done to them. The 1990 Visual Artists' Rights Act, enacted by Congress, for example, is a piece of "moral rights" legislation that permits painters, sculptors, printmakers, and fine art photographers to sue in order to protect their art from being altered, mutilated, or destroyed by the people who own the work. The law also allows artists to recover damages after these violations have taken place.

Below is a list of some of these professional and ethical concerns with the purpose of alerting artists to practices by others that should be resisted. There may be many others, as readers might discover in looking back on some of their own experiences:

Juried Art Competitions and Art Fairs

- Artists should not be charged entry fees for submitting slides of their work to competitions. Just as dancers and actors do not pay to audition and novelists needn't send in a check along with their manuscript to a book publisher, visual artists should not have to pay for someone to look at their work. Show sponsors must find other means of fundraising for their events than demanding that artists provide up-front money.

Entry fees are a tax on artists; the fundraising burden of show organizers should not be placed on the shoulders of artists. Show sponsors may raise money for these events in advance through fundraising (from businesses and governmental agencies) or by recouping their up-front money (charging admissions, creating and selling a catalogue, creating and selling poster or T-shirt images from the show, taking a commission on sales).

Artists can fight entry fees on three fronts: First, they should band together to present a united front in their opposition to these fees, sending a letter to the show sponsors outlining their objections to these fees; second, they might also look to enlist the aid of larger and older visual arts membership groups, such as National Artists Equity Association or the Boston Visual Artists Union, which have long opposed these fees, to send

material to the show sponsor that explains the artists' position and offer ideas on how else to raise money for a juried exhibition; finally, artists might begin a letter-writing campaign to the judge or jurors of the fee-charging show, explaining their opposition to the entry fee, with copies sent to the jurors' employers (trustees, for instance, if a juror is otherwise a museum curator) and to major art magazines and newspapers.

- Artists should not be required to pay for a booth at an art fair in advance of being selected to be in the fair. The money artists are asked to pay is usually returned later, if the artist has not been chosen, but the fair sponsors have almost always cashed the check and drawn interest on it. Artists should be asked to pay for the booth when they are in the show. If the purpose of requiring booth payments in advance is to ensure the artist's seriousness in taking part in the fair, show sponsors should send back the applicant's own check when that person is not accepted.

There usually is a waiting list for most shows, and most artists can take part in them on a moment's notice. Artists don't need to prove their seriousness as much as show organizers have to prove that they aren't in it largely for the artist's money.

- Artists should never submit work for a juried competition or fair before knowing who the judge or juror is. The prestige of these events rests greatly on the stature of the juror, and artists may not wish to expend time, energy, and money on shows of little or no importance. Certainly, artists should have all the information before making this decision.

Too many shows are poorly organized, with sponsors waiting until applications (and application fees) are received before they get around to finding jurors and thinking about ways to publicize the events. Artists should know in advance the time, date, and place of the shows, who the juror(s) is(are), how many visitors are expected (how many came in previous years), what is the sponsor's experience in putting on these kinds of shows, what kind of marketing and publicity efforts are being done to ensure the success of the events, and whether or not there will be any big-name artists in attendance (in the case of a fair) to draw in the public.

- Show sponsors should insure the artwork in their care. Many artists also believe that show sponsors should pay for the packing and transportation of artwork at least for its return to the artist.

Art Dealers, Collectors, Galleries, and Museums

- Artists should not hand over their work to any dealer without some formal (or informal) written consignment agreement. This consignment sheet should address such issues as the term of the agreement (try it out for six months or a year, for instance), the nature of the relationship (exclusive or nonexclusive, for instance), the exact accounting of what is being consigned to the dealer (as well as a receipt), price arrangements (minimum amounts per work or prices for each work and what sorts of discounts may be allowed), the percentage of the dealer's commission, the responsibilities of both dealer and artist (how promotional efforts for a show will be handled, where advertisements will be placed, who will pay for framing and insurance, and whether or not the artist will be compensated for the loss in the event of damage or theft), the frequency and nature of the exhibits (one-person exhibitions, group shows, once a year or less often, when in the year, and how the work will be shown), the requirement for periodic accounting (who has purchased the works, how much was paid for them, where and when have works been loaned or sent out on approval) and prompt payment by the dealer (60 to 90 days should be the absolute limit, 30 days is preferable).

Galleries should also not accept artwork without a consignment agreement.

- Artists should also separately keep track of where their work is and who owns it. California artists whose artwork is resold to California collectors, for instance, are entitled by state law to a five percent "resale royalty." They would certainly want to know whether or not they are owed money.

If artists live in one of the 29 states that do not have laws protecting an artist if his or her gallery goes bankrupt (so that other creditors may not seize art on consignment), they should also file a UCC-1 form for works on consignment in the county clerk's office (requiring a nominal filing fee), which stipulates that the artist has a prior lien on his or her work in the event that the gallery has to declare bankruptcy. (The twenty-one states around the country with bankruptcy protection laws for artists are Arizona, Arkansas, California, Colorado, Connecticut, Florida, Georgia, Illinois, Iowa, Kentucky, Maryland, Massachusetts, Michigan, Minnesota, New Mexico, New York, Oregon, Pennsylvania, Texas, Washington, and Wisconsin.)

- Artists should not automatically cede all rights to their artwork that

is acquired by museums. The sale of the copyright should be separate, and the use that institutions make of images needs to be carefully monitored.

- Artists should disclose all information about the works they are selling. Whether a piece of art is particularly fragile, the size and publication date of a limited edition (of prints or sculpture), as well as what previous editions of the same image exist, all need to be discussed openly.

Eleven states (Alaska, California, Georgia, Hawaii, Illinois, Maryland, Michigan, Minnesota, New York, Oregon and South Carolina) currently have print disclosure laws on the books. (In New York, the law was amended in 1991 to include sculpture.) Since these laws help make consumers more confident about buying art, and therefore more willing to buy it, artists should support these measures by demanding that their prints be labeled accordingly, even if they live in states without these laws.

- Museums should allow artists reasonable access to their art in the event of an exhibition, such as a retrospective, and they should include artists in decisions concerning conservation and restoration of their work. Especially with mixed media pieces or those in which there is an admixture of materials, the artists would be the best source of information of what methods and which materials were used in the creation, and in which order.
- Both artists and dealers should honor their contracts. For example, "if the dealer has exclusive right to selling the work, the artist shouldn't make sales out of his studio," Martin Bressler, legal counsel to the Visual Artists and Galleries Association, said.
- Artists should avoid "galleries" that charge rent when exhibiting one's artwork, or whose "directors" require a jurying fee in order to evaluate the work of prospective artists or a "sitting fee" in order to cover their time in the gallery. The likelihood of sales at these galleries is quite poor; the prospect of having an exhibition reviewed is worse. Vanity galleries for the visual artist, just as vanity publishers for authors, not only do not add to one's prestige or professional credentials but actually, take away from them.

Charity Auctions

- Since current tax law only permits artists to deduct on their tax returns the cost of materials for artwork they donate to charitable

institutions, as opposed to the full market value of the art which a collector may declare, charity auctions should not pressure artists to offer their pieces for these events. Charity auction sponsors should approach collectors rather than artists whenever possible, which allows both the artist and collector to benefit from the resale.

- Charity events should be sensitive to the tax disincentives for artists to give their creations and not continually demand art year after year. "The number of requests for donations of your work jumps up geometrically after you give once," photographer Nicholas Nixon said. "You find yourself on everyone's list. They sometimes treat you as though they're entitled to your work and, once you start to say 'no,' they are not particularly sympathetic. Sometimes, they sneer." Other artists have found the same to be true. "I get annoyed at the way you get asked again and again to give something," printmaker and sculptor Leonard Baskin noted, adding that "artists don't get a lot of feedback from the donation of works."

- Since artists may come to feel resentment over how little their work sells for at charity auctions—vacations and free dinners tend to be more coveted, especially at mixed auctions—they may want to establish minimum bids. This would ensure that the art is not sold unless the bid reaches a certain amount. In general, artists should try to gauge what their feelings will be if they see their good work selling for relatively little money.

- Artists may prefer to offer works for sale at charity auctions, donating the money earned (or a certain portion of that money) to the charitable cause, which they may deduct in full on their tax returns.

Artists who allow themselves to be taken advantage of probably will be. They must behave professionally and ethically and demand to be accorded the same conduct by others. Certainly, artists would be reluctant to harm their careers through adhering too strictly to this or any code of conduct, but they should voice their concerns to offending individuals or institutions and band together in order to press their demands for change. Working in concert with other artists on behalf of their own interests is the final recommended professional practice.

Bibliography

Staying in Touch with Changing Currents in the Art World

As noted in the introduction, a growing quantity of information has been compiled that may be of great help to artists. No one book can tell artists everything they need to know anymore; artists whose long-term goal is to support themselves solely through the sale of their art probably should begin to assemble a library of career-oriented books and other publications.

Updating one's library and having more than one resource book also ensures that the information on which an artist may rely isn't already dated. When copies of a report, *Cultural Centers of Color*, which had been commissioned by the National Endowment for the Arts in 1992, were sent to the listed

organizations in 1993, a large number of copies were returned to the federal arts agency, marked "Address Unknown." Artists who do not stay up-to-date will fall behind.

SOURCES OF PUBLIC & PRIVATE GRANTS

American Art Directory. R. R. Bowker, 1992.

American Council for the Arts. Money for Film and Video Artists. American Council for the Arts, 1993.

American Council for the Arts. Money for Performing Artists. American Council for the Arts, 1991.

American Council for the Arts. Money for Visual Artists. American Council for the Arts and Allworth Press, 1993.

Annual Register of Grant Support. R. R. Bowker, 1994.

Art Resources International: Money to Work, 1992.

Fandel, Nancy A., ed. A National Directory of Arts and Education Support by Business and Corporations. Washington International Arts Letters, 1989.

Fandel, Nancy A., ed. A National Directory of Grants and Aid to Individuals in the Arts. Washington International Arts Letters, 1987.

Gullong, Jane, Noreen Tomassi, and Anna Rubin. Money for International Exchange in the Arts. American Council for the Arts and Arts International, 1992.

Hale, Suzanne, ed. Foundation Grants to Individuals. The Foundation Center, 1991.

Margolin, Judith B. The Individual's Guide to Grants. Plenum Press, 1983.

Morris, James McGrath and Laura Adler, Ed. Grant Seekers Guide. Moyer Bell, 1996.

Siegman, Gita, ed. Awards, Honors & Prizes. Gale Research Company, 1988.

White, Virginia P. Grants for the Arts. Plenum Press, 1980.

OTHER SOURCES OF FINANCIAL SUPPORT FOR ARTISTS

ARTnews. ARTnews' International Directory of Corporate Art Collections. ARTnews, 1992.

Christensen, Warren, Ed. National Directory of Arts Internships. National Network for Artist Placement, 1989.

Eckstein, Richard M., Ed. Directory of Building and Equipment Grants. Research Grant Guides, 1994.

Jeffri, Joan. ArtsMoney: Raising It, Saving It, and Earning It. University of Minnesota Press, 1983.

Jeffri, Joan, Ed. Artisthelp: The Artist's Guide to Human and Social Services. New York: Neal-Schuman, 1990.

Kartes, Cheryl. Creating Space: A Guide to Real Estate Development for Artists. American Council for the Arts and Allworth Press, 1993.

Kruikshank, Jeffrey L. and Pam Korza. Going Public: A Field Guide to the Developments of Art. Amherst: Arts Extension Service, University of Massachusetts, 1989.

Porter, Robert, ed. Guide to Corporate Giving in the Arts. American Council for the Arts, 1987.

CAREER SKILLS FOR ARTISTS

Abbott, Susan and Barbara Webb. Fine Art Publicity: The Complete Guide for Galleries and Artists. Allworth Press.

Alliance of Artists' Communities. Artists Communities. Allworth Press, 1996.

ArtCalendar. Making a Living as an Artist. ArtCalendar, 1993.

Bowler, Gail. Artists & Writers Colonies: Retreats, Residencies & Respites for the Creative Mind. Blue Heron Press, 1995.

Caplin, Lee. The Business of Art. Prentice Hall, 1989.

Cochrane, Diana. This Business of Art. Watson-Guptill, 1988.

Cummings, Paul. Fine Arts Market Place. R. R. Bowker, 1977.

Davis, Sally Prince.The Fine Artist's Guide to Showing and Selling Your Work. North Light Books, 1990.

Davis, Sally Prince. Graphic Artists Guide to Marketing and Self-Promotion. North Light Books, 1987.

DuBoff, Leonard. The Art Business Encyclopedia. Allworth Press, 1994.

Goodman, Calvin J. Art Marketing Handbook. GeePeeBee, 1985.

Gordon, Elliott, and Barbara Gordon. *How to Sell Your Photographs and Illustrations.* Allworth Press, 1990.

Grant, Daniel. *The Business of Being an Artist.* Allworth Press, 1996.

Grant, Daniel. *On Becoming an Artist.* Allworth Press, 1993.

Graphic Artists Guild Handbook: Pricing and Ethical Guidelines. Graphic Artists Guild, 1984.

Holden, Donald. *Art Career Guide.* Watson-Guptill, 1983.

Hoover, Deborah A. *Supporting Yourself as an Artist.* Oxford University Press, 1989.

Indian Arts and Crafts Board. *Potential Marketing Outlets for Native American Artists and Craftspeople.* Indian Arts and Crafts Board (U.S. Department of the Interior, 1849 C Street, N.W., MS-4004, Washington, D.C. 20240-0001), 1993.

Janecek, Lenore: *Health Insurance: A Guide for Artists, Consultants, Entrepreneurs & Other Self-Employed.* American Council for the Arts, 1993.

Klayman, Toby and Cobbett Steinberg. *The Artist's Survival Manual.* Charles Scribner's Sons, 1987.

Langley, Stephen, and James Abruzzo. *Jobs in Arts and Media Management.* New York: American Council for the Arts, 1992.

MFA Programs in the Visual Arts: A Directory. College Art Association of America, 1987.

Martin, Daniel J., ed. *Guide to Arts Administration Training & Research, 1995–1997.* Association of Arts Administration Educators, 1995.

Michels, Caroll. *How to Survive & Prosper as an Artist.* Henry Holt and Company, 1992.

NAAO Directory. National Association of Artists Organizations, 1992.

Phillips, Renee: *New York Contemporary Art Galleries.* Manhattan Arts International, 1995.

Shaw Associates. *The Guide to Arts & Crafts Workshops.* Shaw Associates, 1991.

Shaw Associates. *The Guide to Photography Workshops & Schools.* Shaw Associates, 1992.

Shaw Associates. *The Guide to Writers Conferences.* Shaw Associates, 1992.

Shipley, Lloyd W. *Information Resources in the Arts.* Library of Congress, 1986.

Stolper, Carolyn L., and Karen Brooks Hopkins. *Successful Fundraising for Arts and Cultural Organizations.* Oryx Press, 1989.

Viders, Sue. *Producing and Marketing Prints.* Color Q, Inc., 1992.

Vitali, Julius. *The Fine Artist's Guide to Marketing and Self-Promotion.* Allworth Press, 1996.

ART AND THE LAW

Borchard, William M. *Trademarks and the Arts.* Reed Foundation, 1989.

Conner, Floyd, et al. *The Artist's Friendly Legal Guide.* North Light Books, 1988.

Crawford, Tad. *Business and Legal Forms for Fine Artists.* Allworth Press, 1995.

Crawford, Tad. *Business and Legal Forms for Illustrators.* Allworth Press, 1990.

Crawford, Tad. *Business and Legal Forms for Authors and Self-Publishers.* Allworth Press, 1996.

Crawford, Tad. *Legal Guide for the Visual Artist.* Allworth Press, 1995.

Crawford, Tad and Eva Doman Bruck. *Business and Legal Forms for Graphic Designers.* Allworth Press, 1995.

Leland, Caryn. *Licensing Art and Design.* Allworth Press, 1995.

Messman, Carla. *The Artist's Tax Workbook.* Lyons & Burford, 1992.

Norwick, Kenneth P,. and Jerry Simon Chasen: *The Rights of Authors, Artists, and Other Creative People.* Southern Illinois University Press, 1992.

Wilson, Lee. *Make It Legal.* Allworth Press, 1990.

Wilson, Lee. *The Copyright Guide.* Allworth Press, 1996.

HEALTH & SAFETY IN THE ARTS & CRAFTS

Mayer, Ralph. *The Artist's Handbook.* Viking, 1982.

Mayer, Ralph. *The Painter's Craft.* Penguin Books, 1977.

McCann, Michael. *Artist Beware.* Lyons & Burford, 1992.

Rossol, Monona. *The Artist's Complete Health and Safety Guide.* Allworth Press, 1994.

Shaw, Susan D., and Monona Rossol. *Overexposure: Health Hazards in Photography*. American Council for the Arts and Allworth Press, 1991.

OF RELATED INTEREST

Access to Art: A Museum Directory for Blind and Visually Impaired People. American Museum for the Blind and the Museum of American Folk Art, 1989.

Baumol, William J., and William G. Bowen. *Performing Arts: The Economic Dilemma*. M.I.T. Press, 1966.

Benedict, Stephen, ed. *Public Money and the Muse: Essays on Government Funding for the Arts*. W. W. Norton, 1991.

Cockcroft, Eva, John Weber, and James Cockcroft. *Toward a People's Art: The Contemporary Mural Movement*. E. P. Dutton, 1977.

Conrad, Barnaby III. *Absinthe: History in a Bottle*. Chronicle Books 1988.

Dardis, Tom. *The Thirsty Muse: Alcohol and the American Writer*. Ticknor & Fields, 1989.

Feld, Alan L., Michael O'Hare, and J. Mark Davidson Schuster. *Patrons Despite Themselves: Taxpayers and Arts Policy*. New York University Press, 1983.

Jeffri, Joan. *The Emerging Arts: Management, Survival and Growth*. Praeger, 1980.

Misey, Johanna L., ed. *National Directory of Multi-Cultural Arts Organizations*. National Assembly of State Arts Agencies, 1990.

Mitchell, W. J. T., ed. *Art and the Public Sphere*. University of Chicago Press, 1992.

Naude, Virginia, and Glenn Wharton. *Guide to the Maintenance of Outdoor Sculpture*. American Institute for Conservation of Historic and Artistic Works, 1992.

Netzer, Dick. *The Subsidized Muse: Public Support for the Arts in the United States*. Cambridge University Press, 1978.

Shiva, V. A. *Arts and the Internet*. Allworth Press, 1996.

Shore, Irma, and Beatrice Jacinto. *Access to Art: A Museum Directory for Blind and Visually Impaired People*. American Foundation for the Blind, 1989.

Snyder, Jill. *Caring for Your Art: A Guide for Artists, Collectors, Galleries, and Art Institutions*. Allworth Press,1996.

Whitaker, Ben. *The Philanthropoids: Foundations and Society*. William Morrow, 1974.

Art Publications

A number of magazines and journals are published for artists that include news in the field, trends and opinions, listings of upcoming juried art shows, art workshops, and other opportunities, technical information, and career advice as well as feature articles. Among these are:

ACTS Facts
Arts, Crafts and Theater Safety
181 Thompson Street, Room 23
New York, NY 10012
(212) 777-0062
$10 a year

American Artist
One Color Court
Marion, OH 43305
(800) 347-6969
$24.95 a year

Art Calendar
P.O. Box 1040
Sterling, VA 22066
(703) 430-6610
$29 a year

Art Hazards News
Center for Safety in the Arts
5 Beekman Street, Room 1030
New York, NY 10038
(212) 227-6220
$21 annually

The Artist's Magazine
P.O. Box 2120
Harlan, IA 51593
(800) 333-0444
$24 a year

ARTnews
P.O. 2083
Knoxville, IA 50197-2083
(800) 284-4625
$32.95 a year

Art Now Gallery Guide
Art Now, Inc.
P.O. Box 888
Vineland, NJ 08360
(201) 322-8333
$35 a year

The Chronicle of Philanthropy
1225 23rd Street, N.W.
Washington, D.C. 20037
(202) 466-1200
$67.50 a year

Fairs and Festivals in the Northeast
Fairs and Festivals in the Southeast
Arts Extension Service
Division of Continuing Education
604 Goodell
University of Massachusetts
Amherst, MA 01003
(413) 545-2360
$7.50 apiece; $13 for both

Institute Items
Art & Craft Materials Institute
100 Boylston Street, Suite 1050
Boston, MA 02116
(617) 426-6400
$20 a year (for individual artists)
$50 a year (for companies)

New Art Examiner
1255 South Wabash
Fourth Floor
Chicago, IL 60605
(312) 786-0200
$35 a year

Pen, Pencil & Paint
National Artists Equity Association
P.O. Box 28068
Washington, D.C. 20038
(800) 727-6232
$12 a year

Sunshine Artists USA
2600 Temple Drive
Winter Park, FL 32789
(407) 539-1399; (800) 597-2573
$22.50 a year

Index

Allworth Books

Allworth Press publishes quality books to help individuals and small businesses. Titles include:

The Business of Being an Artist, Revised Edition
by Daniel Grant (softcover, 6 × 9, 272 pages, $18.95)

Artists Communities by the Alliance of Artists' Communities
(softcover, 6¾ × 10, 224 pages, $16.95)

The Fine Artist's Guide to Marketing and Self-Promotion
by Julius Vitali (softcover, 6 × 9, 224 pages, $18.95)

Arts and the Internet by V. A. Shiva
(softcover, 6 × 9, 208 pages, $18.95)

Fine Art Publicity: The Complete Guide for Galleries and Artists
by Susan Abbott and Barbara Webb (softcover, 8½ × 11, 190 pages,
$22.95)

The Artist's Complete Health and Safety Guide, Second Edition
by Monona Rossol (softcover, 6 × 9, 344 pages, $19.95)

Legal Guide for the Visual Artist, Third Edition
by Tad Crawford (softcover, 8½ × 11, 256 pages, $19.95)

Licensing Art & Design, Revised Edition
by Caryn R. Leland (softcover, 6 × 9, 128 pages, $16.95)

Business and Legal Forms for Fine Artists, Revised Edition
by Tad Crawford (softcover, 8½ × 11, 144 pages, $16.95)

**The Laws of Fésole: Principles of Drawing and Painting from the
Tuscan Masters** by John Ruskin, introduction by Bill Beckley
(softcover, 6 × 9, 224 pages, $18.95)

Lectures on Art by John Ruskin, introduction by Bill Beckley
(softcover, 6 × 9, 256 pages, $18.95)

Please write to request our free catalog. If you wish to order a book, send your check or money order to Allworth Press, 10 East 23rd Street, New York, NY 10010. Include $5 for shipping and handling for the first book ordered and $1 for each additional book. Ten dollars plus $1 for each additional book if ordering from Canada. New York State residents must add sales tax.

If you wish to see our catalog on the World Wide Web, you can find us at Millennium Production's Art and Technology Web site:
http://www.arts-online.com/allworth/home.html
or at **http://www.interport.net/~allworth**